JAPANESE AND ORIENTAL CERAMICS

JAPANESE and ORIENTAL CERAMICS

by HAZEL H. GORHAM

CHARLES E. TUTTLE COMPANY
Rutland, Vermont & Tokyo, Japan

Representatives
Continental Europe: BOXERBOOKS, INC., *Zurich*
British Isles: PRENTICE-HALL INTERNATIONAL, INC., *London*
Australasia: PAUL FLESCH & CO., PTY. LTD., *Melbourne*
Canada: M. G. HURTIG LTD., *Edmonton*

Published by the Charles E. Tuttle Company, Inc.
of Rutland, Vermont & Tokyo, Japan
with editorial offices at
Suido 1-chome, 2-6, Bunkyo-ku, Tokyo, Japan

© 1971 by Charles E. Tuttle Co., Inc.

Library of Congress Catalog Card No. 70-130416

International Standard Book No. 0-8048-0927-5

First Tuttle edition published 1971
Third printing, 1971

PRINTED IN JAPAN

The author wishes to express her grateful obligation to Mr. Masando Ono, who because of continued ill health was forced to abandon the idea of full collaboration but who loyally urged me to continue as planned; to Mr. Atsuharu Sakai my old friend and monitor on all things Japanese; and Mr. Shoshun Otake for his happy collaboration on the illustrations for this book.

TABLE OF CONTENTS

LIST OF FULL-PAGE ILLUSTRATIONS

Longfellow's "Keramos"

Cradled and rocked in Eastern seas,
The islands of the Japanese
Beneath me lie; o'er lake and plain
The stork, the heron, and the crane
Through the clear realms of azure drift,
And on the hillside I can see
The villages of Imari,
Whose thronged and flaming workshops lift
Their twisted columns of smoke on high,
Cloud cloisters that in ruins lie
With sunshine streaming through each rift,
And broken arches of blue sky.

All the bright flowers that fill the land,
Ripple of waves on rock or sand,
The snow on Fujiyama's cone,
The midnight heaven so thickly sown
With constellations of bright stars,
The leaves that rustle, the reeds that make
A whisper by each stream and lake,
The saffron dawn, the sunset red,
Are painted on those lovely jars;
Again the skylark sings, again
The stork, the heron, and the crane
Float through the azure overhead,
The counterfeit and counterpart
Of nature reproduced in Art.

PUBLISHER'S FOREWORD

Japan has been called the cultural melting pot of the Orient. This is especially true in reference to ceramics. Greek ceramic art has died out; that of Persia belongs to history; China, where the ceramic art reached glorious perfection, has fallen on evil days and has little to teach us now. Only in Japan are there strong traces of that cultural stream still pursuing eastward outlets.

In the development of the ceramic art, Japan of course owes much to its close cultural contacts with China and Korea. China, in the T'ang and Sung dynasties, reached a pinnacle in art which has never been surpassed and seldom equaled elsewhere in the world.

The Japanese were eager pupils of China's master artists, and from the 16th century onward Japanese pottery developed rapidly. At the beginning of the 17th century the discovery of important deposits of porcelain stone in the Arita district of Hizen Province put the porcelain industry on a firm basis—and Japaese ceramics were in full flower. This book was originally published under the title *Japanese and Oriental Pottery*.

INTRODUCTION

Historical Outline - Glaze - Design - Colour

Classification and Identification

Potters' Marks and Seals

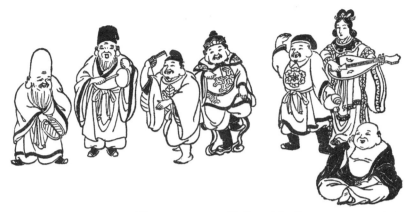

How can one distinguish Japanese porcelains from Chinese, and how can one recognise modern reproductions of genuine old wares are questions on the lips of many visitors to Japan who have neither time nor inclination to go deeply into the study of Oriental ceramics but who would like to take home with them representative pieces of authentic Japanese ceramic art. This little volume is an attempt to answer these and similar questions. In the field of ceramics, as in so many other cultural activities, Japan is at a great disadvantage through lack of available information in any European language. The facts set forth here, inadequate as the author knows them to be, are the result of long years of study and painstaking research.

The new-comer to Japan is confronted with a bewildering array of porcelains all very much alike to his un-practised eye and he has nothing in his own experience or culture on which to base his judgements. Familiar with European porcelain and its traditional decoration influenced by the classical arts of Greece and Rome, he searches in vain for similar motives or colours in the decoration of Japanese wares. Japanese pottery and porcelain decoration is Oriental in origin and as yet there are very few traces of European influence.

Any discussion of Japanese ceramics must take into consideration the fact that true Japanese wares are practically unknown outside of Japan. This statement is startling and perhaps needs some explanation, but it is fundamentally true.

Although political history is out of place in a book on ceramics it is impossible to substantiate the above statement without a quick review of pertinent events of the last four hundred years. Sometime about the year 1549 St. Francis Xavier found his way to Japan. He was in the vanguard of the first wave of European

civilization. For about eighty years Japan allowed free entry to all Europeans. It must be remembered that these were eventful years in Europe. Spanish ships roamed the high seas, then Portuguese, then Dutch and finally English ships followed. It was in the same order that these countries' ships came to Japan bringing news of the religious wars in Europe and of the establishment of colonies in North and South America. Requests for trading privileges in Japan were followed by vain and unwise boastings and threats by undiplomatic ship captains. Thoroughly alarmed, the Japanese government closed its doors to all comers and Japan entered a period of seclusion which lasted two centuries and a half. The laws against the entry of Europeans were vigorously enforced; Dutch traders, the only licensed traders, were confined to the tiny artificial island of Deshima at Nagasaki and the number of trading ships, fixed at first at from seven to ten each year, in 1790 was reduced to one. Trading with Korean and Chinese merchants though not encouraged was not prohibited and ceramic wares from those countries continued to trickle into Japan through the ports of Kyushu, especially those of Karatsu and Nagasaki.

In 1598 Hideyoshi, the Shogun or Supreme Commander of the Army of Japan (there was no navy), set out to conquer China by way of Korea. The only result of this invasion was a great influx of Korean potters into Japan, as a military expedition it was a flop. It was at this time that the craze for pottery utensils for *cha no yu* was at its height, and every Japanese general brought back with him at least one expert potter to teach the native Japanese potters. It is said that one powerful and rich feudal lord brought thousands of potters to Japan. Excellent clay materials were discovered in Kyushu and by the beginning of the eighteenth century the Kyushu kilns were producing a good grade of porcelain. Meanwhile, the people of Europe had discovered Chinese porcelains, " China ware " they called them. But even in China the production of porcelain was in its infancy and enterprising Chinese merchants came to Nagasaki, Karatsu and Imari (ports in Kyushu) to buy porcelain for re-sale in Europe.

Thus it came about that Japanese porcelains were sold in the markets of Europe. These wares had been produced for that purpose, following Chinese models. Any divergence from Chinese originals was through ignorance or carelessness, not intentional, until Kakiyemon developed his own individual style. Kakiyemon's designs were well liked in Europe and it must be admitted that they are representative Japanese. In Japan, however, even Kakiyemon's wares have not been considered of any great

importance because he worked in porcelain and the Japanese have always preferred pottery to porcelain. The porcelains sold abroad, and known as "Old Japan" in Europe, were called Brocade Imari (*nishikide imari*) in this country and have received but scant notice here. It is doubtful if there is a private collection of such wares in all Japan. Their over-crowded surface decoration runs counter to all Japanese art canons and their shapes unmistakably distinguish them from articles made for use of the Japanese in Japan. A pair of vases should warn the purchaser against the dealer who offers them as valuable old Japanese art, because for their own use the Japanese never make anything in pairs and vases are not used in a Japanese house. An exception to this statement must be made with regard to articles for Buddhist religious ritual which requires flower vases and candle sticks in pairs but these are never decorated in colour. Likewise six plates or cups exactly alike must have been made for export, for the Japanese make things for their own use in sets of five; and there is always some slight variation in design or shape.

The first attempts to make true porcelain in Japan were made at the beginning of the seventeenth century at a time that the laws prohibiting trade with Europeans were most vigorously enforced. Porcelains were smuggled out of the country through the agency of Chinese traders, some few were also sold to licensed Dutch traders for sale in the Dutch East Indies and India. In the year 1664 one Dutch ship cargo of 45,000 pieces of Imari porcelain was consigned to Holland directly. Under such circumstances, it is but natural to find strong traces of non-Japanese taste in these export wares.

To understand Japanese ceramics consideration must also be given to the history of the development of this art and the influences upon it of the close cultural contact of China and Korea. It is a fact that the potter's wheel was known in Japan since prehistoric times and that glazed tiles were made as early as the sixth century. Japanese history makes repeated mention of Korean potters coming to Japan and there are several towns and villages where tradition says the descendants of those potters still live. It must be admitted that it is little more than tradition for the villages and their inhabitants are today indistinguishable from their neighbours. It is believed that Jingu Kogo, the Japanese Empress who conquered Korea in the third century, brought back with her a number of potters.

The middle of the sixth century is the date officially assigned to the introduction of Buddhism into Japan. The

immediate and lasting effect of this was the development of **the arts** of architecture, sculpture, bronze casting, weaving, painting, etc. but no mention is ever made of any form of ceramic art at that period. Buddhist ritual requires metal ceremonial utensils and the humble art of pottery had nothing to contribute. But pottery articles are essential to the simple ritual of the indigenous religion of Japan, Shintoism. Unglazed earthenware (*suyaki*) is, to this day, used for the daily offering of rice and *sake*, alike in humble homes and before imposing shrines.

Although, as we shall endeavour to show elsewhere in this book, the art of pottery and porcelain was known to some degree from very ancient times in the West, it came to flower in China along with so many other arts in that great country. China in the T'ang and Sung dynasties reached a pinacle in art that has never been surpassed and seldom equalled elsewhere in the world and Japan was an eager pupil of those master artists. Actually there were two ways in which Japan received Chinese art and culture, one, perhaps the first, through Korea and Korean teachers; and the other through Chinese teachers who came to Japan direct from China and through Japanese who went to China to study.

Japanese ceramic art has felt the influence of four great waves of culture from outside the narrow borders of the country.

First :—That of the T'ang dynasty (618 to 907) and the Sung dynasty (960 to 1126). This brought with it the beautiful old celadons which are known as *seiji* in Japan, and three colour pottery (*sansai*). In their attempt to reproduce the Chinese celadon wares the Japanese happened upon Yellow Seto (*ki seto yaki*) in the sixteenth century and this ware has been accepted by them as meeting their aesthetic needs.

Second :—From Korea in the sixteenth century came a crude form of porcelain, white wares (*hakuji*) and underglaze blue wares (*sometsuke*). Koreans built kilns in North Kyushu at Karatsu and in South Kyushu at Satsuma and elsewhere.

Third :—About the middle of the seventeenth century the Chinese art of overglaze decoration on pottery came to Japan and on the foundation laid by the labours of Korean and Japanese potters that art was developed in Japan. This was the art of the Ming dynasty (1368-1643) and the early part of the Ching dynasty (1644-1910) which from small beginnings in the island of Kyushu spread all over Japan by the eighteenth century.

PLATE I

Design on the back of plate, developed in under-the-glaze blue, showing mixed Occidental and Japanese art.

Japanese adaptations of the Chinese mountain and cloud motive.

Design found in many widths on the outside of plates and bowls always in blue and white. Closely based on Chinese models.

Fourth :—An influence undoubtedly cultural but of doubtful artistic value exerted by the demand for wares pleasing to the people of other countries. This was first felt early in the seventeenth century, spearheaded then by Dutch traders and now in the twentieth century spearheaded by American merchants. Although this influence is directed on wares for export it did not fail to affect the purely local art.

It is not the intention of the author of this book to sit in judgement on the ceramic art of Japan in this the year of our Lord 1951 (the 26th year of Showa in Japan) for we feel that is best left to the discretion of our readers. Our effort is to enable them to recognize what is essentially Japanese and what is due to outside influences. We believe that Japan has contributed to the ceramic art of the world through her love for simplicity and naturalness. We acknowledge Japan's great debt to older cultures but we also think that she has something of value to offer in return. Of all the forms of art in Japan that of pottery is perhaps the best illustration of the Japanese sense of individuality. Japanese porcelains do not show this as pottery does, porcelains are more apt to follow stereotyped shapes and patterns ; but in the making of pottery wares the Japanese artist allows his individual fancy full sway.

The seclusion policy of the Tokugawa Shogunate has placed Japan in the position of being the least understood country in the Orient, culturally. When, in the last quarter of the nineteenth century, Japan burst forth from this seclusion, her people's admiration of foreign things knew no bounds and, alas, also no discrimination. Japanese taste and Japanese art went into abeyance and ceramic productions in their attempt to appeal to European taste (of which Japanese artisans had not the faintest conception) reached unbelievably low levels. Thus, to judge Japanese ceramic art by things that have gone abroad is obviously unfair. The attitude towards wares for export taken by the Japanese in general is one of total indifference, they simply ignore them, and it is doubtful if there is in existence any writing in Japanese on this subject.

Of course some of the productions intended for export must have remained in Japan and these have a certain value to Japanese collectors as marking successive steps in the development of Japanese ceramic art, or are treasured as family possessions because of the circumstances under which they came into the possession of the owners. With the early wares of Imari as with the once scorned woodblock prints (*ukiyo ye*) the passage of time has brought about a change in the thinking of some Japanese. And dealers in antiques for the tourist trade and manufacturers are obligingly reproducing these old wares for sale to the tourist of today.

Historical Outline of the Development of
Oriental Ceramic Wares

Group known as rokkasen, or The Six Poets; one, sometimes two, of them are women. This group has five men and one woman.

The history of the development of decorated ceramic wares runs parallel with the history of many other forms of culture and civilization, from West to East. Cultural influences originating in such ancient civilizations as Egypt, Persia, and Greece traveled eastward by camel caravans over the deserts and by ships over the seas. This fact must not be forgotten in any attempt to understand the cultural products of Asia, and cannot be ignored when trying to judge and appreciate today's ceramic art of Japan. Okakura Tenshin wrote in his Book of Tea "Asia is one" and by this he meant one in cultural forms, for the great cultural current from the West in its surge to the East influenced all countries of Asia.

Glazes

The history of industrial art objects made of clay begins with the sunbaked tiles of Egypt and Mesopotamia and the development of glazes in those countries.

The secret of the preparation of glazes was known only to the potters of Babylonia and Assyria for many years and the current of that form of culture flowed eastward through Persia and Gandra before it entered China. In the ruins of Han dynasty settlements (202 B.C. to 220 A.D.) green glazed pottery is still being brought to light and fragments of glazed articles of the Shang dynasty (1766 to 1123 B.C.) are found.

Historically it must be considered that the art of glaze of the Han dynasty was the result of the amalgamation of two arts, that which came from the West and that which sprang up in China independently. From this fusion of native and imported arts the Chinese potters developed other colour glazes and the three colour (*sansai*) pottery of the T'ang dynasty (618 to 907) came into existence. Among the many arts which came to Japan from China was that of pottery glaze, and so the ancient art of

Egypt in the West came to Japan in the East. The Shoso-in at Nara, the Imperial Repository, has many articles of pottery closely resembling the T'ang three colour wares and from them we can get an idea of the condition of the Japanese ceramic art of that period.

Pottery and the art of glazing made steady progress in Japan, especially in what is known as the Momoyama Period (approximately 1574 to 1602). This period can be called the renaissance in Japan when the cult of cha no yu was at its height and under its influence and encouragement pottery making rose to a high level and in the subsequent half century the manufacture of porcelain was begun.

It was during this period that Japan received from China the arts of under-the-glaze decoration in blue (*sometsuke* or *gosu*) and of over glaze enamel colours (*akaye* or *gosu-akaye*), which completely revolutionized the native ceramics. The perfection of the art of porcelain decoration was a slow development in China from the fourteenth to the seventeenth century when it flamed suddenly into a beauty that has never since been equalled : and it burst upon Japan with an impact that is still felt.

At first only a small part of Japan was affected because all contact with the outside world was confined to a few ports in Kyushu but by the beginning of the nineteenth century this cultural wave had swept all over Japan. Japanese ceramic artists, all unknown to themselves, were following the tradition of centuries, the aesthetic tradition and the accumulated experiences of the potters of the world, and they in their turn produced things of beauty and of individuality.

With the removal of the veil of mystery from the manipulation of ceramic glazes and the mastery of their use, a new element entered and a great modern industry was under way.

Like the knowledge of glazing, pottery design, indeed all art, followed an eastward course. Greece was the home of many arts and its god Keramos, who watched over its potters and clay workers, gave not only the name by which wares made of clay are known today but also many beautiful patterns to the potters of the world. Geometrical patterns which the Egyptian potters used in pre-Sumerian days three thousand years ago reappear in today's small decorative patterns. The Phoenicians gave us the first band decoration, the anchor chain, and conventionalized palm trees. The honeysuckle meander and lotus-rosette of the Proto-Corinthians and Ionians are found all over the world and in the modern designs of Japan today are motives of most varied national origin.

Designs from Greece, Persia and China, cultural relics of those countries, abide side by side in utmost harmony here in Japan, the cultural melting pot of the Orient. Grecian ceramic art has died out, that of Persia is a thing of the past, China where the ceramic art came to such glorious perfection has fallen on evil days and has nothing to teach us now. Only in Japan can be found traces of that cultural stream still pursuing its eastward course.

The migrations of the art of glazing and of design have been discussed at some length, we come now to the consideration of how to determine whether an article is of Chinese or Japanese origin. For this purpose it is absolutely necessary to touch and handle the thing in question for the sense of touch is more to be relied upon than that of sight in this case. Ceramic connoisseurs have allowed themselves to be blindfolded and through their sense of touch alone have correctly determined the age of an article and the kiln at which it was made.

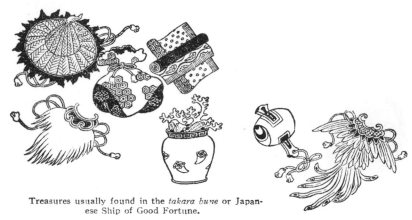

Treasures usually found in the *takara bune* or Japanese Ship of Good Fortune.

The hat of invisibility	Bag of gold	Mallet of Dai koku sama
Coat of invisibility	Two rolls of silk cloth	Japanese angel feather robe
	Jar containing coral	

To be able to intelligently differentiate between Chinese and Japanese ceramics by design only really requires a considerable knowledge of Chinese art. But an easier approach to the subject, and sufficient for the average person, is to familiarize oneself with what is essentially Japanese and to use this knowledge as a foundation from which to progress. Most of the designs on Japanese ceramics came from China via Korea. Korea seems to have passed designs on practically unaltered and to have been very little affected by this operation; for Korean ceramic designs remain even more distinctly Korean than those of Japan are Japanese,

while Japan continues to use and to adopt Chinese designs side by side with purely Japanese designs.

Korean influences are discernible in some Japanese wares, namely the *mishima* wares, although even here it is the method of developing the design rather than the design motive. It was through Korean potters' skill and ability rather than through Korean artists' designs that Korea played so great a role in facilitating the passage of Chinese ceramic art to Japan This may also be due to the fact that after the introduction of Chinese things by Korea the Japanese very quickly looked to China directly and sent students to study the arts there as well as invited Chinese teachers to Japan.

About the only purely Korean design that can be found on Japanese ceramics is that known as "*unkaku*" cloud and bird design—thin attenuated cranes flying among equally attenuated cloud forms.

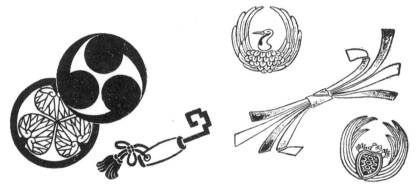

Left to right—The three leaf design in a circle is the *mon* or crest of the Tokugawa family and is found on porcelain designed for them and on many export wares.

The *mitsu tomoye*, purely Japanese development. The Koreans have a similar design but with no spaces between the three comma-like objects). Its exact meaning is not known, it is of very ancient origin; it may express the universal idea of trinity. It is found painted or carved on objects used in both Shinto shrines and Buddhist temples as well as on roof tiles of private store-houses.

The strange looking object with cord and tassel is a store-house key, used to symbolize wishes for great wealth.

The two circular figures of the crane and the tortoise are found on all types of ceramics.

The last is one form of *noshi*, the dried flesh of the abalone (*awabi* in Japanese) used on all presents. It is symbolic of food and a reminder to all Japanese that their forefathers were dependant on the bounty of the sea for their food. This form of noshi is found on the oldest Imari ware designed for use in Japan.

Designs that are purely Japanese in origin and development include the Ship of Good Fortune (*takara bune*) and the treasures it carries (*takara mono*); various modifications

of the Japanese symbol used on gifts (*noshi*); the flaming pearl (*hoshu*) sometimes single, frequently three together; the three comma shapes in a circle (*mitsu tomoye*); certain popular food fishes (*tai, katsuo*) and shell fish (*ebi, hamaguri*); designs based on the markings on a snake's skin, fish scales and the carapace of the tortoise; the tortoise as pictured with a long tail (*mino game*); vegetables such as egg plants (*nasu*) turnip (*kabu*), red pepper pods (*togarashi*); the crests (*mon*) of many well known Japanese families, including the chrysanthemum crest of the Emperor (*kiku no mon*) and the paulownia-flower-and-leaves crest of the Empress (*kiri no mon*); small pine seedings with the roots attached (*waka matsu*); the Seven Gods of Good Fortune together or separately (*shichi fukujin*); the six poets of old, one of them a woman (*rokkasen*); court ladies (*tsubone*); historical figures of warriors in armour; and *bugaku* and *gagaku* dancing figures.

Three court dancers; the male figures are *bugaku* dancers, the female is a *gosechi mai* dancer.

Chinese designs are drawn with a strength and verve that is seldom equalled by Japanese designs which tend to be more elegant and refined. Chinese ceramic designs were executed by master craftsmen, often dozens of men worked on one piece like the assembly line of modern motor-car manufacturing. Japanese designs are more often the result of the carefully, even lovingly, detailed work of a single potter (although Japanese potters since earliest times have been accustomed to specializing in a certain design or colour in endless repetition). There is practically no

PLATE II

Band and border design very typical of well made Old Imari (*ko imari kinrande*). The design of two forms of the Japanese chrysanthemum was first left reserved in white on a red glaze ground, then leaf-veins and flower petals were drawn in red. Some of the flowers have a very thin dull-gold colour glaze but those that resemble the Imperial crest have been left in white with a comparatively large center of dusted-on gold.

Old Imari border design on outside of shallow bowl; highly conventionalized lotus flowers. Flowers and buds in red, leaves in a very light green, transparent enamel; connecting scroll in gold paint on white ground.

Border design on Old Imari dish. Background red enamel; flowers reserved in white, flower petals lined in red; each with three leaves in thin yellow enamel dusted with gold powder.

Chinese ceramic design that has not at sometime been copied by the Japanese potters. In general it may be said that the Chinese

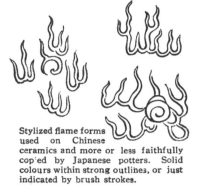

Stylized flame forms used on Chinese ceramics and more or less faithfully copied by Japanese potters. Solid colours within strong outlines, or just indicated by brush strokes.

are more prone to use human figures than the Japanese; especially the eighteen arhats (*rakan*), gaunt old men seated in various attitudes of meditation; the eight sages, old men each carrying a symbolic object, frequently pictured in a bamboo grove (*sen nin*); Chinese children at play; or the beautiful ladies known to Europeans as "Lange Eleizen". Besides the numerous flower and bird combinations, the curly-haired lion-dog (*kara shishi*), the one horned *kirin* and the dragon (*ryu*), fabulous animals of Chinese lore, are frequently to be found on Japanese porcelains. A kind of bird of Paradise, purely a creature of Oriental imagination, known as *hoo* in Japan (which is sometimes mistakenly translated Phoenix); meander or arabesque patterns based on the honeysuckle, lotus or chrysanthemum; stylized mountain and wave designs known in Europe as the "Rock of Ages pattern"; a quite distinctive design called the cloud pattern; the scepter head (*jui* or *jooi*) pattern; the figure of the Buddhist teacher Daruma who in Japan becomes the subject of jokes and is drawn in most undignified positions and situations; representations of the peach,

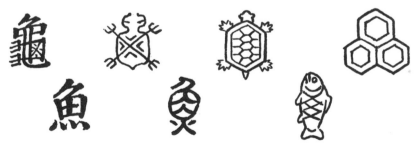

Upper line; various picture-graphs of *kame* or tortoise. Lower line; picture-graphs of the word *sakana* or fish.

pomegranate and citron, usually as repeat patterns in borders; are common to both China and Japan. The Chinese frequently incorporate the characters for good fortune, longevity, riches, etc. in the pattern as a type of decoration while the Japanese artist delights in distorting characters into a semblance of the thing itself. The

eight sacred objects of Buddhism are found more often on Chinese wares, as also the symbolic objects of the eight sages. Houses and other architectural features so often found in Chinese porcelain designs are practically never found on Japanese wares. Here it may be well to mention that the "Willow Pattern" design so well known in Europe and America in the eighteenth and nineteenth centuries seems to have been totally unknown in Japan until within the last few years.

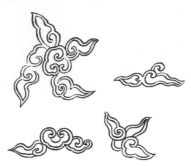

Stylized Chinese cloud forms, sometimes found on Japanese ceramics. Solid enamel colours within strong outlines.

The most striking difference in designs on Chinese and Japanese ceramic wares is to be found in the use of borders and repeated panel designs. The Chinese potter delights in covering the surface glaze of any article with a mass of intricate designs, he seems to have a horror of undecorated surfaces; the beautiful sea-green celadons have incised or moulded designs under the glaze; the three-

Japanese rendition of the Chinese cloud forms as developed by the celebrated artist Ninsei 300 years ago. Ninsei simplified the shapes of the clouds, presenting a cloud mass rather than groups of clouds. Ninsei used gold dust and gold foil freely.

colour and five-colour porcelains have conventionalized cloud or fire designs as a sort of diaper pattern on those parts of the surface of an article that is not covered by the main design.

There is a vast difference between the art designs used by the Chinese potter and those used by the Chinese painter. This is not so in Japan, for although at first the Japanese potters faithfully copied the technic both of making pure white porcelain glaze and of

Cloud forms found on all types of Japanese ceramics, an adaptation of Ninsei's clouds. These may be merely outlined, shaded in gold or colour, or solid masses of colour or gold.

over-glaze enamel decoration they soon began to treat the article to be decorated as the pictorial artist treats his canvas, that is, merely as a surface on which to paint a picture. The artists of no other country have ever reached the heights achieved by the Chinese pictorial artist in his handling of empty spaces in a picture, but it was left to the Japanese potters to apply this technic to ceramic wares.

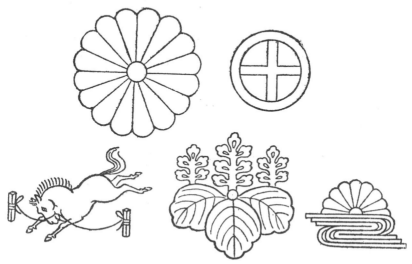

Family crests often found on ceramic wares. Top, left to right; the Imperial crest *kiku no mon* much used on early Imari export wares; crest of the House of Satsuma found on wares made at kilns in Satsuma. Bottom, left to right; tethered horse crest of the House of Soma; crest used by the Empresses of Japan *kiri no mon* usually found in association with the hoo-bird, and crest of the Kusunoki family, *kikusui*, used as a ceramic design or frequently developed into a box for holding incense.

An explanation of this may be found in the working conditions of the potters of these two countries. In China, potters were workmen, patient, artistic and skillful, it is true, but still workmen, employed by the hundreds at great government-owned kilns, turning out thousands of articles according to official orders. The designs were furnished them by the Imperial Court and each piece went through many hands. So strict was the oversight and control of the workmen that even the amount of colouring material necessary for the design was carefully measured out and each workman was required to turn in a fixed number of decorated articles. When there were orders from the Court the kilns were operated, when the needs of the Court had been met the kilns were shut down and the workmen turned away. Of course it must have been that there were small private kilns and artist-potters working alone but

we have no historical record of them. But in Japan porcelain and decorated pottery developed under quite different conditions. The influence of the Imperial Court of Japan was indirect, not direct. Japanese potters worked as individuals, designing, making and decorating each article. Each potter worked at home assisted by his own immediate family, or by a few student apprentices and fired his productions at a community kiln. Almost every feudal lord, and there were more than three hundred of them, operated a kiln at which wares were made for his personal use. Instead of a fixed quota of production being required, the production of the different kilns was often limited. Under the feudal system artisans received their usual stipend whether they worked or not. Pottery making was an art not a trade and under the influence of famous *cha jin* (tea masters) individuality was encouraged in the potters. Not as workmen but as master craftsmen the Japanese potters were encouraged to strive after perfection and their reward was the admiration of their fellow potters and the recognition of their feudal lord. Also decorative design for porcelains developed differently in the two countries, in China the goal sought was perfection and detail of design while in Japan it was perfection of general appearance with design a subordinate requirement.

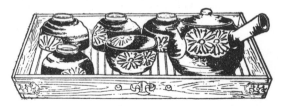

As tea is served in modest households.

Colour is of course closely associated with design and here again we find national characteristics an aid in determining the origin of a piece of porcelain or pottery. Certain colours and certain ways of using colours are found on Chinese wares and not on Japanese wares. With the single exception of seiji, or celadon, one colour porcelains are practically unknown in Japan (disregarding for the moment the imitations of Chinese wares made in Japan). The Japanese prefer a white or neutral colour background for their ceramic designs. Under-glaze blue and under-glaze red are common to both countries, as are the so-called *gosai* or five colour wares. Only long experience can teach one how to distinguish these wares by colour alone. Imari red and Kutani purple, green and yellow, are unmistakably Japanese.

PLATE III

Decorative band on inside of bowl after the style of Chinese Ming Porcelain (*gosu akaye*). The hoo bird depicted with green head and body, red wings and alternate red and green tail feathers surrounded by red fire forms and green and yellow cloud forms.

Decorative border on inside of Old Imari bowl and repeated on the outside. Diaper pattern in under-the-glaze cobalt blue; the two end medallions red with floral reserves of white, the flower in the center gold coloured but the leaves line-drawn in red. The middle medallion is green enamel with white reserves of cloud and flowers, the cloud outlined in red is covered with dusted on gold powder, and one large flower and spiky leaves are done in red.

Decorative band on outside of Old Imari bowl, developed in yellow, green and blue on a background of red. This form of the *hoo* bird and *kiri no mon* can only be Japanese.

The Chinese colours of cerise-red, rose-red, pea-green, egg-yellow, turquoise-blue, all soft beautiful colours have never found favour in Japan and the reason is not far to seek. The Chinese household furnishings, even the houses themselves, are made of dark polished wood of a beautiful brown colour, against such a background these brilliant colours show to perfection, but they would be lost and insignificant against the Japanese neutral tints of unpolished wood and straw matting. Likewise the Japanese scale of colours, more especially the type of pottery the Japanese prefer, does not look well on polished wood.

The Japanese at one period, about the first part of the eighteenth century, in the early days of Imari wares, used a black enamel as decoration on porcelain but it was not a common practice. However, black glaze is used very much on pottery articles, especially on *raku yaki*. Perhaps because of the difficulty of obtaining a purple-black or a pure white colour glaze, such glazes are in high favour with the Japanese potters and public alike. The Japanese call any shade of light tan, or tannish-grey or blue-grey, " white " on pottery; and the cream white of Chinese all-white wares never stirred them to emulation. A milk or snow white enamel glaze is used in the decorative designs on some pottery wares; but, other than an impure and greyish white on certain ritual wares, such as the large incense burners (*koro*) used in Buddhist temples, all-white wares are seldom found in Japan. The white glaze used for decorated rice bowls is deliberately given a bluish or green ish cast in order to enhance the creamy white of the boiled rice.

The beautiful heavy thick glazes known as " Flambe " (or transmutation glazes) with their many shades of blue, red and purple, or the red shading off to green and yellow glazes of " Peach Bloom " were never popular in Japan, except as collector's items.

More certain than design or colour as a clue to the origin of a piece of porcelain is the quality of the porcelain, its glaze and its purpose. It must always be kept in mind that at one time or another every possible Chinese article, every colour glaze and every style of decoration has been exactly

Cake bowls. The Japanese place only a few cakes in a good sized dish.

reproduced by Japanese potters. Many individual potters have become famous for their ability to exactly duplicate certain Chinese

wares. These are not imitations made to deceive (though it may be supposed that such has occurred) and they are frequently signed by the maker. However, such wares do make difficulties for the student of either country's ceramics.

As an aid to the student of Japanese ceramics we give the following hints in the order of their importance:

1. Purpose for which the article was made.
2. Traces of methods of making and firing.
3. Paste (or biscuit) and glaze.
4. Design or pattern of decoration.
5. Colours used.
6. Identification marks or seals.

Purpose for which the article was made :—

At the very beginning we encounter a difficulty which the author has resolved quite simply by ignoring; namely, the fact that in Japan there are two primary classes of ceramic wares, those made for sale and export abroad and those made for the use and pleasure of the Japanese themselves. Wares made for export consist of matched sets of table china, decorated flower vases in pairs and true Japanese things modified to meet the demand of foreign buyers. It is a strange fact that while many progressive Japanese buy and use such articles they are accepted without comment or criticism just as are the modern marvels of electricity, automobiles and aeroplanes. For the purpose of this book we shall follow this lead and turn our attention to primarily Japanese wares.

Here we find first a multitude of bowls, with and without covers, of many sizes and shapes, used for individual servings of soup, rice or boiled vegetables; handleless tea cups, simply smaller sized bowls; and, still smaller in size, sake (the Japanese rice wine) cups. Then come small saucer-like dishes in odd and irregular shapes used for serving fish or vegetables, or for fruit and sweets; sets of one large dish with matching small deep dish, sometimes quite flat and fan or boat or leaf shaped, again deep round tub-shaped bowls, are used for serving the Japanese delicacy of raw fish; medium and large round dishes in bright blues and reds with green, yellow or purple and often much gold used by fish mongers and restaurants; equally large round deep dishes or flat bowls very carefully decorated, usually with designs or symbols of good omen, used in some districts for festive or formal gatherings. The foregoing comprise about all the dishes used for eating from, to which must be added bottles and covered utensils for storing

food. The Japanese way of living admits of only the useful, trivial ornamental objects find no place in a room where custom decrees that a long narrow hanging picture, a stylized arrangement of the season's flowers and an appropriate ornament are sufficient.

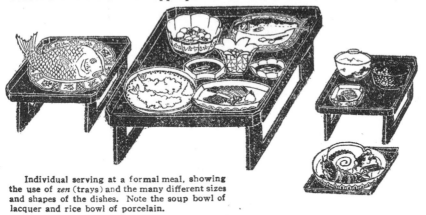

Individual serving at a formal meal, showing the use of *zen* (trays) and the many different sizes and shapes of the dishes. Note the soup bowl of lacquer and rice bowl of porcelain.

So little is known of Japan and the way its people live that it may be well here to rapidly sketch in the surroundings to which Japanese ceramic wares are native. Picture to yourself a room whose prevailing colour is the creamy brown of unfinished wood, one or more whole side open to a garden, floor completely covered with thick soft straw mats and with no sign of furniture of any sort except a couple of golden brown, flat, square cushions. In such surroundings the Japanese love of irregularly shaped pottery dishes is understandable, as also the soft dark glazes and bold designs of cups and dishes which contrast so beautifully with the fine straw of the mats. When a meal is to be served small black lacquer trays are set before each guest, these serve as tables. On every tray will be five small dishes, no two alike, each differing from the others in size, shape and colouring. As the meal progresses the emptied dishes are replaced by others, each one an artistic achievement in which the food served and the design and colour on the dish are in perfect harmony, a feast for the eyes as well as the stomach. It will be noted that food is always served in individual servings carefully prepared in the kitchen, general serving dishes or platters are seldom used. A round plate about the size of an American lunch plate with the edge upturned was fashionable for the serving of fried fish during the Meiji Period (1868 to 1912). These are on sale everywhere and range from crudely drawn designs on commonplace ware to exquisitely designed and executed wares worthy of being placed in a museum.

The Chinese on the contrary furnish their houses with tables and chairs as the Europeans do and serve their food in great central serving dishes from which both host and guests make their own selections with their own eating tools. At a Chinese feast two quite small round dishes are set before each guest, one to hold the food transferred from the central serving dish and one for the food rejected from the mouth during the course of the meal, these are usually made of pewter or silver. Both Chinese and Japanese use chopsticks instead of knives and forks. And it should not be overlooked that neither Chinese nor Japanese make use of the traditional European dinner plate. Such plates, although they may be seen on sale everywhere and certainly are decorated in Oriental style, still are not fundamentally Chinese or Japanese but were made for export and sale to the peoples of countries whose eating habits are quite different. These plates are found in two styles: one, a rather deep dish with the edge fluted or scalloped and more or less sharply upturned, these were sometimes made for the use of the Japanese in Japan: another, plates with a wide flange or brim somewhat like our old-fashioned soup plates, these were made for export only.

Three forms of the very popular *sho chiku bai*, pine plum and bamboo combination.
Top left; A very common form found as center design on Old Imari sometsuke (under-the-glaze blue and white) of poor quality porcelain.
Top right; Another development of pine plum and bamboo, part of the design on a sometsuke bowl of good quality porcelain about a hundred years ago.
Bottom; So-called Kakiyemon development of this design, in colours enameled on the surface in combination with under-the-glaze blue.

PLATE IV

Decorative border on outside of *ko imari kinrande* (Old Imari brocade style) bowl. The three round medallions have white flowers and streamers reserved in a red ground; flowers are drawn in gold paint on the white. Under-the-glaze blue is used for the two blossoms on red diapered back grounds and for the bands outlining the three red medallions. All the flowers are forms of the conventionalized lotus blossom.

Band design used as border also. Old *imari kinrande* pattern, a conventionalized lotus leaf scroll done in gold paint on a red glaze background. Shows definite, though remote, Persian art influence.

Design on rolled edge of Old Imari bowl done mostly in red on a white background known as the *yoraku* (or red ball) design. The large circles are done in red enclosed in a band of green enamel. The diaper panels are done in red with a yellow blossom in the middle. Alternate panels have a peculiar floral motive done in red and yellow with slight dabs of green.

Biscuit and Glaze :—

However, a more certain way of determining the country or origin of a piece is the consideration of the paste or biscuit from which it is made, together with the glaze and the manner in which it is applied. To the feel, there is a very perceptible difference between Japanese and Chinese porcelains. Chinese porcelain wares are light and thin and the glaze is hard and smooth, the edges of a bowl or plate are thin, almost sharp. Japanese wares are thicker and heavier, the glaze is somehow different from the Chinese, almost soft and the edges are thick and rounded. Chinese wares, especially old pieces, show signs of wear on the edges where the enamel (or glaze) chips off in a very characteristic manner, giving the edges a moth-eaten appearance called in Japanese *mushi kui*. Frequently it can be seen by the difference in colour that the glaze at the edge of a bowl is thinner than on the body of the bowl, as though the glaze had pulled away from the edge. This is not to be confused with certain old Chinese wares which have unglazed rims due to the practice of firing the articles upside-down. The glaze on Japanese wares, perhaps because of the more rounded edges, breaks rather than chips off, that is, the glaze seems more incorporated into the paste and a part of it.

On Chinese porcelains the footrim is often beveled rather than square cut having been ground into shape after firing; or shows signs of the sand or gravel on which it was placed in the kiln for firing. Japanese porcelains have a square cut footrim, fully covered with the glaze as clean and perfect as the bowl edge itself. In the kiln the Japanese wares are placed on several small cones or pyramids for firing and the marks of these supports can frequently be seen inside the footrim. Often small radial lines inside the footrim, converging toward the center are found on Chinese wares. But these lines are not an infallible guide because they were reproduced in Japanese wares also.

The glaze on Chinese pottery frequently stops short of the bottom of the object, but a small dab of glaze is put inside the footrim; often there are evidences of the sandy floor of the kiln. An outstanding feature of Japanese pottery is the very considerable amount of unglazed surface exposed, it is part of the decorative scheme and neither the footrim nor inside the rim are glazed and there are no signs of kiln sand or grit.

While the Japanese prefer the thicker and more rugged forms of porcelain wares they have produced and are today producing articles of egg-shell thinness, hard and fine and so translucent as to be almost transparent.

There is one class of Japanese ceramics that is so essentially Japanese that there is little question as to their origin—the wares known as raku yaki. These are discussed in detail elsewhere.

Potters' marks and Seals :—

In China centuries ago these marks may have been reliable and have furnished information as to when and where or by whom a thing was made but they are useful now only as showing that the article could not have been made before the time indicated. In China as in Japan certain potters achieved fame because of their ability to exactly reproduce famous old pieces and they in their turn were reproduced (or counterfeited). The game has been going on for centuries in China. About 1664 Chinese merchants shipped to Europe a boat-load of porcelain wares all marked with the seal mark of Cheng Hua, an emperor who reigned from 1465 to 1487. Later when Japanese potters began making porcelains they copied the kiln marks exactly as they copied the designs. But just as the Japanese potter imparted an elusive something to the Chinese designs that distinguish them from the originals so in copying the Chinese characters making up the seal marks they gave them an unmistakable Japanese flavour, and this sometimes furnishes the first clue to a falsification which might otherwise have defied detection.

More modern Japanese pieces may be identified by individual seal marks but here again trouble enters for the student because of certain practices such as follows : a master potter sometimes put his personal seal on all articles made in his kiln; or a potter signed his productions with any number of different names or with the name of an artist whom he admired; frequently the successors of a famous potter have used that potter's seal for generations; most baffling of all is the accepted custom of signing the original artist's name to a reproduction of his work made perhaps many years after his death.

Nevertheless, the potter's marks and seals on the various wares are most interesting and as Ming dynasty marks are found on Japanese wares and indeed are still being reproduced daily it is well to learn a little about them, if only to relieve the harrassed Japanese whose American friends demand that he read and explain the marks. Read them any literate Japanese can, but to explain them is a different matter. Briefly, marks may be (1) Date marks, that is, giving the name of the dynasty and the name of the ruler during whose reign the article was made. (2) Hall

PLATE V

Simplification of lower design.

A very common design, found in many widths, sometimes simply developed or just barely indicated, again very elaborately developed. This is an Imari kiln pattern, always in blue and white, occasionally the flowers just touched with red. The width and care in detail of this design often give a clue to the value of a piece of Imari—as a clue to age of article this design is most misleading it has been in use for a couple of centuries and is still appearing on new productions. A design similar to this has been uncovered on a wall of one of the catacombs at Rome.

The author at one time thought these designs might signify the kiln at which an article was made but after much and long continued inquiry was forced to give up the idea, as neither dealers nor connoisseurs could enlighten her on this point.

marks, that is, inscriptions giving the name of a hall or building which may be the studio name of the potter; the family hall for which the ritual ware was made; the name of one of the buildings of the Imperial palace for which it was made or even of the store or workshop from which it was ordered; as for example, " Beautiful vessel of (or for) the Jade hall " or "Antique made in (or for) the Shen te Hall." (3) Potters' names, in China these are rare but in Japan they are legion. (4) Marks of commendation or expressions of good wishes and dedications such as "A myriad happinesses embrace all your affairs " or " Virtue, culture and enduring spring " or " Great peace throughout the empire."

Inscriptions found on Chinese wares and copied on Japanese wares :—

> *Yung pao wan shou :*—Ever protecting for a myriad ages.
>
> *Yung pao fu Ch'i t'ien :*—Ever ensuring abundant happiness reaching to heaven.
>
> *Fu ju tung tai :*—Rich as the Eastern Ocean.
>
> *Feng t'iao yu shun, t'ien hsia t'ai p'ing :*—May the winds be propitious, the rain fall favourable and peace prevail throughout the world.
>
> *Yung pao ch'ang ch'un :*—Ever preserving lasting spring.
>
> *Ch'ien k'ung ch'ing t'ai :*—Heaven and earth be fair and fruitful.
>
> *Wang ku ch'un Ssu hai lai ch'ao :*—Through an everlasting spring of a myriad ages may tribute come from the four seas.
>
> *T'ien hsia t'ai p'ing :*—Peace throughout the world.
>
> *Shing shou :*—Wisdom and long life.
>
> *Yung pao ch'ien K'un:*—Ever protecting heaven and earth.

Japanese Classifications :—

The Japanese system of classifying their ceramic wares according to type (*densetsu*) of decoration or thing produced leads to overlapping categories and one small article may be designated by the name of the kiln at which it was made, by the name of the first potter to use that style of decoration and by a name indicating the method by which the thing was potted. The most flagrant example is that of *Oribe* wares.

Oribe, whose real name was Furuta Oribe no Sho, died just three hundred and thirty-five years ago but wares produced in many different kilns in Japan today are still called *oribe yaki* that is, Oribe wares (See Page 34). Of course an American parallel can be found in the Bell telephone or the Edison lamps, but in the world of art it is an unusual phenomenon. And Oribe was neither artist nor potter, he was a teacher of, and authority on, all matters relating to the ceremonial serving of tea, cha no yu. Among the many cha jin (tea teachers), whose influence was strong on Japanese ceramics and who have given their names to certain types of wares are So ami, Shin o, Jo o, Rikyu, Sotan, Enshu, Shimbei, Kuchu, Ninsei and a host of others.

Japanese ceramic connoisseurs are apt to name a piece of pottery by the style or type of decoration, as Oribe yaki, Kakiyemon yaki, Ninsei yaki and usually disregard the actual maker of the article or the kiln at which it was made.

Names :—

It is practically impossible to identify a piece of Japanese ceramics by the name stamped, inscribed or written on it because a potter sometimes used two or more names on his wares, and sometimes several generations of potters used the same name and further, it has always been the custom of Japanese amateur potters to use the name of a famous master potter whose works they admire and copy.

The potters of old Japan, as indeed all people below the rank of *samurai*, had no family names. It is only since the establishment of modern Japan that artisans have felt the need of reconciling the name they were born to and used by other members of their family with their artist name. This custom and the practice of legal adoption causes difficulties in correctly recording the various generations of a line of potters. In many cases it is impossible to ascertain the birth and death dates of an individual potter, the best we can do is to give the period of years within which the potter worked using the name of the potter family of which he is an official " generation " (*dai*).

Seals and Signatures :—

The signatures found on Japanese ceramics, as indeed on all forms of art or artcraft, are usually " nom de plumes " or artist names ; or names in some way connected with the artists productions, either the thing produced or the place at which they were made.

Early Imari wares had no potters' seals or marks; the marks found on early Imari wares are copies of Chinese marks.

Early Seto wares have no potters' identification marks—later the Kyoto artist-potters who worked at these kilns used their own seals.

Kyoto potters almost always sealed or signed their wares.

Kutani wares, except the very earliest, have identifying marks easily recognizable.

In general it may be said that the productions of the very earliest kilns have no marks of identification.

Since 1818 many potters have marked their wares with their personal names and it has also become the practice of some kilns to use a seal.

Japanese system of dates :—

In Japan dates are recorded firstly by the reigns of the various Emperors secondly by reference to the various Shogunates.

In speaking of ceramics prior to 1600 the imperial reign names are used but after that dates are established by the very loose classification of Early Tokugawa, Middle Tokugawa, Later Tokugawa, then the Meiji Period, Taisho Period and the present imperial reign, Showa Period.

The Tokugawa Shogunate lasted from 1603 to 1867—this is sometimes referred to as the Edo Period. This was the time of national seclusion when all the Japanese arts and crafts showed great native development.

The Meiji Period (1868 to 1912) is known also as the "Restoration." Actually it was the time of development of modern Japan and a time when European arts, sciences and all forms of civilization were adopted to the exclusion of native arts.

The Taisho Period (1912 to 1926) was a period of assimilation of European mores and a time of quiescence for Japanese things.

The Showa Period (1926 to)

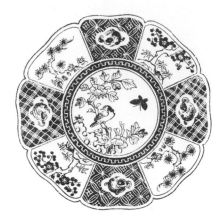

Modern Kutani Plate

Kutani potters are still using traditional Japanese and Chinese designs. Note the pine, plum and bamboo motive; two of the floral panels have blossoming plum trees with bamboo, the other two feature the pine tree. The center design is a simplification of the Chinese peony growing from rocks. The strange little animal in the dark panels has the head of a bird with the tail of a dragon.

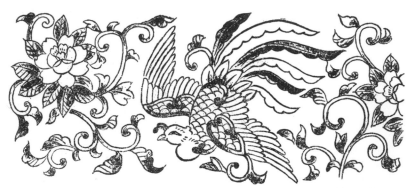

Modern interpretation of the hoo bird with the traditional Chinese peony flower modified to suggest the European rose motive.

Cha no yu
and Its Influence
on Japanese Ceramics

A curve of infinite beauty, a balance of forms, colours that blend harmoniously—that is what we want to look at. But no gazing at the finished object, however perfect it may be, can give the satisfaction that was felt by its creator while finishing it— because then the thing was still alive. Tea people realize the importance of this stage in creation at which a work of art is still alive, craving for the last perfection from its master's hand ; and they take this task with its uncertainty and its joy away from the maker and give it to the beholder.

From Eleanor von Erdberg Consten (Res Artium).

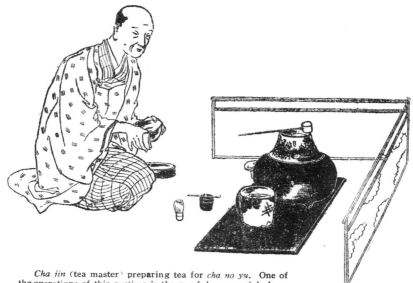

Cha jin (tea master) preparing tea for *cha no yu*. One of the operations of this pastime is the careful ceremonial cleaning of each article as it is put into use. To the left of the server a small bowl for waste water. In front of him on the matted floor a small white bamboo whisk for mixing the tea and a lacquered box holding the powdered tea with measuring spoon balanced on the top. On the lacquered board an Oribe pottery bowl for holding cold water for replenishing the water in the iron hot-water kettle. The large object is a black earthenware fire pot ("*furo*" the making of which gave the Eiraku potters their start in the ceramic art world of Japan) with a cast iron kettle for boiling the water. Balanced on the open top of the kettle is a bamboo dipper with which the hot water is ladled over the powdered tea; the small almost indistinguishable object beyond the furo is the iron lid of the water kettle. This form of serving tea is used only in the summer, in winter the "*furo*" is replaced by a sunken fire box level with the floor mats.

Cha no yu

It is in the making of pottery articles that the Japanese artist expresses in the simplest and most direct way his love of the material he is working with and his conviction that to be beautiful an article must first be useful. And this idea, we humbly submit, is of value to all peoples.

Before attempting to explain in detail the distinguishing features of shape, colour and design of Japanese ceramic wares it will be well to stop and explain one influence which has moulded Japanese taste for centuries, the aesthetic cult or pastime known as cha no yu (literally "hot water for tea"). It is coincidence only that the development of porcelain making took place just at the time that cha no yu played a prominent part in Japanese history, because pottery, not porcelain, is the chosen ceramic ware for cha no yu. However the artitic taste fostered by

cha no yu dictated the form and colour and texture of all forms of ceramics.

The words cha no yu, cha do and cha jin are indispensable in the consideration of any form of Japanese art. Simple words " *cha do* " " tea teachings " and " *cha jin* " " tea-men " they are packed with meaning for the Japanese, and all but meaningless for Occidentals. For more than three hundred years the tea-men (cha jin) have been the accepted judges of what constitutes good taste in Japanese art and their influence is still felt in the etiquette of the daily lives of the people, in their homes and gardens, in their clothing and in their outlook on life. Even the language has not escaped, for the Japanese word expressive of confusion " *mucha kucha* " translated literally means " without tea, bitter tea." For many years the word used to denote any and all ceramic wares was " *cha wan* " or " tea bowl "; and even today common rice bowls are called *cha wan* or *gohan cha wan*, literally rice tea bowls.

Tea ceremony, the usually accepted translation of cha no yu, is most unsatisfactory for the words themselves mean only hot water of (or for) tea. Although the cha no yu of today has come to be representative of conservatism and reactionism, it was not so in the beginning. Originally it must have objectified the spirit of progress, even adventure. The designs on the tea utensils in those days were new, the latest importations from abroad. The tea-men of those days were discontents and pioneers, dissatisfied with the crash materialism of their day and its gaudy, ostentatious art.

They went to the other extreme and in revolt they preached the doctrine of beauty in imperfection and the joy of living in harmony with nature. They entertained their friends in surroundings suggestive of poverty, not wealth; drank their tea from bowls that had been discarded by Korean potters; arranged their flowers in crude earthen pots that had been used by farmers to store seeds in; and rigorously kept the conversation at such gatherings away from the glories of war and the admiration of the spoils of conquest, the things uppermost in the minds of the people of that day.

The first teachers of cha no yu were priests of the *Zen* sect of Buddhism. Their insistence on contemplation and reflection on the oneness of the universe, man and nature, ran counter to the prevailing spirit of war and struggle for military supremacy of their day. It was a time known in Japanese history as the Sengoku Jidai, Civil War Period, when three great leaders

Oda Nobunaga, Toyotomi Hideyoshi and Tokugawa Iyeyasu successively struggled for leadership, and it was also at this time the first vanguard of European civilization was making its appearance in the Orient. In Europe it was the time of the Renaissance and this spirit found expression in Japan too. Hideyoshi, who loved to clothe himself in colourful garments and who lived in grand dwellings, decorated by master artists, which have never been excelled in gorgeousness of colour and decoration, was fascinated by the teachings of cha do. He became an ardent student of cha no yu and his enthusiasm spread to his generals and retainers. The shortest way to his favour was to present him with something that could be used for the performance of cha no yu, so his followers vied with one another in making things of pottery that would meet with his approval. All of Japan was swept with a mania for "cha ki," pottery utensils suitable for cha no yu. Feudal lords, given their choice between the grant of large tracts of land and a famous piece of pottery, eagerly chose the pottery.

In the estimation of the Japanese the most important pottery for cha no yu is first, the cha ire (tea jars), next the cha wan (tea cups). Under the Tokugawa Shogunate the most precious possessions of the military men were said to be tea jars, specimens of calligraphy and swords, in the order named. Toyotomi Hideyoshi was the first to reward services rendered him by his followers with pottery articles to be used in cha no yu. Tokugawa Iyeyasu and his successors were only too pleased to follow this precedent. Such a high value was set upon these intrinsically value-

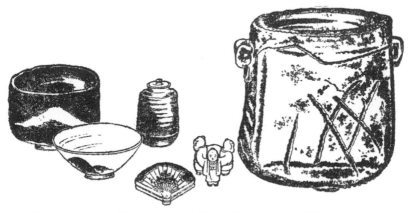

Pottery articles used in cha no yu. Left to right ; deep raku yaki tea bowl for use in winter; shallow Kyoto yaki bowl for summer ; brown tea jar *cha ire* and fan-shaped Kyoto yaki box for holding incense; green porcelain, *seiji mono* stand for holding the top of the hot water kettle and Shiragiya yaki *mizu sashi* or cold water vessel.

less things that it became the custom that a cha ire (tea jar) was granted only for the lifetime of the recipient and must be returned on his death. Sometimes the heir was granted the honour of inheriting it.

All this, of course, proved a great incentive to the development of the potter's art and it is an influence still active today for, although the craze for pottery tea things (cha ki) created a situation where fabulous sums were paid for intrinsically valueless things much as did the Black Tulip craze which swept Holland at this same time, in Japan these things continue to bring a high price and are handed down from father to son as heirlooms. The practice of cha no yu continues to occupy the attention of many Japanese of all classes; poor indeed is the family with no knowledge of it. Although it was developed by priests and feudal lords and its best teachers always have been and still are men, it was a part of the education of all ladies of good family. During the peaceful and leisurely times of the Tokugawa Shogunate women began to take an active interest in it and until the Second World War cast its menacing shadow before it and altered the pattern of Japanese life, no young girl's education was complete without one to three year's instruction in its complicated ritual. In girls' schools it was part of extra-curriculum activities and for those girls forced to work in factories or large offices free instruction was provided, often during working hours. Hotels, restaurants and department stores provided teachers for their female help without charge. All men with any pretensions to culture can at least talk intelligently about the subject and many are well versed in the intricacies of its practice. Until the war the sign-manual of a man's material success in life was the construction of at least one room, if not a small detached building in his garden, dedicated to the rites of cha no yu.

Books have been written and will continue to be written on this fascinating subject, but for the purpose of this book we are concerned only with its effect on the ceramic art of Japan. The present-day cha no yu with its inflexible rules and unalterable ritual is not the cha no yu of the seventeenth and eighteenth centuries. When Japanese ceramics blossomed into perfection in those days the cha jin were the seekers of the new; their ideal was the entertainment of their guests and for this purpose they sought new and different objects and prided themselves on finding beauty in unexpected places. To be able to point out to their guests new and hidden beauty in commonplace things, to delight their eyes; and to be able to relate an interesting story of the finding or making of such a thing to delight their minds, was

the endeavour of the early cha jin. It is an essentially Japanese trait to scorn the obvious, the easily understood beauty of a perfect thing and to prefer the subtile pleasure that comes of the finding of aesthetic beauty in imperfection, or in a thing not beautiful in itself but because it fulfilled the purpose for which it was made or because it has answered the need of man for many long years. One of the teachings of cha no yu is to use what is nearest at hand. Theoretically, cha no yu requires only that one clean and prepare the room, put a flower in a vase in the *tokonoma* (the recessed alcove of every Japanese guest room), boil water and serve one's guests a cup of tea, actually cha no yu enthusiasts spend all their time trying to think of unusual refinements and variations of the accepted routine, and sooner or later they all try their hand at producing a tea cup (cha wan) which they consider answers all aesthetic requirements. This led to the development of a type of pottery which is peculiarly and uniquely Japanese, known as *raku yaki*.

Although we have said that cha no yu consists only of serving one's friends a cup of tea, and this in theory is all it is, in practice it is far more complicated. The tea used is a specially prepared powdered tea. It is made by pouring half a cupful of hot (never boiling) water on a small amount of the tea powder in the bowl or cup from which it is to be drunk. It looks, and to many Westerners tastes, like spinach soup. It is never served casually, but always in a suitable bowl, very ceremoniously, and in a room set aside for that purpose only. Of late years attempts have been made to

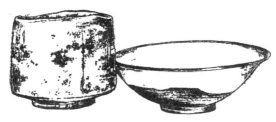

Typical *cha wan*, tea bowls. On the left; red raku yaki, soft thick pottery glazed with a thick orange-red glaze and showing the irregular edge so much admired by cha jin. On the right; shallow wide bowl of Seto yaki, with a semi-transparent greenish-yellow glaze unevenly applied to show the unglazed biscuit base of the bowl. The inside of a tea bowl is always glazed, the biscuit is very often wavey and irregular.

adapt cha no yu to European style surroundings, but with slight success. For the enjoyment of this tea its traditional surroundings are necessary. The room should be small, usually only nine foot square, and a garden is mandatory. No paint or artificial colour is used, only the natural colour of wood planed to a satin finish and the golden tan of the reed mats (*tatami*) on the floor.

Against such a background the various pottery utensils show to their best advantage and the Japanese delight in

harmonious contrast can be given free rein. Against such a background a single white camelia in an unglazed pottery jar makes a thing of beauty. Metal, especially bright polished metal, is taboo; only in summer the pot or bowl (*furo*) which holds the charcoal fire for heating the water is sometimes of iron or bronze, as is the hot water kettle itself. The tea bowls (*cha wan*), the container for the cold water (*mizu sashi*), the low-bowl (*mizu koboshi*) into which the waste water is emptied, the jar (*cha ire*) which holds the powdered tea and the small box for holding incense (*kogo*) all are of pottery or porcelain. In the winter a lacquer lid replaces the pottery lid of the water jar. At any season a lacquered incense box and container for tea may replace the pottery ones.

The delicate workmanship of the highly polished lacquer things and the sturdy roughness of the pottery utensils contrast delightfully and each enhances the beauty of the other. Porcelain is not used much for cha no yu utensils (cha ki), its hard white surface and brilliant colours are not much liked by cha jin but the knowledge of multi-colour enamel decoration acquired in the making of porcelain was used to good advantage by Japanese potters in the decoration of pottery for cha no yu. Because of cha no yu the pottery of Japan is more truly representative of Japanese art than is porcelain, which remains to this day pretty much a copy of Chinese or European models.

The aesthetic teachings of cha no yu have created and perpetuated a criterion by which not only the art but the manner of life and etiquette of the people is judged; for "etiquette" (*gyogi*) in Japan as "decorum" (*li*) in China is of vital importance in the lives of all classes of people. The emphasis of cha no yu on self control and of concentration on the task at hand has undoubtedly contributed to the mental health of the Japanese but the insistance of cha do on formalism and ceremony has exerted an influence that is perhaps open to criticism. Again, we can find proof in the language, for one word expressive of misfortune or trouble literally translated means "the unexpected." But even in view of such evident drawbacks it must be admitted that cha no yu has been the means of developing a large group of people aesthetically keen and it has enabled the Japanese people to retain their sense of what is artistic and beautiful sufficiently to avoid being overwhelmed by the deadly monotony of mass production.

Bernard Leach, the English artist-potter, on one visit to Tokyo, gave a talk before an interested group of people in which he stated it was his opinion that the teaching and practice of cha no yu had developed and perpetuated the aesthetic sense of

a large number of Japanese and that this had protected the ceramic art of Japan.

The names of many of the greatest cha jin (tea masters) are inseparably connected with Japanese ceramics. Few of them were potters and their influence was due to their authority as arbiters of good taste for cha no yu utensils. Beginning with Shuko, who lived in the latter half of the fifteenth century and who was the teacher of Shino Soshin and contemporary of So ami these cha jin shaped the course of ceramic development in Japan

So ami, a retainer of the Ashikaga Shogun Yoshimitsu, who held power from 1444 to 1473, and Shino Soshin, a contemporary, are credited with being among the first to develop the demand for pottery suitable for cha no yu. Shino's name is perpetuated in *Shino yaki* a product of Seto kilns. These wares are characterized by deep crackles in a soft looking thick cream glaze over indeterminate pictures or patterns drawn in iron pigment on the coarse biscuit. In places the glaze bubbles and becomes discoloured producing red tints about the edges. On many of the pieces the glaze is wiped off to expose the biscuit and part of the painted design. There is a great charm about these wares for they are especially agreeable to the touch. They are still being produced.

Takeno Sho o's real name was Nakamura Shinshiro. He came of a samurai family but as his feudal lord fell with his clan in the Onin war (1467-8) his father wandered masterless for a while eventually settling at Sakai as a tradesman. Sho o himself went to Kyoto as a boy and entered into service with Udaijin Kimiyori. He was presented at court and given the title of Inaba no Kami. He studied Zen Buddhism and became a skillful writer of verse. Later he retired to Sakai. His influence on Japanese ceramics seems to have been through his pupils especially Sen no Rikyu.

Sen no Rikyu, whose name appears so often in connection with cha no yu and its pottery was born into the family of a wholesale fish dealer. His father's name was Tanaka Yohei but he early took the name "Sen" of his grandfather who was an artist and a friend of the Shogun Ashikaga Yoshimasa, becoming Sen Soeki.

The young Sen Soeki was one time commanded to serve tea before the Emperor Go Yozei. But as he had no court rank he was advised to retire and adopt the Buddhist name of Koji (meaning Enlightened Recluse). His Zen teacher gave him the name of "Rikyu." His name was confirmed by Imperial Edict and he is known in history as Sen no Rikyu. The Shogun Hideyoshi ordered

Rikyu to revise and put into writing the rules for cha no yu. For many years Rikyu enjoyed the friendship of Hideyoshi but when he was quite an old man Hideyoshi accused him of insolently living in a style above his station in life. At Hideyoshi's order he quietly committed suicide by *seppuku*. He was seventy one at the time.

Kobori Enshu (1579-1647) was not himself a potter but a tea teacher yet his name is associated with a certain type of pottery made at many kilns throughout Japan. The kilns of Shidoro, Zeze, Kosobe, Agano, Takatori, Asahi and Akahada are known as Enshu's Seven Favourite kilns.

Enshu's real name was Kobori Totomi no Kami Masakazu, his father was civil governor of Fushimi. Enshu also used the name "Soko." He served under Tokugawa Iyeyasu, taking the place of Oribe as supreme authority in all things relating to cha no yu. He was a poet, a painter and a calligraphist, besides being exceedingly fond of *ike bana* (the Japanese art of flower arrangement), and his name of Enshu is perpetuated in the *Enshu ryu* of flower arrangement. In cha no yu he was a follower of the style of Sen no Rikyu. He did much to encourage the production of Japanese pottery by personally investigating the possibilities of the clays of various districts and encouraging the potters of many kilns to make things for the use of cha no yu.

Enshu's Seven Kilns

Shidoro;—established in 1575 by Kato Shoyemon Kagetada. Wares undecorated, glaze of rich black-brown and autumn colours of yellow and brown.

Kosobe;—wares unknown until 1625 when they were popularized by Enshu.

Zeze;—originated in 1630 at the command of Ishikawa Tadatsuna, Lord of Zeze under the direction of Enshu. The wares have golden or reddish brown and purplish glazes over a dark grey fine grained biscuit. These wares are much like those of Takatori and Seto.

Agano;—kilns started by Hosokawa Tadaoki (known also as Sansai) in 1602 when he employed a naturalized Korean potter. At first very Korean in style, the wares later became similar to Takatori wares.

Takatori;—an ancient kiln which developed when Kuroda Nagamasa brought back with him from Korea potters named Shinkuro and Hachizo. Wares have dull coffee brown, yellow or rich purple black spotted glazes and bluish grey flambe.

Asahi;—founded about 1600 by Okumura Jiro-zayemon. 1645 Enshu supervised Okumura Tosaku in making tea bowls, of light brown or light blue glaze on a coarse biscuit. 1830-1873 a potter named Chobei Matsubayashi produced modern wares.

Akahada;—started about 1580 but discontinued until about 1645 when it was revived by Nonomura Ninsei. The wares resemble Takatori or Hagi pearl grey crackled glaze clouded with salmon pink. Enshu had cha no yu utensils made here under his direction.

Hon ami (written also Honnami or Hon Ami) Koyetsu, born 1557 died 1637, was a direct pupil of Oribe. He was originally a connoisseur of swords but through the study of cha no yu became interested in pottery and became a skillful potter. He studied pottery-making with Jokei the second raku master and was noted for his skill in the use of the bamboo spatula for trimming tea bowls into shape. His grandson Ko ho (1601-1682) known also as Kuchu sai or just Kuchu also made raku wares after his manner. Kuchu's productions are rare and valuable today.

The name of Matsudaira Fumai Harusan (1751-1818) who was the feudal Lord of Matsuye in Izumo Province is of importance in any consideration of Japanese pottery. He was a cha jin but was especially interested in ceramics. For his own use he designed and ordered made certain tea wares; he was fond of well made "exquisite" rather than rugged wares. Another of his contributions to ceramics was the compilation of twelve catalogues listing and describing famous cha no yu potteries.

It was the cha jin, tea devotees, who rescued from oblivion, and taught the satisfying beauty of ancient and excavated ceramic wares overlooked by less discerning collectors and during the ages that cha no yu has been the great national pastime bowls from widely different sources have given pleasure to many.

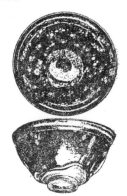

Among the best known are Temmoku cha wan, bowls which were used for serving tea to monks of the Zen sect temple at Tienmu Shan in Chekiang, China. These bowls were not much admired in China, they were cheap and available but in Japan they are priceless. These are of blackish or bluish brown, a hard thin stone ware, conical in shape with a rather small footrim or base.

Temmoku tea bowl, the so-called *yuteki* or oil-spot Temmoku. Note the irregular welt formed by the glaze, called *maku* or curtain formation by the Japanese.

In China they are called *Chien-yao* (yao means kiln wares) and were made at Fukien during the Sung dynasty.

Korean Hakuji, or white ware, bowls used in the country of their origin for serving rice at the daily meal are admired by many. These are of thick, greyish white ware of a rather, to the uninitiated, obscure uninteresting flat bowl shape with thick heavy footrim or base.

Kurawanka cha wan, is a less well known but very interesting kind of tea bowl of a thick hastily potted ware with a soft thick glaze, decorated in under-the-glaze blue designs drawn with a sure firm hand. The glaze is thick, uneven and pleasant to the touch. These bowls are interesting because they are of pure Japanese origin and have historical associations. At the end of the sixteenth century when Tokugawa Iyeyasu was struggling to establish his power throughout Japan, the boatmen on the Yodogawa River between Osaka and Kyoto furnished him timely aid at a crisis in his war career. In gratitude Iyeyasu granted them and their discendants the privilege of selling food from boats to the pleasure seekers on this river. Because of being signaled out by this honour these boatmen became proud and overbearing. "*Kurawanka*" is a vulgar or colloquial expression for the more polite "*meshi agarimasenka*" meaning roughly the equivalent the American "Get your hot dogs here." These bowls at that time were included in the small price of the food offered and were frequently simply thrown overboard when emptied. The custom of selling food in this ware has been abandoned but now fishermen make a living retrieving the bowls from the river bottom.

Another form of Temmoku tea bowls with the design of the hoo bird drawn under the glaze.

Oribe

Of all the names mentioned in any discussion of Japanese pottery that of Furuta Oribe no Sho is most often heard. He was born in 1544 and died in 1615, a period when cha do culture was at its best and he is known as Chajin Oribe—that is, Oribe, Master Teacher of Ceremonial Tea. He served under three war lords: Oda Nobunaga, who died at the hand of one of his own retainers just as he had completed national unification after a long period of civil wars; Toyotomi Hideyoshi, who continued the work

of unification and who in pursuance of a progressive imperialistic policy died while commanding the invasion of a foreign country; and Tokugawa Iyeyasu whose strong centralizing policy succeeded in completely systematizing Japan as a feudalistic state and enforcing the policy of seclusion. A time also that was a kind of Renaissance in Japan, later to be known as the Momoyama Period.

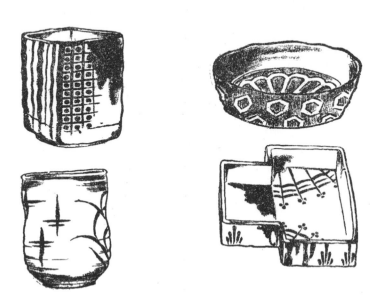

Typical Oribe shapes and designs.

Oribe was born in Mino, near Seto the ceramic center of Japan. His real name was Furuta Shigeyoshi or Shigenari and he was the son of Furuta Shigesada, called also Kan ami, who had been a priest but who left the orders and became a retainer of Hideyoshi with the title of Gemba no Sho. He served as samurai or man of arms under Oda Nobunaga until that leader's death in 1582. Serving under Hideyoshi, Oribe was created a *daimyo*, or feudal lord, in 1585. In this capacity he was put in charge of a castle in the neighbourhood of Kyoto. It was at this time that he made the acquaintance of Sen Rikyu and became his pupil in matters concerning cha no yu.

In 1585 Hideyoshi held his famous tea party at his palace of Ju raku and many great tea masters attended. Although one of the most important pupils of Sen Rikyu, Oribe was at that time but little known. On the death of Hideyoshi, Oribe joined the forces of Tokugawa Iyeyasu. In 1610 he became the tea

teacher of Hidetada, son of Iyeyasu and second Shogun. It was then that his position as tea master became established. Daimyos, small and great, competed with one another to become his pupils and in building houses for cha no yu according to his designs and in acquiring art objects which met with his approval. Consequently his taste was predominant at this period.

In 1614 there was a decisive battle fought between Hideyori, son of Oribe's former master Hideyoshi, and Hidetada who was both his master and his best loved pupil. Oribe fought on the side of Hidetada. He visited different camps to entertain the leaders with out-door cha no yu behind bamboo barricades. One time he was so absorbed in looking for material, from which to make a tea spoon (*cha shaku*), among the bamboo of the barricade

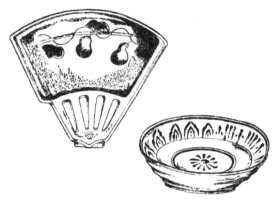

Oribe yaki; pictures reconstructed from remnants of authentic old wares.

that he was seen by the enemy and wounded. The war ended in a truce and while the two shoguns, Iyeyasu and Hidetada, met with various feudal lords to discuss new strategy a retainer of Oribe's as chief conspirator of a group of dissenters tried to set fire to the streets of Kyoto in order to attack the Tokugawa forces. The plan was discovered and the conspirators were taken prisoners. As was Japanese custom, Oribe though ignorant of the treason, was held responsible for the acts of his retainers and he was ordered to commit suicide. This he did, without unnecessary protest, in a quiet and seemly manner. Like his master in cha do, Sen Rikyu, Oribe died a tragic death. Oribe and Rikyu were alike in many respects but while Rikyu made cha no yu monasterical because he was a medievalist at heart, Oribe made it social because he was at heart a modernist. Although Oribe died by his own hand at the command

of his Shogun, he had lived man's allotted time of "three score years and ten" and he had lived at an exciting time in Japanese history. His lot was cast with military men and he followed them in their battles but he was basically a man of peace and he was more concerned with the shape of the tea cup he used in the lull of a battle than with that battle's outcome. His lifetime spanned the turn of the seventeenth century, a time in which all the world was astir and Japan felt the repercussions of expanding Europe. Portuguese, Spanish and Dutch ships reached its shores, bringing new ideas and new things. That Oribe was fully aware of these things is proved by his designs and some of the pottery objects he caused to be made for him. Pottery candle holders in the shape of Hollanders, the Dutchman's long stemmed pipe, bits of European woven designs in his own designs, etc. attest to his interest in what was new and modern. Perhaps it is because of his so typically Japanese awareness of the new culture that his hold on the imagination of his fellow Japanese has been so strong, for even today three hundred years after his death, his spirit continues to exert an influence on Japanese ceramics. Oribe wares are divided by Japanese experts into three classes: Black (*kuro oribe yaki*), Green (*ao oribe yaki*) and Red (*aka oribe yaki*) though it is difficult for the foreigner to separate one from the other. They all have the usual dark green glaze on a portion of the article and the rest of the surface is covered with thick grey glaze on the Black and Green types, and a reddish brown glaze on the Red type. This division of the surface of an article into two kinds of decoration is known as "*some wake*" in Japanese. This green glaze is unique on Oribe wares, it is a lovely soft dark green with the edges of the glaze thinning out into peacock blue and purple-red. Under the lighter grey or tan glaze can be seen a very sketchy design done in bold free strokes in an iron brown pigment. The general appearance is of refined elegance and a close inspection reveals unsuspected beauties in the colour gradations.

Oribe wares are quite distinctive as to shape also. It is doubtful if he ever gave his approval to a perfect or regularly round dish or cup, he seems to have preferred bent or dented shapes which appear to have grown that way rather than to have been made by the hand of man. However, his wares are always dignified, never bizarre. Square deep dishes, linked rectangular trays or bowls, especially the fan-shaped dishes so popular with cha jin are some of the shapes known by his name. His designs were extremely simple, yet somehow they evoke a sense of elegance; two stalks of rice heavy with grains, three persimmons

drying on a sagging line, a couple of blades of grass, or the spokes of a water wheel to suggest a countryside scene.

An amusing porcelain water pot in blue and **white.**

Clays, Kilns
and
Potters' Methods

Location of Ceramic Clays

The cultural, as well as the political and social, history of a country is influenced by its geographical environment and the story of ceramics in Japan illustrates this. An island country lying off the coast of a great continental country Japan was ideally situated to receive cultural impulses from that country. Due to the peculiar geographical construction of her many mountains Japan has an unlimited amount of natural porcelain and pottery clays. Most of Japan's mountains are made up of granite rock and this granite in the natural course of erosion becomes disintegrated and is washed down the mountain-side to form immense deposits of natural kaolin. While the potters of other lands must bring various clays and ingredients for porcelains from different places and mix them, the Japanese potter finds his materials ready to his hand in many places. It is these deposits of natural pottery clays that dictated the location of the earliest kilns. In Japan clay-materials for ceramics presented no problem but the matter of fuel with which to fire the kilns has been a major probl , often n ssitating the removal of kilns as the supply of fire wood was hausted. This fact tends to cause confusion to the European student of Japanese ceramics for as he delves into the history of individual kilns he will find one kiln with its master potter and workmen recorded at more than one kiln site.

Because these kaolin deposits are found at the foot of or on the lower slopes of mountains many Japanese kiln names have some form of the word for " valley " in their composition ; as for instance the well-known Kutani which is written with characters meaning " nine valleys." For this reason also Japanese kilns are clustered in groups rather widely separated from one another, and the many kilns of such groups will produce pretty much the same type of ceramic wares, due to the common use of one type of clay materials.

Ceramic making in Japan has always been a group-project. The clay deposits were free to any potter of the district and the kilns were usually under the direct authority of the feudal lord. During the Tokugawa period, the beginning of which exactly coincides with the first crude efforts to make porcelain, pottery and porcelain making was an art, not a business. If the kiln were small it was a family affair with no outside help, if large it was a neighbourhood affair. The firing of the finished wares was done at community kilns. The potters worked primarily not for money, but for love of their craft. The more skilfull potters made

wares which their feudal lord gave as presents to his friends and superiors, the less skilfull made the thin s that were necessary to the daily life of the potters and their neighbours. This was under the old form of feudalism where the lord was responsible for the livelihood of his men. Later some of the feudal lords kept only one kiln for their own use and encouraged potters at other kilns in their district to make articles for sale. Then after 1868, when Japan became modernized, the kilns became the property of the potters employed in them and the clay deposits went under the joint ownership of the potters. The preparation, that is the excavation and packaging, of ceramic clays is now in the hands of commercial companies and the clays which were once used only by the potters of the neighbourhood are now bought and sold all over the country like any other commercial product.

In the early history of ceramics each group of kilns guarded their trade secrets very strictly. Potters did not openly go from one kiln to another and there are recorded cases where a potter of one location who sold or divulged the secrets of his group to a potter of another group of kilns was punished with death.

Later when such rules and regulations had somewhat relaxed, artist designers went from one district to another, as Ninsei, Oribe and Enshu. Such men made their homes in Kyoto but their influence was felt in many widely separated kilns.

Kyoto is the center of a group of kilns although there are no clay materials to be found there. Kyoto potters use clays brought from great distances. They are attracted to Kyoto because it is the cultural and artistic center of the country. None of the kilns are large, often the master himself is the only worker; and quite unlike the kilns grouped around a kaolin deposit, they are individually owned. Kyoto wares are not difficult to distinguish because they are usually compounded of several clays and carefully and exceedingly well made. Also it was the potters of Kyoto who first signed or sealed their productions.

Kilns

It is thought that pre-historic Japanese pottery was fired in an open fire on the surface of the ground. Historically the oldest kilns are known as cave kilns (*ana gama*) and may be an adaptation of the primitive charcoal burner's kiln. They were holes dug into the slope of a hill, or rather open pits dug in the hill-side and covered with a rounded earthen roof. The pit was

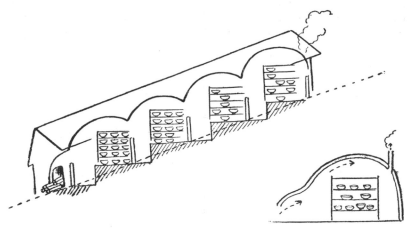

Showing method of packing and firing pottery kilns. At the top; the *nobori gama*, below; an *oh gama*.

filled with pottery and covered with earth leaving two openings, that at the lower end was used as a fire box for heating the kiln, the hole at the upper end served as a chimney through which the smoke escaped. Kilns of this type are in use to this day for the production of small quantities of pottery for local use and are now known as *oh gama* (large kilns). In the days before modern transportation methods were known it was necessary for the Japanese potter to move his kiln from place to place as he exhausted, not his clay supply, but his wood supply, because he found it easier to take his materials to a source of fuel than to bring fuel to his clay deposits; or again groups of potters migrated en masse to a new location in search of fuel.

The ana gama or cave type kilns were wasteful of fuel and in this connection there is a story which is doubly interesting, first for its bearing on the historical development of ceramic kilns and secondly for the light it sheds upon the importance of the ceramic industry in Japan. During the time of Ogimachi Tenno, who reigned from 1557 to 1586, a certain Kato Kagenobu was a mast·r potter at Kujiri of the Seto group of kilns. He was so jealous of his own secrets of pottery making that he built a fence about his kiln to keep visitors out. Yet when he learned that the type of kiln in use at Seto, the old cave type kiln (ana gama), had been superceeded by an improved form elsewhere, he left Seto and journeyed to Kyushu to learn how to build such kilns. On this visit he evidently learned more than just how to build an improved type of kiln for on his return to Seto he began to make

glazed wares. He made articles glazed with a thick soft white glaze which he presented to Emperor Ogimachi. These things so pleased the Emperor that he granted Kagenobu the title of Governor of Chikugo and raised him to Fifth Court Rank. It is well to keep in mind that this was the time of greatest popularity for the cult of cha no yu (ceremonial serving of tea) which so occupied the time and attention of the intelligentsia of that day and for the proper performance of which pottery articles were so necessary.

The new type of kiln of which Kagenobu learned was the *nobori gama* (or climbing kilns). It consisted of series of four or five ana gama set one above the other up the slope of a hill and connected. Fire was built in a fire box attached to the lowest kiln and the smoke and some heat found its way up through the kilns and eventually out at a hole in the upper end of the topmost kiln. To fire a batch of pottery all the chambers were filled with articles of various sizes. Fire was applied to the lowest only and after the things in that chamber had been fired sufficiently that chamber was closed off. Meanwhile, the second chamber had become heated to a certain extent; this was then fired just as if it were an independent kiln and when the articles in it were baked this chamber was closed off and the third chamber was in its turn fired. This continued on to the end of the series. It is said that at times as many as fifty chambers were connected and fired in this manner. Undoubtedly this method constituted a great saving of fuel. These kilns in series are thought to have been influenced by the Korean type of kilns which were built in a series on flat ground. According to some scholars they are simply a development of the primitive ana gama, and it is certain that the two types existed simultaneously during the Momoyama Period (1574-1602). The kilns at first known as cave kilns (*ana gama*) came to be called old kilns (*ko gama*) or round kilns (*maru gama*) when built in series up the slope of a hill, large kilns (*oh gama*) when built singly.

The Korean kilns-in-series were called split-bamboo type kilns (*wari take gama*) and were introduced first at Karatsu. Thus we have ko gama, maru gama, and wari take gama all meaning kilns built in series and to these must be added the name nobori gama, when built on a hill, and finally because of a fancied resemblance to baby crabs on a skewer. " baby crab kilns " (*kani ko gama*).

Since the re-opening of Japan to international intercourse the development of Japanese ceramics has kept pace with developments elsewhere in the world. Beginning with Dr. A. Wagner, a German chemical expert who came here in the early

part of the Meiji Period, foreign experts have been invited and the latest and most scientific methods of production are in use. But side by side with coal and oil burning and electrically heated kilns for the mass production of ceramic wares can be found the old Japanese individualistic methods of firing. Although at present only one maru gama, consisting of but six or seven chambers, is in operation (at Seto), many artist-potters still prefer and use the old oh gama (large kiln). They maintain the very irregularity and unevenness of the old method of firing an article produces much more interesting variations and effects than the new mechanically perfect firing. For this stand they have the support of centuries of experience by Oriental potters; and modern science with all its marvels cannot scientifically produce the colours so admired the world over. When the many shades of green, and the reds and the blues, which evolve from one glaze formula conditioned by the heat and smoke of a primitive kiln are considered, the almost superstitious awe with which Oriental potters regard their kilns is understandable. Both Chinese and Japanese potters believe that there is some unseen power operative in the kiln which transmutes their human efforts into something divine, a sort of indwelling kiln spirit. There are even stories in Japan of such marvelous effects being produced that a kiln was deemed uncanny and abandoned. Certain it is that the odd, unusual and individual changes in colour and surface texture produced in the simple old style kilns cannot be duplicated under mechanically perfect conditions and while the Japanese potter will make for export one thousand things of exquisite beauty all exactly the same, for his own use he prefers every article just a bit different, even if (and perhaps because) that difference is a defect in its perfection.

Japanese methods of making

Japanese potters have known the use of the potter's wheel since pre-historic times, yet all down the ages they have made and even today frequently make articles without its aid. In their big modern factories for making ceramic wares all the known methods of manufacture are in operation; wheel-thrown, jigger-shaped, molded, cast, built-up-in-sections wares pass before operators on endless belt conveyors. The wares are dipped in glaze, sprayed with air sprays or individually hand painted, all at lightning speed in the latest scientific mass production processes. Yet something in the Japanese nature impells them to continue to study and experiment with the most primitive methods of making pottery.

They seem to find the fullest aesthetic satisfaction in a hand-made article which reveals the manual skill and mental and spiritual strength of its maker. Neither the disturbances of war nor the harsh demands of materialism have destroyed the ability to make or the love of soft hand-made pottery.

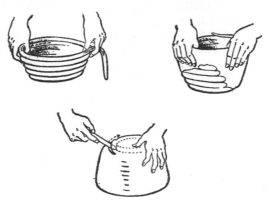

Method of making pottery without using a potter's wheel, even today many Kyoto potters form up porcelain wares this way.

Making pottery wares without the use of the potter's wheel is not unique to Japan of course but the prevalence of such methods is noteworthy. Briefly, there are three methods:

1. *Tataki zukuri* (making by beating)—This method which seems to have originated in Korea is used in making large articles. A wooden hammer or mallet is used to shape a jar or bowl in conjunction with the bare hand, the mallet on the inside of the article. The pattern formed by the regular strokes of the mallet head is thought to resemble the Japanese conventionalized wave pattern and is called *uchi nami,* or inside wave pattern.

2. *Te zukuri* (or hand-made)—The clay material is rolled between the palms into long ropes of a suitable size and coiled round to form the walls of the article. The thing is then more or less smoothed up with the aid of a bamboo spatula and the fingers, but always a trace or suggestion of the rope coils are left. If the article being made, such as a tea cup or a flower vase, needs a footrim (*kodai*) it is formed of a thin coil of the clay and luted on, or cut and gouged out of the thing itself.

3. Also known as *te zukuri* (hand-made). With this method a lump of clay is pushed and pulled by the fingers. This makes a heavy looking mug-shaped article and if it is desired to lighten it and shape it the crude mug-shape is reversed and a

sharp bamboo spatula is used to sculpture the mass into a finer, lighter shape and form a footrim (kodai). Here the problem is to bring out the shape with the fewest cuts of the spatula and no attempt is made to smooth over or disguise the strokes of the bamboo knife.

The reader will note that with all three methods the inside of the article is left rough and uneven. This is deliberately done. Such articles are usually made for use in cha no yu and the uneven surface is considered an aid in making good tea. Frequently no attempt is made to form a footrim, the bottom of the article is left perfectly flat on all three types. Usually on wares made by any of these three processes a thick soft looking glaze is applied inside and out.

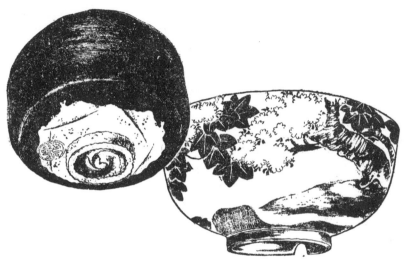

Showing two types of footrim, *kodai*, and an Eiraku seal. The bowl on the right has the *unkin* design described on a later page.

Raku Yaki

Raku yaki or raku wares, is a term which gives rise to much confusion in the minds of the Western student of Japanese ceramics for the word " raku " occurs in different settings; as a part of the names of two different historical pleasure pavilions, the Ju raku tei of Hideyoshi in Kyoto at the end of the sixteenth century and of Kai raku en of Tokugawa Harutomi, a Daimyo of Kishu, near Wakayama in the first half of the nineteenth century; and again in the name Kiraku, a potter of the nineteenth century

in the Province of Kii as well as in the more famous Eiraku line of potters who worked first at Kutani and later at Kyoto.

Raku has come to mean the general type of pottery preferred by cha jin. The raku in Eiraku (永樂) is the Japanese pronunciation of the name of an emperor of the Chinese Ming dynasty, Yung Lo; while the raku elsewhere is the character which means pleasure, or amusing accomplishments. The family name of the potters who use the artist name of "Raku" is Tanaka, and in private life they are known as such. Japanese authorities designate as *Raku kei* a line of potters beginning in the sixteenth century, most of whom have the syllable "*nyu*" in their professional names. In this sense Raku kei means "House or Line of Soft-Pottery-Made-for-Amusement Makers." Also this line of raku pottery makers has two branches, one known as the Principal Kiln (*hon gama*) operated by the legitimate successors to the Raku seal and Branch Kilns (*wake gama*) operated by others than the major line of potters.

This Raku line of successive master potters is an excellent illustration of the custom, followed in all branches of Japanese art, of the master artist naming as his successor to the responsibility of carrying on his style of craftsmanship that one of his pupils he considers best able to do so. If the master's eldest son is a capable artist he of course becomes his father's successor but in case of there being no son to inherit or of the son lacking in ability the master appoints his best pupil to be his successor

Two styles of footrim found in Japanese raku yaki and pottery.

and use his name. Thus it comes about that the geneology of an artist family is often most irregular; and this is rendered more difficult of understanding by the equally common custom of an artist assuming various names at different times in his life; sometimes, indeed, an artist will use two or more names simultaneously. The knowledge that it was a common practice of a master artist to grant a favourite pupil one character of his name tends a little to reduce this confusion (though sometimes an admirer of an artist borrows a part of that artist's name out of the desire to pay him a compliment!) Other than using a part of their teacher's name, Japanese artists take names referring to or indicating their age, their physical condition (as "the deaf" or "the left-handed), or a part of the name of the district in which they were born or worked.

The peculiar Japanese system of teaching an art, which is still practised in modern times, is to keep certain important teachings as secrets to be revealed only to the most

promising pupils. These secret teachings are called oral tradition (*ku den*) and are never written down. It is customary for a master to give written certificates of accomplishment (*menjo*) to pupils who have proved their ability but only the official successor receives the "ku den" and it is the possession of these secret teachings that makes him the new master of that school of art.

Showing the Japanese method of raising a flat bottomed dish by means of small pottery knobs or loops.

Raku yaki as it is used today is a term signifying a certain type of soft, light, thickly glazed pottery, essentially Japanese in origin and development and unique to Japan. Freely translated it means "wares made for amusement" and recalls to the Japanese something crude or something easily made. However, the wares are not crude, they are ingenously sophisticated. This ware for centuries has been favoured by the devotees of cha no yu and every cha jin (or tea master) made his own tea bowls which are known as raku wares. Even today raku yaki wares are practically limited to articles used in cha no yu, tea cups (really small bowls often larger than a rice bowl), incense burners, incense boxes, small jars, vases for flowers, and small ornaments of an amusing nature.

Raku yaki is sometimes made without the use of the potter's wheel, it is formed up and shaped by hand. Free use is made of a bamboo cutting knife (*hera*) and the marks made by this simple instrument are prized because it is said that the individuality of the maker is easily understood through them.

Three forms of *ito giri* or the lines formed on the bottom of a wheel thrown article when it is cut off from the mass of clay out of which it has been formed. Japanese potters used all three methods.

Many Korean wares show the first, or left hand cut.

There are two methods of making this pottery. One, the clay is kneaded and rolled into ropes the thickness of a lead pencil. This rope is coiled round and round on itself making a rough bowl of the desired shape. Then it is further patted and coaxed into shape with the fingers. The marks of the coils are never wholly obliterated and they form part of the decorative effect. The footrim (kodai) is formed and luted into place. The second method, in which the bamboo spatula plays an important part, is to form up a lump of

clay and with the fingers to shape the bowl. The base is left very thick. The half formed article is then turned upside down and the base and footrim cut to shape (See Page 44). The glazing process is the same for both types. It is usually painted or brushed on and frequently several coats are applied one over the other.

It is in these raku yaki wares that the Japanese aesthetic spirit finds its most representative outlet. The tea bowls are never a perfect round, they must fit the hands comfortably. In handling and in drinking from them the bowls are held in both hands. The top edge is never straight or true but undulating so as to feel pleasant and yielding to the mouth and instead of flaring out bell-shaped the top bends inwards the least bit. An appreciable part of the bowl is left unglazed to show the material from which it was made. This is essential and the Japanese cha jin pay much attention to this feature; also they carefully examine the footrim for evidences of the potter's working methods. Tea bowls are made in a great variety of shapes, flat bowls which expose a large surface of tea for cooling are used in the summer but in winter higher bowls with smaller openings are best to prevent the too rapid cooling of the tea. The bowls are large, one type when half filled holds about the quantity of an ordinary cup, these are served individually one to each guest; but there is another type which holds four to five times this amount of tea and is passed around like an old English "loving cup."

The glaze on raku yaki is always thick and soft, both to touch and sight. For contrast with the bright green froth of the powdered tea concoction the glaze is of neutral colours, black and all shades of brown to grey and red, soft yellow and the greyish or yellow-whites copied after Korean celadons. The only form of decoration tolerated is the change and interplay of colour produced by the contour of the article, or by the deliberate thinning or scraping away of the glaze to form sketchy patterns such as Mt. Fuji, a pine tree or a crane. It is only in very rare cases that any design or pattern is painted on the glaze. Japanese ceramic adapts have specific names for every natural formation assumed by the thick glaze while being fired in the kiln, such as "*maku*" "curtain formation" for the thick soft roll formed by the edge of the glaze or *nagare* (flowed formation) for the long trickles of glaze ending in a blob or "tear."

Raku yaki is said to be of three general types :—

Red raku yaki (*aka raku yaki*) which varies from a reddish orange colour of rather objectionable brilliance through a soft and agreeable reddish tan to a very attractive soft cream colour.

Black raku ware (*kuro raku yaki*) which has a soft brownish black glaze.

Incense burner ware (*koro raku yaki*), also called *shiro raku yaki,* or White raku ware.

Although today the general term for these wares is "raku yaki" at the time of their inception they were called "*Kyo yaki*" (Kyoto wares) or "*ima yaki*" (literally, "now" or new wares).

Raku yaki is also used to designate a kind of soft pottery which bakes at a very low temperature and it has become the custom to set up a temporary potter's wheel and kiln for the entertainment of guests at a garden party or some such place, truly a "ware made for amusement." These wares are intrinsically worthless and artistically impossible.

In the first half of the sixteenth century a Korean, some say a Chinese, potter named Ame ya came to Kyoto where he opened a kiln and made pottery of a commonplace sort, for it is recorded he made roof tiles. He became a naturalized Japanese taking the personal name of Masakichi which after his marriage he changed to Sokei. He married a Japanese woman and took her family name of Sasaki. His wife seems to have been a potter of some ability herself for after Sokei's death in 1574 she made a kind of pottery called Nun's ware (*ama yaki*) which today commands a high price and is often imitated. Their eldest son was named Choyu but was commonly called Chojiro. There was also a younger brother whose name was Jokei (also Kichizayemon). The two brothers became known to Toyotomi Hideyoshi when they made roof-tiles for his pleasure pavilion "Ju raku tei." This was at the time that the craze for cha no yu had reached such force and Sen Rikyu, Hideyoshi's favourite tea master, had the brothers make utensils for use in that pastime. Sen Rikyu became fond of Chojiro and gave him his, Sen Rikyu's, family name of Tanaka. As has been explained elsewhere this granting of a family name was considered a great honour. Tanaka Chojiro died in 1592. He is considered the first generation of the House of Raku (Raku kei). This Chojiro used what is known as "*hera bori*" (that is, spatula engraved) signatures on the tiles made for Hideyoshi's Ju raku tei. Jokei, the younger son of the naturalized Korean and his Japanese wife, who took his father's name of Sokei but who was also known as Kichizayemon, became a protege of Hideyoshi who allowed him to sign his productions "Best under Heaven" (*tenka ichi*) and gave him a gold seal with the character "raku" or "contentment" from the name of Hideyoshi's pleasure pavilion, Ju raku tei. Wares signed

with this seal were known first as Juraku yaki, then just as raku yaki. It was he who adopted "Raku" as a family name.

The fourth generation of the family ceased using this gold seal, giving as an excuse that it was lost but the real reason is more likely, the fact that a new family, the Tokugawa, had risen to political power and these raku potters were then in the employ of the new rulers.

The succeeding generations of the House of Raku follow:

Third Generation :—1599–1658. The son of Jokei was named Kichibei ; at different times he was known as Kichizayemon and Nonko. He studied pottery making under Hon ami Koyetsu and in turn he passed on his learning to his grandson, Sonku-Chusai Koho. When he grew old he became a monk and took the Buddhist name of Donyu (meaning "entering into the teachings of Buddha"). The syllable "nyu" was used by his successors for eight generations. Nonko died in 1658. A certain Takinohoya Togobenzo contributed to the fame of Donyu through his excellent reproductions of Donyu's wares. Nonko, or Donyu, is best known for his glossy

Showing glaze formations on tea bowls. On the left;
the *kai ko* or silk worm formation.
On the right; *maku* or "curtain" formation.

black glaze and especially for the beautiful wavy line of his *maku gusuri* ("curtain formation glaze") on tea bowls. These bowls are highly prized by cha jin and are known as *Nonko guro*. Nonko also made a peculiar red raku pottery which contains much sand in its glaze but is beautiful for its depth and softness of colour.

Fourth Generation :—He was the son of Donyu named Chozayemon, also known as Ichinyu. He was left-handed as his wares testify. One of his sons developed a new style and built the *raku waki gama* and founded a school of raku potters which lasted twelve generations. Donyu also had another son whose name has been forgotten, but who is known to posterity because of the fame of one of his descendants by name of Chozayemon. This Chozayemon (1601–1682) under the patronage of the feudal lord of

Kaga invented the pottery known as *ame gusuri* and founded the *Ohi gama* (Ohi kiln) at the village of Ohi. Chozayemon wares were characterized by a deep brown glaze, while his descendants, of whom there are eight generations, usually made wares with a much lighter, brownish-yellow.

Fifth Generation:—Named Sonyu, he was the pupil of Ichinyu and was known also as Chusai Koho. Died 1725.

Sixth Generation:—Named Sanyu, he was the adopted son of Sonyu. Died 1740.

Seventh Generation:—Named Ch,nyu, he was the son, some say brother, of Sanyu. Died 1769.

Eighth Generation:—Named Tokunyu, he was the adopted son of Chonyu. Died 1775.

Ninth Generation:—Named Ryonyu; he was the son of Tokunyu. Died 1835.

Tenth Generation:—Named Tanyu, he was the son of the Ninth generation Ryonyu. This Tanyu was called to Waka-yama by Tokugawa Seijun of Kishu and established a kiln in Manato at Tokugawa's estate of Seinei ken where he made what is known as *Seinei ken yaki*. Died 1854.

Eleventh Generation:—Named Keinyu, he was the adopted son of Tanyu. Died 1893.

Twelfth Generation:—Named Kichizayemon.

Thirteenth Generation:—Named Ryonyu.

Fourteenth Generation:—Named Kichizayemon.

There were also twelve generations of the Branch Kilns.

Each official "generation" was established by the incumbent master appointing his own successor, to whom he gave a written diploma. But more important than the diploma were the "ku den" oral transmission of teachings which were passed on by word of mouth and never put into writing.

Eiraku or Yeiraku Potters

About 1540 there lived at Nara a potter named Nishimura Soin, familiarly called Zengoro. He was the official potter of the Kasuga Shrine at Nara. The date of his birth is uncertain but he died in 1558. His father was a samurai of a clan loyal to the Ashikaga Shoguns. As potter for Kasuga Shrine he made the unglazed earthenware utensils used for the ritual offerings at the shrine; such things as containers for the wine (sake) offerings and shallow round bowls or deep plates used for vegetable offerings He also made earthenware *"furo"* or receptacles for holding charcoal fire. These furo are a special type of brazier and are in use even today for heating the tea water for cha no yu.

Zengoro made furo of a good shape and developed a method of making them a pleasing lusturous black without the use of glaze. Together with Take no joo, a tea-master and pupil of the renowned Rikyu, he developed a style of furo especially for use in cha no yu. These became very popular and are known as Nara furo. He taught the secret of making these to his son before he died, Zengoro also used the artist name Sozen.

Zengoro's son the second of this line, also used the name Sozen. He left Nara and moved to Sakai of Izumi and began making the Nara furo there. He died Nov. 11th 1594 after having passed on the secret of making the furo to his son.

The third generation of this line also used the name Sozen. (For some light on this confusing custom of old Japan our readers will find an explanation under "Names" in Page 22).

Zengoro Sozen 3rd left Sakai of Izumi and went to Kyoto, then the Capital of Japan and the center of culture. He first lived in a place called Tenjin no zushi near Todoin in Rokujo of Shimo-kyo. Later he moved to Kami-kyo, Shimmachi at Kami-Tachiuri Anraku Koji. In Kyoto he continued to make the earthen furo for which his family were already famous. To this day a place where he once had his kiln is called Furo no zushi. The greatest tea master (cha jin) of that time, Kobori Enshu, gave him a copper seal as a token of his, Enshu's acknowledgement of Sozen as a master furo maker. Every succeeding generation of the master potters of this line used this seal on all the furo made at their kilns. But Sozen 3rd, wrote on the boxes in which the

Sozen buro

PLATE VII

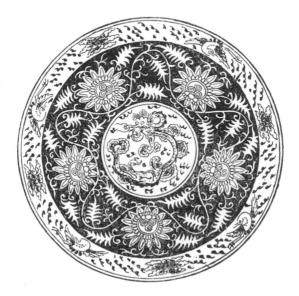

Plate made by Eiraku Wazen.

The center and outside border are in under-the-glaze blue, the broad band surrounding the center design is painted in gold paint on a background of dark Indian red thick opaque enamel. The back of the plate has a wide band of the red enamel bordered on the outer edge by a narrow Greek-key pattern and on the inner edge by a band of triangles and very conventionalized leaves in gold. Size, ten inches in diameter.

Very typical of this style of Eiraku wares.

furo were kept "Furo, Artisan Zengoro" and these furo are known as Sozen buro.

Seal reading "Sozen," incised with a sharp instrument on clay *furo*, fire-pots.

Sozen 3rd died Feb. 3rd 1623 and his family continued to use "So" in their artist names down to the 10th generation who took the name of Ryozen. After Sozen's death his wife continued his work; she was known as Shozen the Nun. She died in 1631.

Stamped seal reading "Tenka ichi Soshiro," best under heaven, or in modern language "Best potter in the world."

Sozen's brother, Soshiro, was also a furo maker of high esteem, although he never seems to have taken the name Zengoro and does not rank as a generation in the Eiraku line. He was a favourite potter of Toyotomi Hideyoshi who gave him a seal marked *Tenka ichi*, or First under heaven. The change of feudal power from the Toyotomi family to the Tokugawa family took place during Soshiro's time but despite the political upheaval he continued his work unaffected. The second Tokugawa Shogun, Hidetada, invited him to live and work in Tokyo (then called Edo). There he lived in comparative luxury as the invitation included the provision of a grant of twenty koku of rice and a retinue of five servants. He died at the age of 65. "Zen" is part of the original Zengoro and to this day Zengoro is used, not so much as a family name, but as an alternate name for the master potter of each generation. Other than a carefully kept record of the date of their deaths nothing is known of potters who followed Sozen 3rd.

Seal of Ryozen, tenth Zengoro of the Eiraku family of potters.

Seal reading "Zengoro" used by Ryozen given him by the tea master Sen no Ryosai and in Ryosai's own hand-writing.

Seal reading "Zengoro" given Ryozen by Kobori Enshu.

The 4th generation, known as Soun, died July 22nd, 1653. The 5th generation, known as Zengoro Sosen, died Aug. 3rd 1698. The 6th generation, known as Zengoro Sotei, died

Apr. 25th 1741. The 7th generation, known as Zengoro Sojun, died May 15th 1744. The 8th generation, known as Zengoro Soen, died Oct. 12th 1769. The 9th generation, known as Zengoro Sogen, died Feb. 3rd 1779.

The tenth generation of this line of potters used the name Zengoro Ryozen as mentioned above. He continued the making of furo, the secret of which had been handed down to him but he also began to make raku yaki under the influence of the tea masters (cha jin) with whom he had been associated in the making of the furo. Further, he made copies of the pottery of Annan (*annan yaki*) and of Cochin China (*Kochi yaki*). The cha jin Sen no Ryosai gave him a seal in Sen no Ryosai's writing to be used on the furo made under his teachings as a sign of high approval. In 1788 Ryozen was burned out and moved his kiln to Abura koji, Ichijo Minami, still in Kyoto. He died Jan. 12th 1841. His son Hozen, who was to become one of the two most outstanding figures in this long line of artist-potters continued the family occupation of making furo.

Zengoro Hozen, the eleventh generation of this family was born in 1795. He was the adopted son of Ryozen. When he was only thirteen he began to show an interest in pottery making

Incised seal reading "Hozen tsukuru" or made by Hozen.

Stamped seal "Hozen."

and bent every effort to master the secrets of the porcelains of the Ming dynasty of China. So in earnest was he that he undertook the severe discipline of the "One thousand days' homage" to the shrine of Kitano Tenjin to pray for success in his work. After many years of arduous work he succeeded and became recognised for his copies of Ming ceramics.

In 1827 he went with the cha jin Sen no Soza to the Nishihama castle of Tokugawa Chiho, Lord of Kishu. This castle had a garden called Kai raku en and there Hozen built a kiln and continued to make both pottery and porcelain. The wares produced at this kiln are known as *oniwa kai raku en yaki* or Garden Kiln Wares.

Hozen was extremely versatile and made such diverse wares as sometsuke blue and white under-the-glaze porcelains in the style of Shonsui; copies of Kochi yaki, or Cochin China pottery decorated with green, purple and yellow glazes in which the colours are put on in solid masses kept separate and from running into one another by the raised outline of the decorative design (See Page 55); and *kinrande* porcelain with a

solid brick or Indian red background decorated in gold designs brushed on with liquid gold (See Page 51). He also made excellent celadons, (*seiji yaki*) and Korean style articles.

He was the first Japanese to master the technique of gold decoration on a red ground (*kinrande*) also known as *aka ji kinga* and in course of his many experiments in trying this method he made beads which were used as netsuke and ojime. These became known as *Eiraku dama* and are much prized. This name Eiraku, was given him written on a silver seal by Tokugawa Lord of Kishu who became very fond of Hozen's productions. Eiraku is the Japanese pronunciation of the name of a Ming emperor Yung Lo in whose reign (1403–1424) in China this type of porcelain was first produced, and the implied meaning was that Hozen's work was equally as good as the Chinese productions. This name has since become world known, for the potters of his line who followed continued to use and today still use Eiraku as a sort of trade name along with their individual artist-names.

Kumande cha wan or Tea bowl by Eiraku Hozen. Showing the family crest of the Tokugawa Shoguns and the sho-chiku-bai (pine, plum and bamboo) design developed in gold on a red ground.

Shortly before receiving the silver seal of Eiraku, Hozen had received, also from Lord Kishu, a gold seal reading "*Ka hin shi ryu*" which may be literally interpreted as "Follower of the style of the potter Kasen." This name Kasen is found on some Ming china and is thought to be the name of the

Silver seal reading "Eiraku" given Hozen by Tokugawa of Kishu.

Gold seal reading "Ka hin shi ryu" given Hozen by Tokugawa of Kishu.

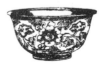

Tea Bowl by Eiraku Hozen
Small bowl with floral design in turquoise blue on a distinctive violet purple ground; the heart-shaped petals of the central flower are white with a faint purplish cast.

potter who made it. However this seal was not to be used at his own discretion but only on those articles approved of by his lord.

It should be noted that while it was the wares decorated with gold on a red ground glaze that won for Hozen the

nick-name of Eiraku, those wares today are known as Eiraku ki rande (Gold brocade style made by Eiraku). Occasionally "Eiraku" means a totally different style of pottery, a ware decorated on the biscuit by glazes held within raised outlines like cloisonne. "Eiraku ware" today means a rather fragile ware decorated in brilliant opaque glazes of egg-yolk yellow, turquoise blue, grass green and a bluish-purple. Eiraku kinrande wares feature finely drawn small patterns of "*kara kusa*" (a vine arabesque) or the symbols associated with the Ship of Good Fortune (takara bune) or the hoo bird in gold or silver on a dull red background.

Although a native of Nara his fame spread abroad in Japan and he was invited by various feudal lords to visit their domains and instruct their potters. He also worked for some time at the kilns of Kaseyama in Yamashiro near Nara, besides acting as instructor to potters in Settsu. Falling under the influence of the style of Nonomura Ninsei in 1840 he set up a kiln at Omuro to produce earthen wares in the Ninsei style. Hozen's works had an imperial admirer and Prince Takatsukasa recognized his ability by

Seal given Hozen by Prince Takatsukasa.

giving him a writing which reads "*Ito Yomei*"; such writings are considered family treasures in Japan. He was also recognized by the great financial families of Mitsui and Konoike and was allowed free access to these families' treasures of old Chinese porcelains. This was a great factor in the advancement of his technique and style. He became fired with the ambition to make porcelain after the style of Kinso, a Chinese kiln, and exhausted all his resources in this new study.

Having no funds with which to continue his experimenting along new lines he instructed his son Wazen in the traditional methods of the family and turned over the business to him. Hozen then began a period of wandering about the country, still obcessed with the idea of developing new glazes and styles of decoration for his much loved ceramics. In 1850 he went to Tokyo but did not succeed in establishing a kiln there. Then he went to Otsu where the priest of Emma-in Temple gave him financial aid to open a kiln and he began to make a ware known as *konan yaki·* From 1851 until his death in 1855 he turned out many beautiful things from this kiln.

In private life Hozen was known as Nishimura Zengoro.

Hozen had two sons, Wazen the elder who became Zengoro the 12th and Zenshiro the younger who became

PLATE VIII

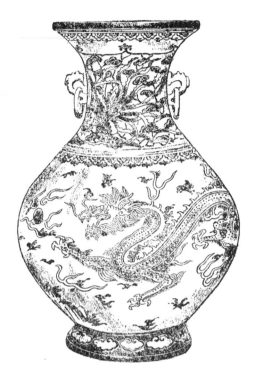

Eiraku Flower Vase

 One type of Eiraku wares which features yellow, blue and purple glazes used in a manner suggesting cloisonne enamels. The design is raised and very rough and sharp to the touch.

 The body of this vase is closely covered with green and blue waves (not shown in the drawing) with a yellow dragon and yellow and blue fire-forms.

 The neck has a purple hoo bird surrounded by a blue fungus-arabesque on a yellow background. The small ears and pendent rings are of the same yellow.

 The mouth and base are purple, the latter having yellow cloud-forms outlined with blue.

Zengoro the 13th under the artist-name of Kyokuzen (he was also known as Toho). Under the name of Toho, Zenshiro used the seal of the Omuro kiln and but little else is known of him.

The twelfth generation of the family, called Wazen was born Aug. 28th 1824 and inherited his father's business in 1853. Some time during the early part of the Meiji Era (1868 to 1912) he changed his name to Eiraku. Whether or not the original family name of Nishimura continued down to his time is not clear. Wazen excelled both in painting and calligraphy and was an accomplished artist but he laboured under financial difficulties as a result of his father's fanatic search for perfection in his art. He built a temporary home and kiln in a western suburb of Kyoto, in the garden of Ninna Temple where the great potter Ninsei had once had a kiln.

Seal of Wazen, written by the tea master Yabunouchi Sosho and carved by the famous Zoroku.

When the Imperial Princess Kazu was married to a Tokugawa Shogun, Wazen was appointed to make the cha no yu utensils for her trousseaux under the supervision of the cha jin Yabunouchi Sosho. His work was of such excellence that he was given a seal by this master tea man.

In 1866 Wazen was invited by Maeda, feudal lord of Daishoji, to Kaga and he stayed there five years. The wares he made at this time are known as Kaga Eiraku and the influence of his style remains in Kutani to this day.

Seal used by Wazen on articles made for Kazu no miya and for this purpose only.

Typical of his work at this time are the matching sets of dishes for serving Japanese food which combined sometsuke under-the-glaze blue and white with kinrande, designs in gold on a red ground. It was here also that he brought to perfection the style of decoration known as akaye, red designs on a white ground. It must be remembered that the kiln at Daishoji is but one of the many which today are lumped together under the one word "Kutani." In 1871 he went to Okazaki in Mikawa where he built a kiln and worked for three years. About 1875, under the encouragement of the powerful Mitsui family he built a kiln on the bank of the Kikutani River at Higashi-yama, Washio-cho. His wares from this kiln are known as *Kikutani yaki* and are stamped with a seal given him by Takafuku Mitsui. All his seals were buried with him as he requested on his death bed. He died in 1897.

Seal used by Wazen the twelfth Eiraku potter at his kiln on the Kikutani River. These seals were written by Takafuku Mitsui under whose patronage the kilns were operated. The outline of the seal is in the shape of a *fundo* ancient gold coins, a design used as hardware decoration in Mitsui's house.

The thirteenth generation includes two contemporary potters. Wazen, though he lived to reach the good age of seventy-five was always frail and in bad health. He had no children of his own and an adopted son named Sozaburo, whom he reared as his own but who was actually the second son of a lacquerer named Chokan, died twenty years before Wazen himself. About the only work that this Sozaburo can be credited with is the handwriting on the boxes which contained his adopted father's master-pieces, he did very little work in ceramics of any kind and apparently never had a seal. A potter named Yasuke who had been a pupil of the gifted Hozen turned out a great many beautiful things and it is to be feared that many of his works have been credited to his master teacher. He died at the age of eighty on Feb. 24th, 1884. Yasuke, called Yasuke 2nd though

Boxes made by Sozaburo

Interesting because they show the care and thought bestowed on the containers of tea bowls. The bowl wrapped in a silk cloth is first placed in the smaller box. That box is then put into the larger one which in its turn is put into a third box of plain white wood.

no one knows who Yasuke 1st was, used a seal reading *Kyu raku*, Old raku. One authority says "Hozen received two exclusive seals of honour known as '*Ka hin shi ryu*' and '*Yeiraku*' to distinguish his products and Yasuke was accorded the same privilege. This Yasuke is often referred to as the thirteenth Eiraku.

Seal reading "Kyu raku" used by the potter Yasuke sometimes called the thirteenth Eiraku.

Seal reading "Yu" given to Tokuzen by Mr. Sumitomo when he ordered him to make sixty-one incense boxes for the third anniversary of his father's death.

Seal reading "Eiraku" used by Tokuzen.

The fourteenth generation is known as Tokuzen. He was born in 1854 at Abura koji in Kyoto and succeeded to the family name of Eiraku and to that family's fortunes, which were however at a very low ebb, not having recovered from the disastrous twelfth master-potter's search for perfection. Tokuzen was a great potter and many of the things he made are of excellent quality and deserve special note and much praise. He died Oct. 25th 1910. The fourteenth generation is considered as extending to 1928 because Tokuzen's widow Myozen carried on the family business. In 1912 she personally was given a seal by

Seal reading "Kikuzawa" used by Tokuzen, fourteenth Eiraku potter.

Takamune Mitsui and many years later in 1927 Takamune urged her to use the name Myozen on her wares, thus recognizing the excellence of her work. She died about 1928.

Seal reading "Eiraku" used by Tokuzen the four eenth Eiraku potter. This seal was used also by his widow, Myozen.

Seal reading "Eiraku" given Myozen by Takamune Mitsui.

Seal reading "Eiraku jugo sei Shozen" (Shozen the fifteenth Eiraku) made just before his death.

The fifteenth generation, known as Shozen was a nephew of Tokuzen. After the death of Myozen he carried on the kiln and its traditions and on April 20th 1929 he formally succeeded to the Eiraku family. To celebrate the occasion Takamune gave him a silver seal and Mokurai, Chief Priest of the Kennin

Zen Temple, gave him the artist name of Shozen. On the 100th anniversary of the death of the famous Hozen (the eleventh Eiraku potter), Lord Kishu gave Shozen a gold seal and commissioned him to make certain articles for him but Shozen died before he had completed the work, Dec. 28th 1933.

Seal reading "Sempu" given Shozen by Tokugawa of Kishu.

Seals used by Eiraku 16th reading " Hozan."

The sixteenth generation of this famous line of potters, who is known either as Eiraku, Nishimura Zengoro, or Hozan is living and working in Kyoto, producing wares of various types and of exceedingly fine workmanship and beauty. He continues to make the traditional wares of his family but has developed a style of his own. He may be said to be representative of his times; his productions are faultless, potted of a very thin hard porcelain, and his style of decoration reflects the modern trends in the art world of Japan.

As this book goes to press the present Eiraku is actively carrying on the traditions of his family and producing wares worthy of the long line of artist-potters who have preceeded him. American book publishers have their Book of the Month Clubs, here in Japan this potter has established a " Dish of the Month Club." For a very nominal sum subscribers receive ceramic articles both beautiful and useful, all with the unmistakable Eiraku touch. The membership of this club is of necessity limited as each article receives the personal attention of the master potter.

In summary

It would be an impossibility to list the various kinds of ceramic wares having the Eiraku seal: for generations these potters have been artists and individualists and their productions include exact duplicates of ancient Chinese potteries and porcelains, Japanese wares whose decorations are based on Chinese models, and ultra modern wares that could be produced only in Japan, truly Japanese in form, feeling and style of decoration.

But they also produced two quite distinctive and entirely different kinds of wares.

A ware most easily recognizable but rarely seen is based on the pottery of Cochin China of three hundred years ago. These wares are light in weight and fragile, not porcelain but a kind of faience, in unmistakable colours and they do include ornamental vases suitable for the decoration of modern European houses, as well as the traditional things for the serving of tea. The colours are lemon-yellow, turquoise blue, grass green and a bluish purple. The glazes are soft looking enamel glazes and the designs are raised above the surface of the ground, much resembling old Chinese cloisonne designs, often dragons or flowers.

The second type of wares is often met with and imitations of it abound. The articles are such as sake cups, Japanese dinner sets of cups, bowls and plates of various sizes and bowls of all sizes for cakes etc. These have an Indian red ground glaze with gold or silver designs brushed on, frequently combined with sometsuke, or under-the-glaze blue and white decoration. The blue of the sometsuke is a clear dark blue, very pleasing and the designs in gold on the red ground are mostly of the treasures carried on the Japanese mythological treasureship or the traditional Chinese arabesque, trailing leaf design. Sometimes the designs are in silver and both gold and silver may be polished to restore the brightness. A ware resembling this has designs of cranes without stretched wings, or figures of humans, but they are imitations and not Eiraku productions.

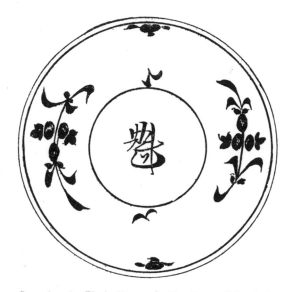

Gosu akaye by Eiraku Hozen. Inside of a small bowl about six inches in diameter and a little more than two inches deep. The Chinese character *sakigake* (harbinger), the lines and most of the floral design are brushed on in red with very slight touches of a bright grass green. Design based on Chinese Sung dynasty wares. Such designs are known also as *akaye*.

Pre-historic
and Early Potteries

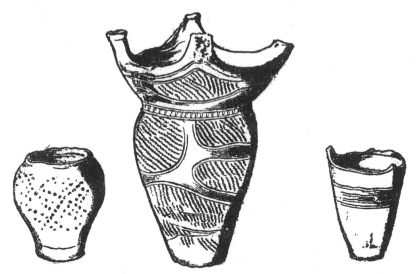

Jomon Pottery. Pre-historic cooking pot and cups, m de of a rather coarse reddish clay without the use of the potter's wheel and but lightly baked.

Brief Mention of Pre-Historic Pottery

The Japanese classify their pre-historic pottery into two groups: Yayoi wares (*Yayoi doki*) so named because of the place in Tokyo where the first specimens of this ware were discovered, and Jomon wares (*Jomon doki*) because of the rope (*jo*) marks found on most pieces. Jomon doki is known also as *Na no tsuke* and *Ainu doki*.

Jomon wares are perhaps the oldest, being found at lower levels than Yayoi wares, but there are places where the two types are found at the same level, suggesting simultaneous use. Jomon wares, as their name indicates (jo means straw rope or mat while mon means design), have markings on them showing the use of such ropes or mats to hold the vessel in shape before firing. In shape they are rather complicated, heavy and thick, and the designs on them are sometimes very elaborate in a primitive way, consisting of curved and straight thick lines raised above the surface with the mat markings in the spaces between. In some specimens the raised lines are made of clay ropes and the mat effect has been produced by scratching the surface with some sharp implement, obviously a development or imitation of the original rope and mat marked vessels. These wares appear to have been built up by hand, evidently the potter's wheel was not yet known.

Yayoi wares, on the other hand, are wheel thrown and although made of the same soft earthen ware and fired at the same low temperature, are simple and elegant in shape with practically no design beyond that made by "hatching" or scratching the entire surface. These wares are comparatively thin. Although startlingly like pre-historic pottery of other countries, Jomon and

Yayoi or *Iwaibe* Pottery.
Wheel thrown, of a fine hard clay slate grey to almost black in colour.

Yayoi wares may be indigenously Japanese, and were used for ritual purposes as well as for practical use. They were made of earthen ware and unglazed; in colour they range through various shades of greyish-black to reddish-brown depending on the location of the producing centers. Markings on some of the vessels seem to point to the fact that they were fired, or baked, in an open fire on the surface of the ground, evidently covered kilns were not yet known. Jomon and Yayoi are names given to these pre-historic earthen wares by modern scholars. In the written records of Japan other nomenclatures are used.

Suyaki, is the general term used for all unglazed pottery wares, especially with reference to ritual uses. These vessels, used for religious offerings, are known also as *Imbe yaki* and later as *Iwaibe yaki* or *Iwaibe tsuki*, and some of the kilns at which they were produced are in existence today, that is to say, pottery in some form or other is still being made at the old kiln

sites. Specimens of Imbe yaki and Iwaibe yaki have been found in ancient dolmen and graves of pre-historic times apparently intended to hold food supplies for the dead.

Japanese history opens with the reign of Jimmu Tenno and 660 BC is given as the date of the founding of the empire. The first mention of any pottery wares is in the story of Jimmu's expedition against the northern barbarians when he made "eighty platters (*hiraha*), eighty Heavenly small jars (*ta kujiri*) and sacred jars (*izube*)" of clay brought secretly from Kaguyama for the purpose of divination. These things must have been true pottery, not just unfired clay vessels, because the method of divination was to place the jars in a river.

There is also a record of a potter working at Ushima in Izumi some time between Jimmu Tenno and Suinin Tenno (who reigned from 29 BC to 70 AD).

In 27 BC a Korean prince came to Japan and took the Japanese name of Ama no Hihoko. He asked and was granted permission to visit various districts in search of a place to live and he settled in the Province of Tajima and became a maker of pottery. The potters of the village of Kagami no Hasama are his descendants and the descendants of his followers.

Potters guilds, or organizations, have a long history in Japan for it is recorded that in 3 AD Nomi no Sukune was appointed official in charge of the clay-workers' guild (*Hashibe*). Until that time it had been the custom to bury with an emperor or prince most of his immediate followers and attendants. Nomi no Sukune protested that such a custom was not a good one even though it had been followed for centuries. He suggested that he call one hundred clay-workers from Izumo to make clay shapes of men and horses (*haniwa*) to be substituted for the living originals. This idea appealed to Emperor Suinin and he rewarded Nomi no Sukune with a kiln site and changed his title to Hashi no Omi or "High government official in charge of clay-workers." His descendants took the family name of Hashi. The potters of Omi made earthen wares for every day use, for cooking and for food storage. Those who were called to the court to make the haniwa settled at Pottery Village (Toki-mura) near present-day Osaka and their descendants are still making pottery there.

The images which were made at that time are known as haniwa, "clay rings" or "clay circles," because they were set in circles about the tombs of the emperors. *Tsuchi ningyo* (clay dolls) may be used of them descriptively but they are usually spoken of as haniwa. They consist of terra-cotta cylinders with human or

animal figures on top. Haniwa are a fascinating subject for speculation but are pertinent to this book only as marking the development of unglazed pottery at a very early date and the early organization of potters into guilds called variously Hashi, Hanishi, Hashibe or Hasebe.

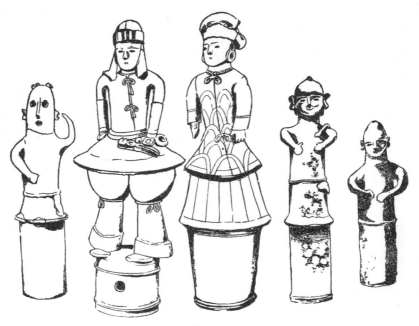

Haniwa.
They range in size from a foot and a half to three feet.

 In the year 70 AD, a number of Korean potters came to Japan. They settled in various districts where they found suitable clay materials and taught the Japanese of these districts to make pottery. Later they became naturalized and took Japanese names. Again during the years between 355 and 472 potters came from Korea bringing their methods of pottery manufacture and they taught Japanese potters how to make roof tiles. In 470, they established a kiln at Suemura in North Kyushu which later became known as Karatsu.

 During the reign of Kotoku Tenno (645 to 654) the potters guilds (*be*) were re-organized and they were placed under the office of the Imperial Court Butlers (*hashi no omi*). Evidently up to that time any one who worked with earth in any capacity had been classed as clay-workers. Now they were divided into

pottery makers and civil engineers (if we are allowed to use so modern a term for the men who built roads, made river banks to control the flow of water, etc.). A hundred years later in the seventh century there is a record of the fixing of the number of hours a potter could be required to work, surely the first record of labour regulation in Japan. During the years 645 to 655 there was a further change made in the potters' guild. The office of Hashi no Omi was abolished and the clay workers were placed under a new bureau of the Imperial Court, that of *Hakosuye mono no Tsukasa* or "Office of Box and Pottery Making." Later this bureau was in turn amalgamated with the Imperial Board of Cookery, *Daizen shoku.*

Just when the knowledge of glaze entered Japan is not known. We know that in 552 many Chinese and Korean art objects came to Japan along with the teachings of Buddhism and some glazed pottery must have been included. We have records that during the reign of Kammu Tenno (died 806) glazed roof tiles were made in Takagamine a village north of Kyoto. These tiles were said to be " *aoi* " in colour, a word which is applied indiscriminately to either blue or green.

By the early part of the eighth century glaze was in use at the kilns of Hizen and at the end of this century glaze was generally known and in use on pottery everywhere but porcelain was not yet developed.

About this time, too, a Japanese priest Gyoki traveled all over Japan teaching potters new and advanced methods which he had learned in Korea. He is credited by some with introducing the potter's wheel but it is known that this was in use long before his time. The wares he made are known as Gyoki yaki.

About 815 potters from Yamada-gori in Owari went to Korea, where they stayed several years studying the Korean methods of producing pottery. On their return they continued to make pottery but left nothing by which we can judge their work, nor do we know the kilns at which they worked.

In the Shoso-in, the Imperial Storehouse at Nara established by Empress Komyo in the eighth century, there are about sixty pieces of glazed ceramic wares of the style of the T'ang dynasty. For a long time it was thought that these had come from China but it is now believed that they were produced in Japan. Some of these wares are dated 811.

Early in the tenth century (905, to be exact) the Imperial Court ordered the production of some large pottery vessels (*kame*) and a law was issued that any potter who made a jar (kame) large enough to hold one hundred gallons of water

would be exempt from eighty days labour and one who made jars large enough to hold fifty gallons would be excused from ten days labour.

We also have records of taxes from Owari and Nagato Provinces being paid in pottery articles. This too in the year 905.

From this time on it is no longer possible to follow a general line of development in the history of pottery and porcelains. Each district produced typical wares and developed independently of the other districts.

Teshoku Portable oil lamp, with slot in the handle for hanging on a wall; just over four inches high, diameter of the base the same as the height. Coarse hard stoneware biscuit with a speckled opaque thick coffee-brown glaze, resembling wrought iron more than anything else. The base and hollow stem are wheel thrown in one piece, the bulbous top was made separately and attached.

Unglazed Pottery of Historic Times

Unglazed pottery wares used for Shinto observances are called *kawarake* or suyaki and are made at many kilns in many places. These include the small plates for uncooked rice and the peculiarly shaped bottles in which sake is offered to the kami.

Suyaki is also the name of the sun-baked clay dishes on which it was formerly the custom to serve the emperor's food. The dishes were used only once and then destroyed.

A ware closely resembling the suyaki called *horoku* is used for such diverse articles as a kind of plate used for parching beans or other seeds for food; the small clay disk which Japanese fencers bind on their foreheads (the one who first succeeds in breaking his opponent's is adjudged the victor): and a large flat disk on which is burned the handful of wood and straw for the "sending off" fire in the Obon Festival.

Examples of popular use of Hotei-sama on small incense boxes, seal and bottle.

Bizen

Following the Jomon and Yayoi wares comes a kind of earthen ware unglazed but fired at so high a temperature that a natural glaze is formed on the surface. There seems to be no fixed terminology for these wares for they are known as Iwaibe yaki, Imbe yaki, Sueyaki and Yakishime yaki. *Sueyaki* is the term still in use for any unglazed wares. Iwaibe yaki and Imbe yaki are used most frequently in speaking of vessels for ritual and burial purposes. Yakishime yaki is applied to earthen ware vessels with a trace of natural glaze. Kiln-sites for the making of this unglazed ware have been found in various parts of Japan. The wares produced at the kilns were more or less uniform and the best were made during the 8th and 9th centuries, after the 13th century this uniformity was lost and the wares began to take on local characteristics. In general it may be said that these kilns flourished until the beginning of the 16th century when the knowledge of glaze began to infilter into the country. Among the first to make modifications of the traditional suemono (or sueyaki) were the kilns of Bizen in Okayama Prefecture, Shigaraki in Shiga Prefecture, Tokoname in Aichi Prefecture and Tamba in Hyogo Prefecture. The kilns themselves underwent certain changes also. The pre-sue wares were fired in kilns built on level ground and the use of a new and improved type of

kiln allowed the wares to be fired at higher temperature. These were the ana gama, later to be known as nobori gama, and they were undoubtedly influenced by Korea. Many vessels of the sue yaki type are identical with Korean wares of the same period.

These wares have been found in ancient tomb sites where they were used for holding food and wine for the dead. They are well made wheel-thrown bowls of various sizes and shapes of a dark brown or very dark grey colour, thin and hard. Besides the ritual or ceremonial wares the sue kilns made pottery for household uses and for holding seeds and it is these commonplace useful things that are held in highest esteem by the cha jin, especially the wares of the 14th century. About this time there seems to have been a distinction made in the nomenclature of the wares of the Okayama kilns—those destined for household use are called *bizen yaki*, the name of the kiln, while ritual and tea wares are called Imbe yaki, that is, wares made by members of the Imbe clan or tribe. A certain amount of Imbe yaki is still being produced at some kilns but the same kilns now also turn out wares to meet the modern demands.

Bizen yaki is quite distinctive in appearance often it so closely resembles bronze that a close examination is necessary to ascertain the difference. The clay is extremely tenacious and can be manipulated into any desired form and it retains its shape, unimpaired, under intense heat for long periods. The products of the kilns have varied greatly. As has been noted the first productions were for both ritual and household use and are known as Imbe yaki and sueyaki. The wares known as *ko bizen* or Old Bizen date back to the thirteenth century and the seed jars, now used by cha jin for water jars and flower vases, were first made for household use from the end of the thirteenth to the beginning of the fifteenth century. These are wheel thrown and no artificial glaze was used; the marks known as "*ito giri*," the concentric circles made on the bottom of the article · when the potter cut the thing free from the wheel are one of the distinguishing marks of those wares. See Page 46. These ito giri are still being produced by many potters at many kilns by modern artists, especially those of the raku school. Old Bizen wares also show free use of the bamboo spatula. The accidental mis-shapes made by the careless handling of the articles during the forming and firing appealed to the aesthetic sense of the cha jin of that day and ever since articles have been intentionally mis-shaped to meet their demands. The first pieces of Old Bizen to arrive in Europe bore a small mark, a cresent or a single cherry blossom, stamped into the base.

In 1582 Toyotomi Hideyoshi, when acting as military governor of Bizen Province stayed for a while at the home of one Oba Gorozayemon, by his name a potter. Hideyoshi himself made some pieces for use in cha no yu and ordered some of his retainers to do so also. He selected six of the most outstanding local potter families, the record distinctly states that it was six families of potters not six individual potters. They made for him tea wares, flower vases, containers for tea, cold water holders and artistic ornaments for the decoration of the room in which the cha no yu parties were held. As a reward and in token of his appreciation of their efforts he issued orders that there should be no "warlike acts" in that or adjacent districts. Surely a magnificent reward when we consider the usual fate of a country and its people with an army quartered on it!

Old Bizen Incense Burner

Old Bizen piece resembling bronze. A Chinese lion-dog called in Japan *kara shishi*, standing in a lotus blossom. Height about ten inches.

The seventeenth century with its European contacts brought new life to the kilns of Bizen because of the demand for export wares. Figures of gods, mythological personages, birds, fishes and animals were turned out in quantities, but a fairly high standard of excellence was maintained. The figures were first moulded and then given an individual touch by a master potter, edges were sharpened, details picked out and shapes varied by gentle pressure of the hands, so that no two objects were ever exactly alike. Old Bizen was never glazed artificially. Later a greenish clay was discovered; wares made of this clay are known as *ao bizen* and are rare and exceedingly valuable. Still later, as the knowledge of glaze spread *iro bizen*, Coloured Bizen was developed. In this the potters became very skillful. A small image of a Chinese sage in the possession of the author shows a wonderful command of the potters medium. It is glazed, with a thick soft greyish-white glaze, almost putty coloured, but the edges of the folds of his garment and the hair of his head and beard are almost sharp enough to cut one's fingers. The glaze seems to have been just a very thin clay plastered over a carefully modeled base of a fine light-coloured biscuit of Bizen clay. The thing was not moulded but seems to have been formed up out of a slab of clay. The modeling is vigorous the entire figure admirably posed, the face intelligent and although the figure practically colourless it is strangely attractive. The figure is hollow and the inside is glazed, obviously with the same glaze as

the outside but of a much thinner consistancy, and has been flowed on. This ware is known as *haku bizen* or White Bizen. Iro bizen, or Coloured Bizen utilizes a great many coloured glazes. The object is always very carefully modeled and the glaze of whatever colour thick and soft looking. Pieces of iro bizen are rare and they are never cheap. Although Bizen wares have few European admirers the Japanese value them highly.

After about 1850 many pieces of Bizen ware were exported and as is to be expected the quality of the wares greatly deteriorated. Modern potters have neither funds nor time for the old slow long firing methods and they use a glaze to produce the effect of the old wares. Most of the articles are made in moulds and but little time is spent on retouching or individualizing them. Also they are usually closed in at the base, not hollow, and frequently the potter uses his own seal.

The six potter families which were established by Hideyoshi prospered and increased. During the middle of the nineteenth century their number was increased to forty-six. The names of individual potters are practically unknown. At the end of the sixteenth century we find the name Mikazuki Rokubei. Mikazuki translates "three day moon" which is the Japanese expression for cresent moon, and we know that some of the earliest pieces had a cresent seal these may have been his work. A potter named Kageshige Toyo is famous today for his wares in the style of Old Bizen. Ninami Dohachi 2nd who was a pupil of Okuda Eisen and had a kiln at Awadaguchi in Kyoto came to Bizen where he established himself at the Mushiaki kiln and exerted considerable influence on the wares of the Bizen kilns.

Wares known as ko bizen, or Old Bizen were produced between 1760 to 1800.

Among the most characteristic wares of the Bizen kilns are the following.

Hidasuki yaki : — Articles were fired wrapped in straw which had been soaked in salt sea water. This left red marks or stains on the articles and this variation in colour and accidentally produced designs pleased the cha jin of that time.

Matsuba kage : — Articles were imbedded in pine needles in the kiln and fired. This produced the outline or "shadow" of individual pine needles, like a pattern on the surface of the article.

Old Bizen Flower
Vase

Heavy reddish brown pottery vase of earlier make than the incense burner. This ware belongs to the type known as *Imbe yaki.* Height about twelve inches.

PLATE IX

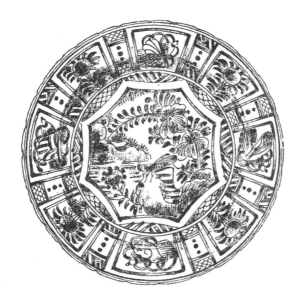

Sometsuke, or Blue and White Plate

A very early Karatsu production, of a type often sold as Chinese. Probably made by a Chinese potter at Karatsu. The design and colouring are Chinese but close examination reveals Japanese characteristics. Such wares as this are very difficult to classify.

Enoki hade :—Certain articles in every firing were not reached directly by the heat of the kiln and developed a bluish-violet colour like the bark of the Enoki-tree.

These three transmutations were natural changes occurring in the firing in the kiln under primitive methods and they had a great appeal for the cha jin who gave them these suggestive names.

After the kilns were modernized and improved such effects no longer appeared and modern Bizen products lack the charm of individuality or variety.

Karatsu

Though their productions are of but slight interest to European admirers of Japanese ceramic wares, the kilns of Karatsu are of the utmost importance in the history of the development of ceramics in Japan. The wares, a kind of coarse earthen ware, show an astonishing variety of articles and methods of decoration especially in comparison with other Japanese kilns where one kind of article or type of decoration has prevailed for generations of potters. The wares are well liked by the Japanese in general. So great was their popularity that Karatsu yaki was the general term for all forms of ceramics in Kyushu. Old pieces, *ko karatsu*, are of great value in the eyes of those who are interested in ceramics from the point of view of cha no yu but there is little in them to appeal to one at first glance. Their colour scale is low, ranging from greyish-white, through golden browns to brownish black and the decorative designs either exceedingly sketchy, developed in blue-greens and browns (*e karatsu*); or with fulsome detail incised and inlaid with much repetition (*Karatsu Mishima*).

The very name of the kilns Karatsu, that is *Kara*, China and *tsu*, port, China Port, gives us a clue to the wares. From earliest times this port has been a point of contact between Japan and the Continent, and it was here, too, that Korean influences poured in. Perhaps because these kilns were early used by Korean potters to make their own accustomed pottery, Korean art influences predominate. Chinese influences are not lacking but the wares are basically Korean in form and feeling.

Early records say that during the period between 593 and 661 (which interestingly enough coincides with the reigns of two Empresses) Korean pottery wares were made at Karatsu; and we know that Karatsu has been a port for Chinese trade since the eighth century. There is very little authentic in-

formation regarding the earliest Karatsu kilns. One story is that they were first started by three Korean potters who came to Japan with the Japanese Empress Jingu Kogo (who reigned from 201 to 269). It is not until the middle of the twelfth century that there is any certainity, and the first productions of the kiln set up then by a Korean potter were mostly earthen ware of a very crude kind, though they were glazed with an artificial glaze.

These earliest glazed wares which are known today as Old Karatsu (ko karatsu) were in the form of a kind of bowl used for measuring rice, called either *yone hakari* or *beiryo*, the Japanese and Chinese pronunciation of the same characters (米量). The clay used was whitish and the glaze thin and mat-like rather than glossy. Another ware classed also as Old Karatsu (ko karatsu) was produced from 1324 to 1469. These wares are known as *nenuki*.

The clay or biscuit was sometimes white, sometimes reddish and the lead coloured greyish glaze always left the base of the article exposed. These nenuki articles are ancient looking and very elegant.

During this same period (1324 to 1469) the kilns turned out a product known as Interior Karatsu (*oku karatsu*). These show unmistakably Yi dynasty Korean influences, and in fact were imitations of Korean pottery; the glaze was either a pinkish yellow, called persimmon colour (*kaki iro*) or a thin yellowish glaze which tended to green at the edges of pieces. The best oku karatsu has wrinkles about the footrim, which is low and rather flat with the inside scooped out. As their name suggests they were imitations of Korean wares produced at interior towns of Korea, such as Ping-yang, Seoul etc.

Seto karatsu, produced between 1467 and 1573 got its name because the thick glaze of Seto (*ko seto*) was used. These wares show a decided Chinese influence in shape and decoration, but modified by passing through Korea and the hands of Korean potters. The thick white glaze used resembled that which the cha jin Shino liked; a greyish-white glaze with deep irregular crackles and deep pin-prick spots where the glaze failed to fuse into a solid mass, and the most prized pieces had considerable sections of the glaze that had congealed in such a manner as to suggest a mass of earthworms.

Here we must enter another highly controversial name, Goroshichi. As in the case of Shirozayemon it is an unsettled question if Goroshichi ever existed. At any rate he is supposed to have been a potter who worked at the Karatsu kilns about 1530.

Certain large tea bowls, made of a fine light coloured clay and decorated in floral and geometric designs in under-the-glaze blue of a poor colour are assigned to him. His glaze was a good white, soft-looking both pitted and crackled and he covered the entire surface of his cups with the glaze, even the inside of the footrims. These bowls were quite large and were used when the cha no yu people served tea in a single cup which was passed around like the European loving-cup. The practice of serving tea this way has always existed simultaneously with the use of individual tea bowls. To this day cups of this "out-size" are called "*goroshichi*," instead of the usual "cha wan." Originally and when first made they were not intended for tea bowls but for the serving of food.

Karatsu productions up to this time, the end of the sixteenth century, which include yone hakari, nenuki, oku korai, Seto Korai and the Goroshichi wares were made of pottery and exhibited strong Korean influence. People interested in cha no yu set much store by them and delighted in the evidences of that influence, even in the slight imperfections caused by the crude potting methods. Marks called *kai me* (shell marks produced by the shells on which the article was stood in the kiln and the small round, regularly spaced marks called *uchi nami* (beaten waves) made by the peculiarily Korean method of hammering a thing into shape instead of throwing it on a potter's wheel are eagerly looked for. This Korean method of potting large jars or bowls is known in Japan as *tataki zukuri* and serves to strengthen the clay while it thins it. Also the roughness which the surface of an article took on when thrown on the wheel due to the toughness of the Karatsu clay is considered interesting and desirable.

At Karatsu as elsewhere the end of the Korean invasion resulted in an increased tempo in the production of the kilns and modifications of the wares. Terasawa Shima no Kami, newly appointed feudal lord of Karatsu, engaged a number of Korean potters and reopened the kilns which for some reason had been abruptly discontinued in 1574.

A ware called Mottled (or Spotted) Karatsu, *madara karatsu* was produced about 1600. This ware shows the influence of the *kai me yaki*, a pottery made in North Korea. The colour of the glaze is said to be "candy" coloured, *ame iro*. It is produced by running an uneven layer of greyish-white glaze over a transparent dark brown glaze.

Korean-Karatsu, *Chosen Karatsu*, produced between 1573 and 1644 was made of materials imported from Korea, both paste and glaze. The glaze was a thick opaque beautiful glaze

which under different firing conditions in the kilns developed colours ranging from a shiny blue-black through various shades of blue to almost white, and the more unevenly the glaze settled on the biscuit the better it was liked. The Japanese name for this beautiful glaze *namako gusuri* or sea-slug glaze hardly does it justice.

Karatsu Mishima Wares

Of the many wares produced at the Karatsu kilns that known as *Karatsu Mishima* shows the most obvious and easily recognizable Korean characteristics. The name is misleading for Mishima (三島) is a town in Japan and no pottery was ever produced there. However the Japanese thought that the rows of small repeat patterns resembled the rows of characters in the yearly calendar for which Mishima was famous. It should here be noted that Mishima wares are made all over Japan. The picture opposite shows a plate from the Yatsushiro kilns but its design is interesting because it illustrates the point under discussion.

Although so many of the Chinese designs came to Japan through Korea and were actually the work of Korean potters, Korea herself remained practically un-affected. Korean designs are distinctly Korean and show far less Chinese influence than do the most Japanese designs. All forms of Korean art bear Korean characteristics which distinguish them from the Chinese originals and it is in their pottery decorative designs (not the shapes) that Korean influence on Japanese ceramics is most apparent. The small symmetrical branches of three or four full-blown blossoms with their accompanying leaves and flower buds, usually in circular or oval medallions and the rosette-like isolated blossoms in bands have no known prototype in China. The flowers resemble small chrysanthemums, but the general effect perhaps indicates Near East influences. At any rate this design is typically Korean as is also the method of executing the design. These are incised or engraved in the biscuit, they are then filled in with a white, sometimes picked out with black or green, clay and the whole covered with a thin transparent glaze. The typical Korean glaze is transparent, glassy and thin and not intentionally crackled. In colour it runs from greenish and greyish white to all shades of greenish-grey, grey and blue-green. No two pieces are exactly the same shade, but the prevailing tone is somber and to many people unattractive. The best glazes have a decided bluish cast and the general impression one of great elegance.

PLATE X

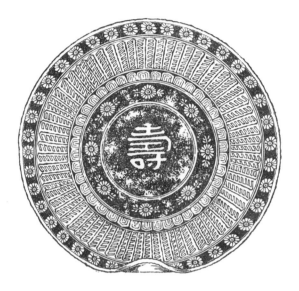

Karatsu-Mishima Type Plate

Modern reproduction of traditional Yatsushiro ware. Eight-inch, round plate with about five inches of the edge pushed up slightly to break the even roundness. Mishima type of decoration formed partly by engraving and partly by stamping the design in the reddish biscuit and filling it in with a thick white slip. The whole plate thinly covered with a pinkish pearl grey transparent glaze, producing a metalic lustre effect. The general effect with its cream white and warm tan design resembles the colours on a dove's body.

The back of the plate has been treated differently. It was first painted with a blue-grey slip which was lined with concentric circles produced by two strokes of some broad sharp pointed comb-like implement, called *hakeme*. On these lines a very scattered irregular pattern of the small daisy and leaf groups were stamped. The whole then glazed with the pinkish pearl glaze.

The so called Mishima wares of Japan are more roughly executed, usually the design is impressed by small molds or dies rather than carved out and the overall glaze varies with the kilns at which it is produced and may be a very light greyish white or dark grey, or as in the illustration opposite Page 76 some shade of reddish-tan. This method of decorating is known as *in ka*, literally flowers (ka) made with a seal or stamp (in). Mishima type wares were never very great favourites with the cha no yu people, although they are found among the productions of the oldest kilns and are probably contemporary with oku karatsu.

There is a second style of decoration which originated in Korea and which is still occasionally seen, the *hake me yaki* or Brush-stroke wares. It consists only of a single vigorous brush stroke, beginning with the brush full of pigment or glaze and trailing off into nothing before completing the circle. On Karatsu pottery wares it often consists of a brush stroke of thick white glaze over a darker ground glaze.

At the end of the sixteenth century the knowledge of making porcelain began to permeate the kilns of Japan and from this time on the Karatsu kilns turned out porcelain articles, not at first a fine porcelain but a ware having a ringing resonance. However, there are in existance certain pieces of a fine hard chinaware decorated in blue under-glaze designs of archaic patterns which are variously said to be "made in China," "made in Karatsu by Chinese potters" or "made in Korea." Supposedly one is left to make their own decision on the matter. Certainly all the usual requirements for a Chinese article are in evidence yet the usual verdict is "Karatsu wares."

With *e karatsu*, Picture Karatsu, we are on firmer ground. These wares are heavy porcelainous stone ware which while they exhibit many Korean features bear also unmistakably Japanese marks. The biscuit is reddish brown, the general effect is somber. Although called e karatsu that is, Karatsu wares with designs, the decoration is very scant, the designs drawn in brown or black pigment under the glaze are so sketchy as to defy exact definition, the same design is sometimes said to be bunches of grapes, or again wisteria flowers; other less complicated designs of a few quick brush strokes are defined as grass waving in the wind, reeds standing in water or rice plants heavy with grain. This method of decoration, using iron pigment, is known as "*richo tetsu sa*" because it was used in Korea during the Ri dynasty. E karatsu also included wares on which the design was incised and filled in with white or black producing an effect of inlay.

The cha jin Oribe lived and worked at Karatsu on two different occasions for six months in 1587 and again for almost two years about 1593. Under his influence beautiful glazes were developed, blue, yellow all shades of brown and black as well as many shades of so called "white" glaze.

A ware now called *horidashi karatsu* or "excavated Karatsu" was made during the period 1624-1716. These wares were evidently regarded as failures at the time of making and were discarded. Later they became greatly liked by the cha jin.

About 1854-59 the feudal lord Ogasawara made what is known as *kenjo karatsu* that is Presentation wares. These were intended for friends of Lord Ogasawara as presents and were never offered for sale. They were most carefully potted and fired, of a fine yellowish or brownish clay with a crackled transparent glaze and were decorated in the Mishima style with white inlaid designs of clouds and cranes (*unkaku*). This is also known as "*haku mon*" or white pattern wares.

In the nineteenth century also, Karatsu wares were imitated at the Banko kilns at Ise. These are distinguishable from the parent wares only by the potters' marks on them.

In any discussion of Japanese ceramics it is impossible to avoid the word imitation although that word has unpleasant connotations. The fact that at different times and in many places wares were copied (or imitated) with the deliberate intention to deceive and thereby profit by the deceit must not be ignored but in most cases there was no such intention. In the beginning of pottery making in Japan all such knowledge came from China so we may say the Japanese "imitated" Chinese ceramics, just as today they are imitating all forms of Western culture and civilization. As time went on and a purely Japanese form of pottery was developed individual potters imitated the Japanese pioneers in this line. It is the present writer's contention that "imitated Chinese wares" should be replaced by "made under the influence of Chinese wares" in some cases and in others by "duplicated"; as for instance in the productions of the Banko kilns and the many Ninsei copies. It is a peculiarily Japanese trait to first copy exactly anything they admire and after they have mastered the knowledge of making the imported thing to change it and "Japanize" it; or in the case of Japanese things to exactly duplicate the object and then to develop some individualistic feature which marks it off from the original. This point, so confusing to the Western student, causes the Japanese connoisseur no difficulty because he is accustomed to look for the individual touch.

PLATE XI

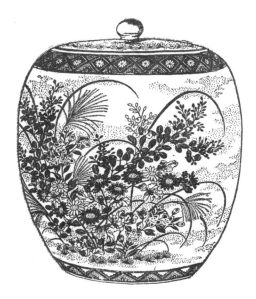

Covered Jar of Satsuma Ware

A good specimen of modern Satsuma ware called nishikide Satsuma featuring the seven flowers of autumn. Actually only four are shown; a small chrysanthemum, a kind of blue bell, bush clover and a kind of pampus grass.

The general effect is quiet and elegant; the cream coloured background with cloud-forms of gold dust set off the jewel-like colours. Seven of the chrysanthemums, parts of the bush clover, and the borders are developed in a soft red quite unlike the Imari or Kutani reds. The green of the leaves is a jade-like green, shading off into blue. White enamel is used sparingly in the flowers of the bush clover and chrysanthemums, while the blue-bell blossoms are not blue but purple of a soft violet shade.

This is a *mizu sashi* or water jar used for cha no yu; rather unusual and reflecting the spirit of protest against the subdued beauty of the cha no yu pottery which was rampant in some circles at the end of the Tokugawa Period.

Satsuma Ornament for the Tokonoma.

Satsuma

The term Satsuma to a Japanese includes all the various ceramic productions of Satsuma Province. There are more than fifty-six kilns, most of which are located in and around Nayeshirogawa where the first Korean potters settled. But Satsuma as used abroad has come to cover the wares of many different, totally unrelated, kilns.

The feudal lord Shimazu Yoshihiro on his return in 1598 from the attempted conquest of Korea, brought with him twenty-two Korean families whom he settled in Kagoshima and Kushikino, but in 1601 they all removed to Nayeshirogawa. One of these Korean potters, a man by the name of Hochu seems to have become a favourite of Yoshihiro who took him with him to his own castle town of Chosa in Ora-gun, Osumi Province and there set up a kiln to make things for use in cha no yu (*cha tsubo* and *cha ki*). The products of that kiln are now known as Old Chosa (*ko chosa*) or Old Satsuma (*ko satsuma*). Old Satsuma (*ko satsuma*) was not a refined ware, it was in fact rather coarse because too much influenced by the Korean models, and almost entirely Korean in type. Still it was well liked by cha jin. It was neither porcelain nor pottery, but a ware which the Japanese call *katade*. Later when

Yoshihiro went to Ryumonji he took Hochu with him. Hochu built a kiln at Tatsu no kuchi and became the originator of what is now known as Ryumonji wares (*ryumonji yaki*).

Bokuheii, another of the original Korean potters, built for himself a kiln at Ijuin about 1603. On the advice of Yoshihiro, Bokuheii went to Satsuma and studied with the potters there. About 1614 Bokuheii built another kiln at Nayeshirogawa where he had located good white clay materials, and the productions of this kiln were known as white Satsuma (*Satsuma haku ji*). During the last decade of the eighteenth century an artist by the name of Kimura Tangen was employed to paint designs on this white ware.

This white Satsuma has a close, hard, fine-grained paste with a very fine crackled glaze of soft ivory white and is decorated with soft enamel colours.

Satsuma wares were later influenced by Awata potters who came to Satsuma as early as 1648. But the influence was not reciprocal. Awata wares were always Japanese in feeling while Satsuma never quite got free of Korean influences. The glaze of the two wares takes the crackle somewhat differently. Awata wares have a fine almost perfectly round even crackle (the potters have a name for this style of crackle, " *rensen kanu* "), while Satsuma wares have a crackle small and fine, but a close inspection discloses a series of branched lines, making the crackle angular rather than round.

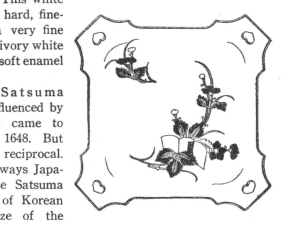

Satsuma *haku ji*, white Satsuma ware small dish, Kakiyemon decoration, about two hundred years old. All parts of the design except flowers and buds are outlined with very fine black lines. The entire colour scheme is very light and delicate ; the flowers are done in an orange-red opaque enamel which dominates the whole ; the book or scroll is washed in in a very pale lemon yellow ; leaves are turquoise blue and a very pale violet-blue, shaded not filled in entirely as is the scroll. The three smallest buds appear to have actual gold powder dusted on, a very good illustration of the purely Japanese use of gold, just enough to highlight and add richness to the design.

It was at the Chosa kilns that the Satsuma brocade style wares (*Satsuma nishikide*) were developed. It should be noted in passing that the provinces of Osumi (where Chosa is) and Satsuma were both under the feudal lords of the Shimazu family and that at the time now under discussion most of the

ceramic kilns of Japan were under the direct supervision of various feudal lords all over the country. The reader has perhaps noted that throughout the early history of Japanese ceramics it is the patron of the kiln, whether hereditary owner of the kiln or only an artist who approved of the products of the kiln, whose name is associated with the productions of that kiln rather than the potters who actually made the wares. It is not till much later that the individual potter received recognition and then first at Kyoto where they gathered in the vicinity of the Imperial Court and worked at their own small kilns, amateur rather than professional potters. Thus the productions of the kilns of Chosa, Nayeshirogawa, Tateno, Ryumonji, Sarayama and Hirasa are lumped under the term Satsuma because they were all in the domain of the feudal lord of Satsuma. The Chosa product known as Satsuma nishikide was decorated with enamel colours, a delicate iron red, a glossy blue, a bluish green, a soft purple, black, and a yellow very sparingly used, in light sketchy floral designs. This ware was perfected at the end of the eighteenth century by Kono Senyemon, working under the direction of the feudal lord, when he added gold to the above listed colours. They are known also as *iro satsuma* or coloured designs Satsuma.

Hirasa ware, *cha wan*, tea cup, about four inches deep, design of autumnal flowers. Pattern developed in dark red, violet blue, light green, flowers and border outlined in gold.

Old Satsuma incense burner in the Ninsei style.

In 1774, still at the direction of the feudal lord, a man named Ijichi Denyemon was sent to Arita and brought back an expert potter from there. Thus we see that at an early date Satsuma potters were cognizant of the newest techniques of the potters of many districts. The Satsuma kilns flourished until 1868 when the combined effects of a disastrous fire and the political turmoil of the Meiji Restoration reduced their output. For some years now they have been making coarse utensils to meet the local demand. In 1875 the official Satsuma clan kiln of Tanno ura re-organized as a modern industrial company.

Besides the white Satsuma (*haku ji*) and the nishikide wares the Satsuma kilns made a totally different type of pottery, a thick heavy pottery ware glazed with a thick black glaze, with over-glazes of brown or milky white, called black Satsuma (*kuro satsuma*) or white Satsuma (*shiro satsuma*) depending on the

predominance of the white or dark coloured glazes; and a third type called by the not very attractive name of serpent and scorpion glaze (*jakatsu yaki*). Jakatsu yaki was glazed with blue, yellow and black glazes run together and over these again white glaze, it had sort of grotesque beauty. These dark glazed wares reflect strong Korean influences. The kilns made also a copy or imitation of the Siamese Swankalok wares, a pottery decorated in geometrical designs in brown. Still another Satsuma ware is decorated with inlaid patterns following Korean models, called *Mishima Satsuma.*

A ware which is almost indistinguishable from Satsuma is *Hirasa yaki*, sometimes called *Sarayama yaki*, because the kiln was in Sarayama village of Hirasa District. Clay for this ware was brought from Odatoku-mura in Kagoshima. It is decorated in nishikide, the so-called brocade style.

What the Japanese call Satsuma yaki is quite different from the wares known abroad as atsuma. In fact this type of wares furnishes an excellent example of the difficulties experienced by the amateur student of Japanese ceramics. The ware most readily acknowledged as Satsuma by the Japanese has been described as "glazed in ferruginous brown and very dark green with brilliant splashings of black and golden brown and powdered-tea green"; "tea-leaf glaze of unctuous surface splashed with greenish brown"; "design lightly penciled in greenish brown glaze on brown crackled glaze" or "greyish brown clay, variable purplish brown, in places of aubergine hue, with overglazes of thin mirror-glaze of rich black and powdered-tea colour running down."

The ware with which the average European associates the name Satsuma is a light porous semi-porcelaneous pottery of a soft, crackled, golden cream colour decorated in enamel colours, mostly in floral designs. While admitting that such a ware was at one time made at Satsuma a Japanese would more likely designate it by some one of the dozen or more kilns at which such ware is now made, as Kobe, Kyoto or Tokyo.

Old Satsuma ware water vessel. Blue enamel wisteria blossoms with soft light green leav s on a creamy tan ground, the edges of the bucket and cross bar in the blue enamel of the blossoms. Design after the style of Ninsei.

A third kind, exported as Satsuma wares with raised designs of human figures, saints, warriors and geisha girls or with realistically molded dragons writhing all over the object are foisted upon the unsuspecting stranger to Japanese art as "typically Japanese." These wares the native connoisseur simply refuses to consider and dismisses them with a scorn-laden "Export wares."

In the first decade of the nineteen hundreds a ware called "blue and white Satsuma" was offered for export. It consisted of under-the-glaze blue decoration on large incense burners and ornamental bowls. The glaze is very grey, very finely and beautifully crackled and the designs confined almost entirely to Chinese landscapes and large peony blossoms executed in minute detail.

Hayata Takemoto

Of the many kilns that made Satsuma style wares one deserves particular mention. The story of its founder is typical of the early Meiji Period.

Hayata Takemoto, born 1848 died 1892, was the son of a *hatamoto,* that is "flag bearer" loyal to the Tokugawa Shogunate. His father became Minister of Foreign Affairs and Takemoto himself took part in the war between the Imperial and Shogunate forces in Choshu. On his return to Tokyo he was obliged to remain in hiding for some time. When Emperor Meiji came to the throne and in the first flush of enthusiasm over export business Takemoto in co-operation with a man named Ryokichi who had been a potter at Seto established a kiln at Takada Toyokawa-cho and began the manufacture of Satsuma style articles. For some time the venture was not a monetary success and they were forced to make crude earthenware pipes and even bricks for which there was a local demand.

However, about 1873 their luck turned for in that year they received a prize for a Satsuma style incense burner at the International Industrial Exposition at Vienna in 1873. From then on they continued to improve the quality of their productions. Their wares, though not conforming to strict Japanese taste met with approval abroad.

Hagi Wares

Hagi yaki, a thick but fine grained pottery with a thin yellowish-white or bluish-pink glaze with large fine

crackles originated in the Province of Nagato in the town of Hagi. It was developed out of a Korean ware called *Ido yaki* by a Korean potter named Rikei who accompanied the feudal lord Mori Terumoto when he returned from the Korean expedition. Rikei became a naturalized Japanese and took the name of Koraizayemon. He made wares with pink cloud-like formations on a grey glaze, also the Korean *hake me*, a form of decoration which has always appealed to the Japanese, swift wide brush strokes, clearly showing the beginning and the end of the strokes. For these Koraizayemon used grey, pale green and later a lavender-blue glaze. His wares are known as Old Hagi (*ko hagi*). *E hagi* or decorated Hagi has very sketchy floral designs in iron pigment under the glaze.

Koraizayemon's family has continued as potters for eleven generations. A pupil of his, Kurasaki Gombei, developed *oni yaki* or diabolical glazed wares so-called because it was thought only a demon could produce such beauty. This Gombei was invited to Rakuzan, a suburb of Matsuye in Izumo by Lord Matsudaira Tsunataka about 1675 where he built kilns and made pottery resembling what he had learned to produce at Hagi. The productions of these Rakuzan kilns ceased for a time, but later Lord Matsudaira Fumai, whose name is so well known to tea-cult enthusiasts, reopened them and set Tsuchiya Genshiro and Nagaoka Sumiyemon to making pottery for cha no yu. A distinctive feature of Hagi wares is the spatula cuts and gouges to give irregularity to wheel thrown bowls and vases. Hagi bowls have a rather high footrim which is slashed in one place forming a Λ shaped opening.

Shortly before 1780, Tsuchiya Genshiro, under the patronage of Lord Fumai, revived the Fujina kilns at Fujina in Izumo. These kilns had been established by Funaki Yohei in 1764, but they had produced nothing noteworthy until under the direction of Genshiro. Here in the years immediately preceeding 1780 a quantity of very fine pottery was produced.

In 1816 Lord Fumai established Genshiro at Osaki in Tokyo where he made tea utensils.

Celadons
Forerunners of Porcelain

Celadons

The Japanese call these wares "*seiji*"; "sei" meaning a bluish-green and "ji" (porcelain). "Sei" or "aoi" is used to designate either blue or green and neither the Chinese nor the Japanese seem to feel the need of any more definite term. However, it is easy to remember the Japanese name because of its similarity to our English word "sage" or sage-colour, which exactly describes the colour of some of these wares.

The word Celadon is used in two different ways. Some authorities call any one-colour glaze a celadon but the usually accepted definition is an all over glaze of some shade of green. The word itself is said to have been applied to a certain type of green glazed ceramics because the time they made their first appearance in France was coincident with a very popular play in which the hero, Celadon, wore this peculiar shade of green.

The outstanding feature of celadon wares is the thick, opaque, soft-looking almost wax-like glaze which appears to be a part of the ware, not just an applied surface. Celadons originated in China but the potters of both Korea and Japan attempted to copy them. Speaking in general terms, Chinese celadons range in colour from dull sage-green to a beautiful green which is almost robin's egg blue; Korean celadons are frequently a dull greyish-white, or brownish-grey but they also produced a lovely blue-green; Japanese seiji are more nearly a true green of a very light shade with a slight bluish tint. The Japanese celedons are too perfect, they lack the rugged strength and sturdiness of either the Korean or Chinese; their glazes are glassy and hard looking, not soft and waxy and they are too evenly distributed over the article. Chinese celadons are by far the most beautiful, they are never shiny

but they have a soft dull glow which the glazes of Korea and Japan do not have.

Chinese celadons which made their appearance during the Sung Period (960–1279) are of many shades of green, from olive-green, grass-green, through sea-green and blue-green to grey-green. The shapes are massive, the walls of the article quite thick, and the designs usually strongly drawn floral arabesque, or lotus flowers; or fish in pairs are executed in relief, stamped or engraved on the biscuit before the glaze is applied. Frequently the article is glazed more than once and this results in a wax-like undulating surface pleasing to the eye and to the touch. Some Oriental connoisseurs maintain that the elusive beauty of old celadon is due to the gradual chipping away of the outer layer of glaze. Chinese celadons may have a very large crackle, especially those of the late Ming dynasty (1368–1644), but many show no signs of any crackle.

Korean celadons usually are decorated with white or black (or both) incised designs under the glaze which is harder looking than the Chinese and is very often crackled. Japanese seiji has a thin-looking glaze, inclined to be a bit shiny, but of a pleasing, blue-green colour and decorated mostly by embossed designs under the glaze, never crackled. It must be remembered that each of the three countries frequently copied the wares of the other two. Ordinary thin glassy glazes, no matter what shade of green, are not called celadon or seiji. The Japanese make a ware covered with a very thick opaque greenish grey glaze with large crackles, this is not called celadon but "crackled wares" (*hibi yaki*).

One shade of Chinese seiji is known as "*kinuta*" because the first piece of that colour to come to Japan was a vase in the shape of a "kinuta" (a kind of wooden mallet used by Koreans to finish or iron their linen garments).

No two pieces of celadon are ever of exactly the same shade of green. Perhaps it would be easier to say what shade of green is not called celadon. Bottle-green, peacock greens or grass greens are not within the scope of celadon.

There is a kind of celadon which is much liked by both the Japanese and Chinese. In Japan it is called *tobi seiji* or buckwheat-celadon because of brownish-red spots which appear during the firing of a piece, due to an excess of iron in the biscuit. These seem at first to have been accidental but modern Japanese potters produce them at will and govern both size and shape of the spots.

Celadon wares occupy a very high position in the estimation of all Orientals. The earliest celadons were considered

mysterious and almost supernatural. First known during the Sung dynasty these wares found their way all over the world and were imitated in India, Persia and Egypt as well as Siam, Korea and Japan and later in Europe. To this day there are natives of Borneo who treasure old pieces of Chinese celadons as a charm against sickness or misfortune in the home. They believe these wares were made out of the same clay which the Creator used in making the sun and the moon.

In Europe it was believed that celadons would turn colour on being brought into contact with any poison. The first pieces known to Europe were considered very valuable and were owned by kings and queens. There is a bowl in the royal collection at Cassel which dates from 1435. It is mounted in a Gothic silver mounting. In England the "Warham Bowl" was bequeathed to New College, Oxford, in 1530 by Archbishop Warham.

The first Chinese celadons were imitations of bronze vessels for ritual uses and are therefore severe in shape and generally heavy in feeling. In ancient China bronze was used for the various utensils necessary for the religious ritual of that time. Later jade was laboriously carved into imitations of the bronzes. But jade was difficult to procure and only the very wealthy could afford utensils of this precious material. It is thought that the first celadon-glaze pottery pieces were an attempt to copy these jade utensils.

Yellow Seto (*ki seto*) developed out of the Japanese potters' first attempts to produce true celadons. But these potters were unskilled and the beautiful celadon green eluded them. Unless one understands the transmutations produced in glazes in the firing it is difficult to realize the relationship between the thin glassy glaze of Yellow Seto (ki seto) with its green and brown and yellow colours and the soft thick jade-coloured and jade-like celadon wares of China. Later the Japanese learned how to produce true celadon glazes but they have never been as fond of these wares as the Chinese are. Good celadon wares were produced at Arita, Okawachi, Kyoto, Sanda and Himeji.

Crackled Wares

While we have just stated that in general Chinese celadons are both plain and crackled, Korean celadons are mostly crackled, and Japanese celadons uncrackled, there are many exceptions to this rule.

Crackles are produced in glazes by a deliberate selection of foundation biscuit and glazes which contract differently

when subjected to a given temperature. At one time it was thought in Europe that crackle was produced by plunging the article into cold water, but it is known differently now.

Oriental potters are exceedingly skillful at the manipulation of crackle effects, they can control not only the size of the cracks but the shape of same : Chinese potters often produced two or more kinds of crackle on one article. In China it was a common practice to rub colour into the cracks. If a piece of celadon is carefully examined it will be seen that there are first large strong and dark coloured crackles, produced by the heat of the kiln ; between them again is a fine net-work of tiny cracks which develop in the course of years. In old Chinese celadons, three or four centuries old, this process has continued until the entire outer surface of the glaze has chipped off, leaving a soft satiny texture indescribably beautiful.

The Chinese have given names to two forms of crackle found most often on celadons.

1. Crabs claw crackle ; which has long branching crackles, like branching twigs and the cracks are thin and deep, formed by fissures or breaks in the glaze.

2. Earth worm crackle ; this form has long cracks also but the cracks curve and wind about and while they are not at all parallel they do not branch out as the crabs claw crackle does. The cracks themselves are wider and appear to have been made by the glaze pulling apart in the baking process.

Typical crackle patterns.
Top ;—found on Chinese celadons.
Left ; —Satsuma.
Right ;—Awata.

In Japan the best celadons are not crackled, but Japanese potters are exceedingly skillful in the manipulation of this form of decoration on other wares. They prefer a small round crackle with no decided heavy cracks. The artist-potter Ninsei produced a fine crackle distinctly characteristic, tiny round forms as regular and as even as a bee-comb.

The crackle of Awata and Satsuma wares are much alike but the Awata crackle has long branching lines and the crackled surface forms, though small, are angular and irregular in size and shape. The crackle of

the Satsuma wares constitutes their chief claim to beauty. The glaze on both the Awata wares and the Satsuma wares is thin and glassy if compared with a celadon glaze but the fine crackle breakes the surface into thousands of tiny planes and produces a soft effect. Satsuma crackle is not as fine as that of Ninsei, but like Ninsei it is round and even and without long branching cracks.

Some old long established kilns are still producing a crackle ware, called hibi yaki, in crude thick shapes and of a dark unattractive thick glassy glaze. The crackle is large and deep and artificially coloured or blackened.

Modern potters are today producing an attractive ware in shapes suitable for daily use. The glaze is glassy, a grey with a strong admixture of blue, which tends to settle thickly in the bottom of the article. The crackle occurs where the glaze is thickest and the effect is strangely beautiful, like thin shattered ice over blue water.

During the first quarter of the nineteenth century there was a fad for imitating a crackled background for coloured designs on white reserves by sketching in under-the-glaze blue an exaggerated approximation of the Awata crackle.

Sanda Yaki

The celadons produced at Sanda are considered the best of the Japanese celadons, and they compare favourably with those of China. The kilns were established about 1788 by a potter named Kanda Sobei at Minowa-mura in Settsu. At first this potter made sometsuke, under-glaze blue and white, and employed potters from Arita for this. In 1801 he found a local stone suitable for making celadon glazes and called a pupil of the great Eisen, named Kamesuke, to produce them for him.

Very common design on both Chinese and Japanese ceramics. Just what meant to be represented is uncertain, perhaps stylized clouds; or it may be *jooi* heads.

One Colour Wares

The Japanese do not seem to be particularly fond of one colour porcelains or glazed pottery. With the exception of the blue-green true celadon porcelain which they use for small bowls and cake dishes, incense burners and figure ornaments for the tokonoma; and coarse white porcelain flower vases and incense burners for funeral furniture, they practically never make articles of one unbroken, unmottled colour. Of course it must be kept in mind that for their own pleasure the Japanese use very little true (European) porcelain; they prefer soft, sturdy-looking semi-porcelain or glazed pottery. When they make a one-colour glazed article the colour will always be unevenly distributed, dark where the glaze settles thickest, shading off into a lighter colour where the glaze is thinnest. Even their cheapest, most commonplace, earthen wares or crockery utensils will have a dab of lighter or darker glaze to produce a variation of the basic colour.

Among the single-colour ceramics made for the Japanese themselves may be mentioned :—

Flower vases, flower pots and hibachi with a green glaze resembling true celadon, made at many kilns all over Japan; the same with a beautiful dark blue, hard, thick-looking glaze resembling Sung Chinese wares, made at Kyoto.

Low stands, or slabs, called "dai" in Japanese in semi-porcelain with a dark purplish-blue glaze, produced only at Hirado.

Tokonoma ornaments of human figures (Chinese sages, the Seven Gods of Good Luck); animals and birds of good omen such as the Chinese lion, the crane, etc.; and fruits such as the peach of immortality, the pomegranate, etc. while most often produced in celadon are sometimes made with brown, dark bluish-green or tanish white glaze, chiefly at Bizen.

And it must not be forgotten that, at some time or other, some individual Japanese potter has exactly reproduced the ceramic wares of any and all countries in the world, ancient and modern, European and Oriental, for his own individual satisfaction; while other potters have gone into mass production of downright imitations of salable articles for sale to the unwary tourist and collector. It may perhaps be well to note here that today great quantities of Chinese ceramics are being sold in the shops, presumably as Japanese wares.

Imari Kilns
and Potters

PLATE XII

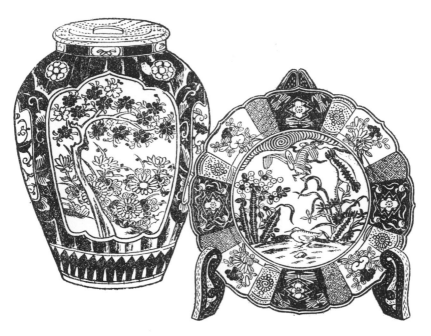

Old Japan Wares

The vase belongs to the earliest period of Imari wares and has but two colours, dark indigo blue under the glaze and a very thin red enamel colour; originally there must have been considerable gold but it has worn off except in a few places. Design is typical of the earliest pieces, purely Japanese. The plate is representative of the next step in the development of early Imari wares. The design is interesting as showing the emergence of Japanese motives. The fan shaped medallions on the rim at the top and bottom of the plate could only be Japanese because they feature "noshi," a Japanese symbol for a gift, the other designs show a Japanese interpretation of Chinese motives.

For many years this type of porcelains was thought by the rest of the world to be representative of Japanese ceramic art but it is now known that this is not the case. Articles such as these were made by the hundreds for export but were never used by the Japanese themselves. They are attractive to the eye and their beauty is attained with the utmost economy of colours. Under-glaze blue of a purplish hue, bright orange-red over-glaze with a very sparing use of gold on a white background are the only colours used on the vase but the general appearance is rich. The plate has a third colour, bright turquoise green. Its design belongs to no recognizable tradition. The great bird, hovering in the air above what appears intended to be its mate but which looks more like a barn-yard duck, seems to be a cross between a crane and a dragon and no botanist could name the flowers. For another treatment of this design see Imari Some-Nishikide full page illustration.

History of Imari Kilns

Imari ware, *Imari yaki*, is the generic term for the ceramic productions of North Kyushu and includes the wares of several unnamed kilns as well as the better known Arita, Nabeshima, Okochi, Mikawaguchi, Hirado, etc. This name came into use because Imari was not only the center of ceramic production in North Kyushu but it was also the only port of export for almost two hundred years. Imari has given its name to a great class of ceramics. Under the strict laws of the Tokugawa Shogunate foreign merchants were barred from all Japanese ports except that of Nagasaki and even there only very few ships a year were allowed, with the result that trade out of all other ports, including Imari, was smuggled.

North Kyushu is that part of Japan nearest to China and has been in constant contact with Korea and China for centuries. It was here that the beautiful ceramic wares of the Ming and Ching dynasties of China entered Japan. Imari wares were directly influenced by the wares of the latter part of the Ming dynasty (1368–1661) and the most prosperous and flourishing era of the Ching dynasty (1662–1795). This new influence entered a field fully prepared for it because Japan had already learned to make glazed pottery through the instruction of Korean potters. As early as 794 there is a record of the making of glazed tiles and many Korean potters are known to have made their homes in Japan. In 1598, at the collapse of Hideyoshi's attempt to invade Korea, hundreds of Korean potters were brought to Japan, many of whom settled in Kyushu and built kilns.

At first they did not produce white glazed porcelains. At one time it was thought that the porcelains of Old Imari (*ko imari*), Coloured Nabeshima (*iro nabeshima*) and the beautiful Kakiyemon decora-

Old Imari Small Dish

Small Imari dish of early nineteenth century. The shape imitates a folded square of red backed white paper, one of the folds decorated with a red geometrical diaper, the inner fold with green and yellow squares. The leaves of the flowers are rather elaborately shaded with enamel colours including grass green, turquoise blue, delft blue and purplish-brown. The blossoms are developed in solid red, red and white, red and very thin muddy yellow enamel colours with one in gold paint. The blossoms are outlined in red, the leaves in black.

The back of the dish has the usual *Tai Ming Sei Kwa Nen Sei* in under-the-glaze blue; the Kaga potters adaptation of the Nabeshima comb design on the footrim and three single flower centered arabesque motives. This was probably made in Imari but decorated by Kutani potters, a frequent practice.

tion appeared overnight, but it is known differently now. Recent excavations in and around Arita reveal an amazing story. Fifty or sixty years passed before the Korean potters succeeded in making a true porcelain. In many cases it was the second generation who made any progress and contrary to the general supposition, they did attempt to produce celadon wares. The excavations at Uchida and Kuromuda, nine miles north-west of Arita, where a white glaze porcelain was produced from local clays before any were produced at Arita, show that great efforts were made to develop attractive patterns for decoration. They reveal also many failures, unsuccessful glazes, mis-shapes due to too low heat in the firing and other kiln troubles. The patterns for decoration varied from Chinese ink drawings to geometric designs. Fujiwara and Tempyo styles entered showing the steady development of Japanese art taste, which flowered in the wares of Kakiyemon, Old Imari and Coloured Nabeshima.

The products of the Imari kilns may be divided into five classes:

1. Under-the-glaze Blue and White (*sometsuke*).
2. Three Colour Imari (*sansai*) or Old Japan.
3. Five Colour Imari (*gosai*) or Brocade-like Pattern Imari (*nishikide*).
4. Kakiyemon Imari.
5. Imari kinrande, designs in gold on a red enamel ground.

Pure Chinese design copied with very little modification by Japanese potters. Known to European students of Chinese ceramics as the Rock of Ages pattern it. represents highly stylized mountains and several forms of stylized waves. On Japanese ceramics it is frequently used as a band decoration on the outside of an article, sometimes as a part of the main design on vases, etc. Mostly in blue and white.

PLATE XIII

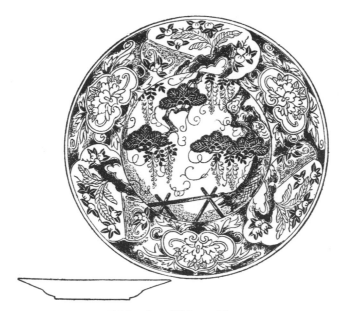

Old Imari or Old Japan Plate

A ten-inch, deep plate with wide rim of the earliest period of Imari wares.

The glaze is of poor quality, pitted and grey. The under-the-glaze blue is applied very unevenly and shows the form of decoration typical of the earliest pieces, the blue is spread on in solid masses and the design developed in gold paint on the surface. The rim of the plate is blue with three large and three smaller reserves in white which are in turn decorated with red enamel colour with a very free use of gold paint.

The design is entirely Japanese though the three smaller medallions show Chinese influence. The center design shows the Japanese version of "clinging vine and sturdy oak" a conventionalized pine tree with an equally conventionalized wisteria vine. The pine tree is blue, the wisteria red, the tendrils of the vine are done in gold and red.

The large asymmetrical medallions show seven *tachibana* fruits— a kind of orange—and three leaves of the banana palm growing out of a rock. The tachibana leaves and the banana leaves are developed in red, the oranges are filled in solid with gold and the banana leaves are heavily gilded.

This plate was undoubtedly made for export.

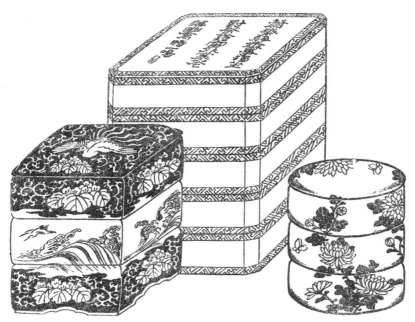

Ju bako, tiered-boxes or sometimes *bento bako,* lunch boxes. Only the poorer classes of people use ceramic jubako, they are usually of lacquered wood. These are used only at New Year to hold the various choice tidbits of food prepared for guests because no food is freshly cooked on New Year's day, the one day on which all Japanese rest and rejoice.

Under-the-glaze Blue and White

These wares have a quiet beauty and do not appeal immediately to everyone. But for one who loves blue they are a never ending joy. The blue, which is produced by some form of cobalt or indigo pigment painted directly unto the biscuit after which the entire object is glazed, varies greatly in hue. It may be a soft, light coloured grey-blue; a strong blue showing quite black where the pigment has settled with an overall tint of purple blue; or a beautiful vibrating sapphire blue clear and transparent looking. This last shade of blue is found more often in the Ming blue and white but the blue of some Hirado or Nabeshima wares approaches it closely.

In Japanese these wares are called *sometsuke mono* that is, dyed wares, for the ordinary wares. When they wish to express admiration for the shade of blue they use the term *seikwa* or blue-flower blue. *Gosu* is used to distinguish Chinese Ming or Ming-style blue and white.

— 93 —

Under-glaze blue designs are about the same as those found on all types of Japanese ceramics:—Floral patterns, geometrical designs, human figures, fabulous animals, birds, fish, with perhaps more landscapes than are found on the polychrome wares. Under-glaze blue decoration is often used in combination with the over-glaze enamel colours of the other types of Imari and Kutani decoration.

Three Colour Imari Wares

This class must be subdivided into two kinds: 1. Under-glaze blue with over-glaze red on a white ground. 2. Over-glaze red and green enamels on a white ground.

The first group includes the ware known abroad as Old Japan or Old Imari. It has a dull purplish under-glaze blue with an orange red enamel glaze on a white ground, picked out with more or less gold paint. The designs are mostly floral with the surface of the article well covered. A feature of this ware is the frequent use of the cherry blossom and basket of flowers. The general effect of this type of Imari ware is rich and attractive despite the fewness of its colours and the inaccuracy of its designs.

The second and much smaller group is a direct copy of the *gosu akaye* of China. Sparce bold designs are brushed unto a white ground glaze in red and green enamel colours. The designs are limited to flowers, birds and fishes with, occasionally, roughly drawn human figures.

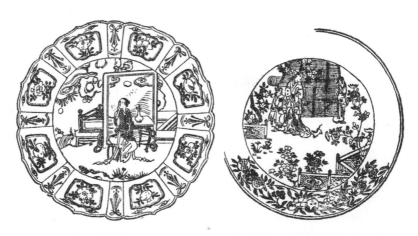

On the left; a typical Chinese plate featuring a female figure in an architectural setting. Note the paneled border.
On the right; Japanese rendering of the same idea.

PLATE XIV

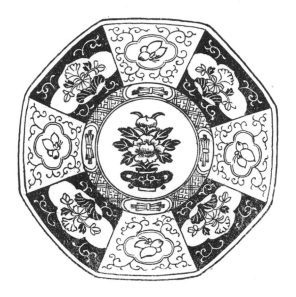

Old Imari *Nishikide*

Early Imari dish about six inches in diameter. The upturned edge of the dish has four red and four under-the-glaze blue panels ; on the blue panels a white reserve with lotus flowers in very nondescript poor purple with touches of pale yellow, buds red and leaves a turquoise blue-green. The under-the-glaze blue panels have reserves of white with turquoise and yellow butterflies outlined in red. Scroll pattern on both blue and red panels in gold paint, the edge of the dish is gilded also.

Center design, a red flower and one bud with under-the-glaze blue flower basket and leaves, is known as the *hana kago* or flower basket design, much used on the earliest pieces.

The rather wide border around the central design is in under-the-glaze blue with insets (or reserves) of white with a red bowknot-like design touched with turquoise colour. These bow-like objects represent the Japanese noshi—a few thin strips of dried *awabi* meat tied into a bundle, which must accompany any gift.

The glaze is soft and thick looking but of a bluish white, badly speckled with grey on the back evidently the result of faulty kiln firing.

The back of the dish is decorated with three floral sprays in under-the-glaze blue and red, two of camellia flowers and one of plum blossoms. Inside the *kodai* or footrim is a broad band of unglazed biscuit with a glazed and blue-ringed circular spot an inch and a quarter in diameter.

Five Colour Imari and Brocade Imari

Although there is some little difference in the designs used on these two types of Imari the colours are the same. Named in the order of development, they are:

Under-glaze blue; usually a clear dark transparent blue, but at times of a decidedly purple cast and muddy looking.

Red enamel or glaze; in the older pieces a bright clear orange-red; at times an opaque orange-red, quite distinctive, known as " Imari red."

Gold paint mixed with a kind of glue.

Green enamel or glaze; a clear light blue-green, turquoise colour, usually transparent sometimes opaque.

Black enamel or glaze; a shiny opaque black which seems to wear or chip off easily.

Yellow enamel or glaze; a thin semi-opaque dirty yellow often a mere wash on the surface glaze.

Purple enamel or glaze; a thin semi-opaque lavender colour, sometimes verging into brown.

Blue enamel or glaze; sometimes in the oldest pieces a brilliant transparent sapphire blue, usually a dark opaque purplish-blue, again a beautiful violet blue much used by the potter-artist Kakiyemon.

A characteristic of the green, yellow and purple glazes on the oldest pieces is that the outline of the design is clearly discernible, drawn in cobalt blue under the glaze.

Brocade Imari (*Nishikide Imari*)

The style of decoration of these brocade wares is copied from the five coloured polychrome wares of late Ming and early Ching dynasties of China.

At first the designs were almost entirely adaptations of Chinese patterns. It was not until quite late that purely Japanese designs developed. But it cannot be too often emphasized that although the designs on Japanese ceramics are Chinese in origin, Japanese potters have invariably given them a

distinctly Japanese twist. The necklace and red ball designs on Imari wares are distortions of Ming designs and even the simple Chinese hermit, Kinko, riding through the waves on the back of a carp is different from its Chinese prototype. Dutch men and Dutch ships are often pictured on Imari porcelains. An important characteristic is that the entire surface of the object is covered with the design, practically none of the ground glaze is visible. It is for this reason, because the design so closely covers the whole surface, that these wares are called "Brocade," not because as has been erroneously stated they were copied from actual brocades. The Japanese refer to the autumn tints on the mountains as brocades, and any mass of brilliant colours is called " brocade." The Brocade Imari wares were in turn copied by the Chinese in China and sent to Europe in competition with the Japanese product, where they were known as Chinese Imari.

Five Coloured Imari (*Gosai Imari*)

These wares are much like the Brocade Imari but the designs are less complicated and more of the ground glaze is exposed. While these Five Coloured wares did not seem to be as popular abroad as the Brocade wares, they found a ready market at home in Japan.

The designs on the Five Coloured Imari are based on Chinese models but they show a decided Japanese tendency. Floral patterns are most in evidence and human figures seldom appear. Certain typically Japanese renderings of Chinese motives appear in these wares, such as the highly stylized " sho chiku bai " combination of pine, plum and bamboo and the Japanese hoo, the sacred " Feng " of China. The attributes of the Seven Gods of Good Luck (*shichi fuku jin*) and the treasures carried on the Japanese Ship of Good Fortune (*takara bune*) and other purely Japanese motives replace the Buddhist and Taoist symbols of Chinese porcelains. The basket of flowers featured on Chinese porcelains takes on a Japanese form and is used as a decorative motive for the center of bowls or plates. Chinese ceramic designs show a much greater use of architecture and interiors than do the Japanese.

PLATE XV

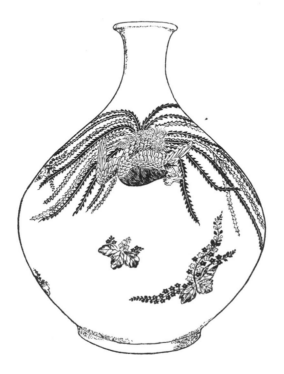

An excellent example of Kakiyemon ware, date
uncertain. The design a highly stylized *hoo* bird with
two *kiri no mon*, or Imperial crests formed of the leaves
and flowers of the paulownia tree.

Colours: The bird's head, breast and curly tail
feathers are red, the body and wings a dark purple, the
long tail feathers alternately red, green and purple
with yellow mid-ribs. One crest, green leaves with long
curving red blossoms; the other and more usual form
has leaves of blue with red flowers.

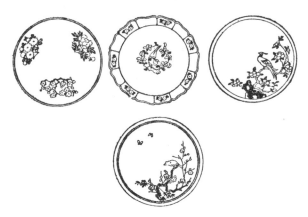

Showing typical Kakiyemon patterns of flowers, or flowers and birds and butterflies.

Kakiyemon Imari

About 1646 a Japanese potter, Sakaida Kakiyemon, working with other Japanese potters under Chinese teachers, succeeded in producing the first true porcelain decorated in enamel colours. Kakiyemon, his pupils and his descendants worked at many kilns in Japan and it is the style of decoration which he originated, which gives a ware his name, not the kiln at which it was produced. In judging or identifying a piece of porcelain a dealer will say first that it is Kakiyemon ware and later casually mention the kiln at which it was produced. The matter is further complicated by the fact that wares decorated in his style even today are called Kakiyemon wares, though Kakiyemon himself lived and worked just three hundred years ago; and again today certain of his supposed descendants are producing beautiful pieces.

Kakiyemon's designs departed sharply from the usual crowded brocade patterns of his day, which covered the whole surface of the piece to be decorated. He introduced a new method of decoration. Instead of covering and thereby hiding the surface glaze his designs drew attention to its beauty and texture. He seems to have preferred a thin hard compact porcelain with a pure white glaze that resembled the white of a hard boiled egg and is spoken of as "*nigoshide.*" While he worked mostly on small wares, bowls, cups, and the numberless small plates and dishes used in the homes of the Japanese, he showed no special preference for any one shape or object. It is doubtful though that Kakiyemon himself ever decorated a vase, such as we today call a flower vase

because in his day such things were not used by the Japanese people.

He was the first Japanese potter of ability to produce purely Japanese designs. His designs are easily recognizable as they are painted in clear rich enamel colours with a palatte of red, green, yellow and purple-blue and he often edged his pieces with a reddish-brown (*beni ye*). He also used under-glaze blue in combination with these enamel colours. He never decorated more than one third to one half of the surface of an article. He seldom used borders and practically never used a repeat or geometrical pattern. It can be said of him that he was the first to paint pictures on porcelain, not just decorate porcelain.

He took his designs from Chinese art but he was influenced by the Kano school of Japanese art. He never used figures of humans, and very seldom animals, the one exception was the lion-dog of China (*kara shishi*).

Imari Kinrande

Some kilns of Imari also turned out a kind of kinrande closely resembling the Eiraku wares of Kutani. However the red is the typical Imari red, quite different from the Kutani red and the designs in gold are the usual Imari stylized floral patterns not the meander used at Kutani. The sometsuke designs of Imari kinrande are landscapes whereas Eiraku made frequent use of the dragon in clouds.

One of the chief attractions of Imari porcelains, which they share with all other pottery and porcelain in Japan is that no two pieces are ever exactly alike. At first glance they may appear to be all the same but a close inspection will reveal minute variations in form or colour. And, strange to say, it is these slight imperfections in glaze or drawing or form that produce an individuality and charm that grows upon one.

It should be noted that Imari wares were often put to the most common uses and they include bottles for holding large quantities of *shoyu*, oil or *sake*, bowls for the storage of food and the large round plates used in public inns and restaurants. The paste or biscuit of Imari wares is comparatively heavy, most articles are thick and a bit coarse, those of large size are very heavy. Imari wares have never held a high place in the estimation of the Japanese themselves. Yet it was the wares of Imari and the designs of Kakiyemon that made so great a contribution to the ceramic art of Europe and the New World.

PLATE XVI

Imari *Some-Nishikide*
or
Brocade Style Under-the-Glaze Blue Plate

This plate, about eight inches in diameter, is an exceptionally beautiful example of Old Imari, obviously a close copy of a Chinese original. The colours are bright and clear and the design brushed on with the strong sure strokes of a master brush. Of the twelve diaper panels on the upturned edge of the plate no two are alike, six have geometric patterns and six floral. The flowers, plum blossoms, are in reserve on an under-the-glaze blue ground with red pistils and stamens. The geometric patterns are developed in red, green and yellow enamel on the glaze.

The central design shows two Chinese pheasants, one on a rock, flanked on one side by a spray of lotus blossoms and on the other by plum blossoms. Much of this design is done in under-the-glaze indigo blue of an exceptionally clear brilliant tone, the general shape of the rock, the ground, stems and some of the leaves of the flower sprays are in this blue. The birds are developed in red and green with touches of purple and yellow enamel colours. Flowers are all done in red with yellow, while the rock gathers to itself all the colours used and ties the composition into a most harmonious, pleasing whole. Two shades of green or rather, grass green and turquoise blue, are used and some of the leaves are outlined in black.

The dish itself is thin but heavy and has the sharp edges usually found on Chinese wares and signs of having been thrown on a wheel are clearly evident. The edge has been turned up by hand and pinched into shape with the fingers. The wavy effect of the upturned edge has been increased by the decorative design. The rather deep footrim has been formed separately and luted on by the thick bluish white glaze. The back of the plate while still in the biscuit state has been engraved with flower and butterfly groups, and then glazed, what the Chinese call "*an hua*" or secret ornament. In the center in under-the-glaze blue are six Chinese characters which read *Tai Ming Sei Kwa Nen Sei* in Japanese, meaning in English "Made in the reign of Emperor *Ch'eng Hua* of the Great Ming Dynasty" (1465-1487). The actual age of the plate is perhaps two hundred years.

Imari wares may not reach the highest aesthetic standards but they possess a special beauty of their own and their brilliant and rich colours found, and still find, many admirers abroad. Old Japan, Brocade Imari and Kakiyemon Imari have become known all over Europe and their influence is still recognizable in the wares produced there today.

Of the various wares produced in the Imari kilns those that are best known abroad, Old Japan and some of the brocade Imari, are practically unknown in Japan and certainly they are not considered artistic. Wares decorated in the style of Kakiyemon are considered first class and pieces that perhaps may have been decorated by Kakiyemon himself or by his immediate successors are beyond price. Ranking next to Kakiyemon designs, blue and white (sometsuke) wares are valued by the Japanese and authentic old pieces are very valuable. The intermediate wares which we have classified as Five Colour and Three Colour are not considered particularly artistic but are in very common use. Old pieces among them bring high prices because of their historical value, not as works of art. Before the Second World War Imari porcelains were unbelievably cheap, a few *sen* would buy a beautiful bowl or dish, and even the poorest people ate from dishes which elsewhere would be treasured as objects of art. So cheap and so little valued were these wares that in some parts of Japan, especially in Tokyo, it was the custom on the last day of the year to smash up and destroy such dishes as had become chipped or cracked during the year.

Imari Marks

There are no potters' seals or marks by which Imari wares may be identified for the simple reason that Japanese potters used none. For this we may adjudge two reasons, apparently contradictory yet typically Japanese. First, because the earliest potters worked under the direct supervision of their feudal chiefs and the wares they produced belonged to the feudal lord, not to the potters: or the kiln was the joint possession of a neighbourhood group, or of a master and his pupils and all shared equally in any honours received.

Secondly, a Japanese artist, even a humble potter, believes that the subtle impress of his own personality on anything he makes is sufficient identification.

The oldest Imari productions usually bear the seal of the Chinese model which they copied; in other words, any seal on the back of a plate is merely a part of the design. Many

Imari plates made two hundred and fifty years ago, or those made day before yesterday, bear a seal reading "Made in the reign of Ch'eng Hua of the Great Ming Dynasty." The Ming dynasty lasted from 1368 to 1643.

Fuku

The oldest mark used on wares intended for use in Japan was a written seal, drawn with a brush in under-the-glaze blue, which reads "fuku" or good fortune. For export a blossom of indeterminate sort was brushed on over the glaze in red, sometimes touched up with gold. It is fairly safe to state that no piece of Imari porcelain made before the Meiji Period (1868 1912) would bear the signature of the potter or decorator. However, since the establishment of modern Japan even the humble potter has become self conscious and about fifty years ago individual potters began to use a seal or a written signature. Today certain big commercial potteries use a trademark on their productions.

The much talked of "Kakiyemon" was the name of an individual and is never found on any of the old ceramic wares. His family name was Sakaida Kizayemon but because the feudal lord for whom he was the official potter was fond of a kaki (persimmon) colour which he developed he became known as Kaki-yemon and it is this name that is identified with a certain type of decoration, not with articles made by him. Kakiyemon has been revived as a family name and is now to be found on some excellent wares, made at Arita mostly.

Some time during the Meiji Period a family of potters skilled in all the Imari types of decoration began to use the name Imayemon and have taken it legally as their family name. Wares signed Imaizumi Imayemon (brush-written under the glaze in blue) are above criticism, though quite costly. Prior to the Meiji Period potters did not rate a family name, they were simply Goro or Jiro or Saburo of such and such a kiln. In pre-Meiji Japan only samurai and court and feudal nobles had names. The two syllables "ye" and "mon" form a part of many Imari potters' names: yemon is a survival of ancient days and means gate-keeper. Kilns in the Imari districts were the prope ty of the feudal lords and the potters who worked at the kilns were not only crafts-men but at times guards and protectors of their clan chiefs. In contrast to the "yemon" of the Imari potters' names the "ya" of Kutani points to the fact that the Kutani kilns were from the beginning owned and operated by small merchants, though here also under the patronage of the feudal lord. "Ya" as a suffix to a name means "house of"

PLATE XVII

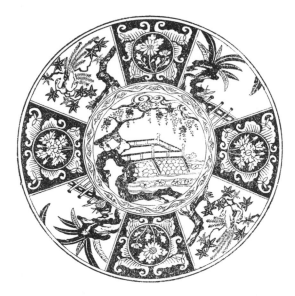

Early Five-colour Imari Plate

About two feet in diameter; this plate belongs to a later period than the Old Japan wares. The design shows strong Chinese influence but the Japanese touches are unmistakable. Note the cherry blossoms, which are purely Japanese and the square platform which is purely Chinese in origin.

Conventionalized clouds, very Chinese in style, make the border around the center design. In shape the dish is a very shallow bowl, a large flat center with very wide curving rim. On the rim are four blue panels and four white ones. The blue panels have red medallions, two with lotus and two with chrysanthemum designs. Of the white panels, two have banana trees and rocks and two have birds of paradise on the branches of maple trees. The edge of the plate is white.

In the four blue panels the under-the-glaze blue shows traces of the style of the Old Japan wares; that is, the blue is daubed on in uneven masses and the design on it developed in gold paint. But elsewhere the blue is brushed on more carefully and shaded. The blue is a clear bright cobalt blue not indigo blue, but the red is very orange and where applied thinly, as on the cherry blossoms, almost a dark pink (as on the Old Japan pieces). Scattered here and there in the design are touches of very pale yellow, brownish purple, grass green, turquoise blue and black enamel colours. These colours mark it of the latest period of Old Japan wares.

This ware is also called *nishikide*, Brocade or *kinrande*, Gold Brocade, ware.

The back of the plate has a four inch wide arabesque vine design in under-the-glaze blue. Five spur marks in the center show how the plate was supported in the kiln.

On the back are six Chinese characters reading "*Tai Ming Sei Kwa Nen Sei*" which means "Made in the reign of Ch'eng Hua of the Great Ming Dynasty"—This Ch'eng Hua reigned from 1465 to 1487. Most old Imari pieces are marked with Chinese marks which are not intended to be the date of making, they are just part of the design. Actually this plate was made about five hundred years after the marked date!

or " shop of." As a rule those potters who used the yemon name made wares decorated with coloured enamels over the glaze. The present Imayemon claims to be the thirteenth in his line, though he himself admits it is only a guess, all he is sure of is that for centuries his forebears have been potters in Arita. Since the occupation many potters are using a stamped seal on their productions, usually stamped in the biscuit and glazed over.

Other than this quite new name of Imayemon, the famous Kakiyemon and Fukugawa there has never been a potter's name associated with Imari wares, despite this remark that was overheard in a curio store one day, " No madam, this ｌiece is not signed, it was made by Imari's younger brother who did not sign his wares "!!!

The first departure from the complete lack of any identifying marks and before signatures were used is found in the practice of writing on top of the glaze the name of the kiln at which the wares were produced. It should be noted here that the foregoing applies only to Imari wares. The potter artists of Kyoto almost invariably used stamped seals or incised signatures and the Kutani kilns had identifying marks from the first.

Kakiyemon

Typical Kakiyemon dish center; over-glaze enamel colours, the flowers in red and an almost colourless yellow, the bird and leaves violet-blue and turquoise-green with sketchy outlines of black. Actual date unknown, thought to be about first part of nineteenth century.

Kakiyemon was born Sakaida Kizayemon in 1596 at Nangawara at the edge of the town of Arita about sixty miles east of the city of Nagasaki. This district is the place where all forms of Chinese ceramic art first entered Japan and which was even then a great pottery producing center. His father Sakaida Ensai was a man of some social standing and importance. Tradition says Ensai was fond of *haiku,* that is, the writing of short poems, and this literary fad of the father influenced the life of his son. For it was his father's friend, a priest of the Shoten-ji Temple at Hakata, Kyushu, also a lover of haiku who introduced Kakiyemon to a man who was to inspire him wth a zeal for the pursuit of the elusive beauty of coloured enamel decorations on porcelain.

This man was Takahara Goroshichi, a potter who had been under the special patronage of the Shogun Toyotomi

Hideyoshi. Because of the political turmoil ensuing from the downfall of the Toyotomi family, Takahara had retired to the Shoten-ji Temple. Here the priest in charge introduced him to the son of his old friend Ensai. Takahara recognized the ability of the young potter and Kakiyemon became his pupil. It is known that Takahara and Kakiyemon worked together for some time but nothing remains of that period in Kakiyemon's life.

At some later date when Kakiyemon was living and working at Arita, he met a pottery dealer named Higashijima Tokuyemon who was also a potter of some repute. Higashijima had journeyed to Nagasaki where he met a Chinese potter to whom he paid a large sum of money to teach him the art of over-glaze enamel decoration. Returning to Imari he joined forces with Kakiyemon in experimenting and research into coloured glazes.

It was at this time that Sakaida Kizayemon made an " *okimono* " or tokonoma decoration of a coloured persimmon (*kaki*) and presented it to the feudal lord of that district. The ornament so pleased him that he ordered Kizayemon to change his name to Kakiyemon. In feudal Japan to be granted a name was considered a great honour. Ever since then the eldest son of the Sakaida family when he succeeded to the headship of the family took the name of Kakiyemon. The present head of the family is Kakiyemon the thirteenth.

Although Kakiyemon may be said to be the first maker of coloured porcelain in Japan, he cannot be said to have invented or discovered the process. He only made use of the secret of metallic oxidation discovered in the middle Near East thousands of years ago. This method has a long tradition but it has always been guarded as a trade secret so that to Kakiyemon must be given the credit of pioneering in a little known field. His art may be considered great in the same sense that we speak of the art of stained glass, the secret of which is lost to the world today.

Kakiyemon developed and popularized, not only in Japan but in Europe, a strongly individualistic style of porcelain decoration which though based on Chinese models is purely Japanese in taste and feeling. He was the first potter to disregard the Chinese style of crowded patterns covering the entire surface of the article to be decorated and his designs show the Japanese love of simplicity and of skilfully contrived blank spaces. He was a consummate artist and his designs were adaptable to objects of the most diverse shapes.

He used pure rich enamel colours; a pleasing orange-red; a bright clear blue-green, almost turquoise; a clear

opaque yellow; an over-glaze violet-blue; a purple or aubergine which shades at times into brown; and a black over-glaze enamel, together with a good under-the-glaze blue which he introduced sparingly. He also occasionally high-lighted his designs with gold paint. Seldom covering more than one third to one half, at the most, of the surface to be decorated his designs were sketchy and light.

Kakiyemon was most fond of flowers and birds or butterflies. He seldom, if ever, painted figures and his landscapes were confined to rocks and trees or rocks and flowers. He drew his designs with a freedom and verve and yet with the exquisite detail that marks them Japanese. He, like all the other Imari porcelain artists, used the Chinese motives of the lion-dog; the hoo bird; the zigzag fence; the conventional sho chiku bai (pine, plum and bamboo combination); the peony; the chrysanthemum. He seldom used borders or repeat designs and never geometrical designs. His style was naturalistic, not conventional.

In 1646 Kakiyemon took some of his productions to Nagasaki where he sold them to a Chinese merchant for export to Europe. Although his designs were derived from the Chinese it is a strange fact that because of their popularity in Europe, even the Chinese originals were called by his name and his designs were copied in China itself. The influence of Kakiyemon's designs can be seen in the Delf wares of Holland, the Meissan wares of Germany and the Worcester wares of England. His wares were both copied and imitated in Europe. During the period of 1690 to 1700, many of his wares went to Europe. This was perhaps his best period.

Kakiyemon lived and taught at many different kilns in and around Imari and even during his lifetime many potters produced "Kakiyemon" porcelains. Many of the original productions of Kakiyemon the first undoubtedly went abroad. Kakiyemon the second and third also produced some outstanding wares, after that potters bearing his name simply worked in the style of Kakiyemon. Just what marks the dividing line between valuable old Kakiyemon productions and less costly Kakiyemon style porcelains is not definite. Perhaps because the sparce pattern demands a fine porcelain and a beautiful white glaze, even today modern Kakiyemon style articles are proportionally more expensive than other wares.

Design on Modern Arita Porcelain.

History of Arita Kilns

The porcelain clays found in Hizen Province could be used without further refining, but tended to sag out of shape if subjected to any great heat. This necessitated a preliminary firing at a fairly low heat before the under-glaze decoration was applied.

The early history of the Arita kilns is closely associated with the names of Korean potters as well as the famous Japanese, Tokuyemon and Kakiyemon and later, about 1650, the Fukugawa family of potters. About 1605 a Korean potter named Ri Sampei came to Matsuragori, under the protection of Nabeshima Naoshige, the feudal lord of Saga. Ri Sampei who took the Japanese name of Kanaye Sambei, found good porcelain clay at Izumiyama and began the manufacture of true porcelain decorated in under-the-glaze blue (*sometsuke*). The famous pair Sakaida Kakiyemon and Higashijima Tokuyemon about 1647 succeeded in making the first enamel decoration on porcelain. Together they spent some years at the Arita kilns, experimenting and developing a good white glaze on a fine hard biscuit. It was here that Kakiyemon perfected his individual style of decoration. Both the three colour and five colour Old Japan wares for export were manufactured here until about 1830.

The potters of the Arita District produced their wares at small individual kilns in their homes and fired them at a

PLATE XVIII

Design on the outside of an Old Imari *nishikide* bowl showing two forms of highly conventionalized lotus blossoms with leaves.

Colours:—The middle section is a dark under-the-glaze blue; flower white with petals outlined in pale yellow enamel paint; leaves in yellowish brown; flower and leaves start from a light blue-green scroll. This blue-green also is used in the band separating the sections of the design. The two similar sections have a ground of red enamel colour with the floral design reserved in white and out-lined in light yellow and finely drawn red lines.

This design is very common on Imari porcelains of the eighteenth century but is again being produced in modern reproductions of the old and is frequently offered as "old Imari".

This circular form of floral motives was popular fifty to a hundred years ago usually developed in colours. It may have been first used by one of the later Kakiyemon potters for modern dealers call this "Kakiyemon style".

common kiln. These were known only by the general term Arita wares. Certain wares (*oniwa yaki*) were produced at what are known as "Garden Kilns." Of these the best known are Nabeshima, Okochi, Mikawauchi, and Hirado. The material used was the same for all, the local clays, but at some kilns it was more carefully refined than at others. Only long familiarity can enable one to distinguish the wares of the different kilns. It was not the habit of the Arita potters to mark their wares in any way. This was perhaps due to the lack of assertion of individuality among the potters and the result of the group spirit which is still a strong characteristic of the Japanese

Old Imari bowl center design of hoo bird and dragon in under-the-glaze blue, carefully drawn and shaded.

people, but a contributing reason is that the potters of those days considered it an honour to have their productions bear the name of their feudal lords. Occasionally, a potter of outstanding ability would receive a special art name as a reward, granted him by his feudal lord. Even in such a case, the seal was used only on the pieces which the potter considered his best. Each kiln, or each famous potter, had their own speciality, as to thing made or style of decoration, but of necessity there was much overlapping. One potter would work at different kilns, often at the request of the feudal lord, or one artist would create designs for several kilns. And

Center design in Old Imari bowl showing the fabulous Chinese animal known as the kirin, a kind of Oriental unicorn. The body of the animal in under-the-glaze blue outlined and dotted with gold paint and surrounded by flames done in red enamel with touches of yellow, green and purple, white background.

there are more than one instance of a community of decorators to whom many kilns sent their wares to be decorated. These towns were known as Akaye-mura (red picture village). Even taking into consideration the fact that the different artist-potters used the same materials for their wares and the universal tendency to follow what is popular at the moment, the artists of old Japan did not think it necessary to sign their works but each depended upon the strong individual characteristics of his style to identify his work.

The potters of certain neighbourhoods had fixed days on which the kilns were available to them. Such kilns were called "clan" (or government in English) sometimes official kilns

because they were operated as a clan project, not as the private business of the potters. No details are at present available as to how they managed the selling of their wares but it is most likely it was handled on what we today would call a co-operative basis, that is by guilds or associations (*kumiai*).

It is difficult for those of today, when the manufacture of any thing less than the atomic bomb is an open secret, to understand the secrecy maintained regarding the production of porcelain wares by the potters of the seventeenth century. Many stories are told of potters sacrificing

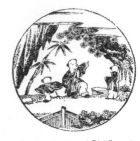

Center design of Old Imari bowl, developed in under-the-glaze blue. A Japanese interpretation of the Chinese children design. Note the felicitous design of pine, plum and bamboo used as background for the figures.

wife and family to learn the formula of a coloured glaze or some method of firing. At Arita during the first half of the seventeenth century a pottery merchant named Aoki Koyemon learned the secret of decorating by designs in gold on a red ground (*kinrande*) which he imparted to his friend, Wanya Kyubei, a porcelain dealer of Kyoto. Wanya in turn passed the information on to Ninsei and it became known in Kyoto. When Lord Nabeshima learned of this Aoki was sentenced to death.

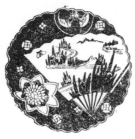

Nishikide Imari
Fourteen-inch plate made in the latter part of the nineteenth century. The fan is white against an under-the-glaze blue ground. The under-the-glaze blue is a dark cobalt blue with a purple tinge, typical of that time but there is an unusual pale blue enamel colour used to suggest water. The irises are developed in a bright orange red while the three pronged flower and the outline of the other large flower are in the typical "Imari red." The chrysanthemum is in a very light shade of purple with blue center and surrounded by five grass-green leaves. The iris leaves are developed in grass green and purple outlined and shaded in black. The general colour effect is bright and pleasing. The dish was probably designed to display cooked foods for sale.

Along with the clan kilns there were the Garden Kilns (*oniwa gama*). The wares produced at such kilns were not for sale, but were used for presents and were called presentation wares (*kenjo yaki*). These kilns were often actually in the garden of the feudal lord or at least were owned and managed by him. The potters were the immediate retainers of his household and their duty was to produce the most perfect wares it was possible for them to make. No fixed quota was required of them and they punched no time-clocks. Under such circumstances, it is no wonder they made the beautiful things they did. Very few of these wares ever went abroad and until

PLATE XIX

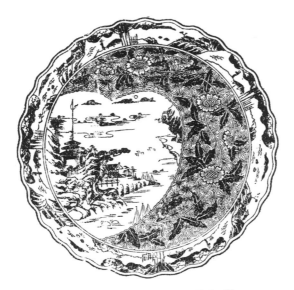

Early Imari *Sometsuke*, Blue and White Plate

Plate about two feet in diameter decorated entirely in under-the-glaze blue of a soft greyish-blue colour. The shape of the plate and style of decoration show it to be a very early piece and, though Chinese in inspiration, can only be of Japanese workmanship. Note the peculiarily Japanese treatment of the sailing boats and pine trees in the distance.

Heart shaped medallions such as this first made their appearance about two hundred years ago, they are based on the Chinese round fan.

In Kyushu these large plates were used as serving plates for formal family gatherings. Food is served from this large dish unto individual small dishes. In and around Tokyo these plates are used only at hotels and restaurants.

On the back there is an under-the-glaze blue arabesque vine design about two and a half inches wide and six Chinese characters reading *Tai Ming Sei Kwa Nen Sei*—that is, "Made in the reign of *Ch'eng Hua* of the Great Ming Dynasty" (1465-1487). Merely a part of the overall design.

they become more generally known any fair judgement of Japanese ceramics is impossible. The Korean potters who worked at such kilns were naturalized and raised to samurai status, the highest honour at the bestowal of the feudal lords.

The wares first produced at the Arita kilns have been described under the heading of Imari wares.

After 1858 when Japan began the export of ceramic wares the so-called "Nagasaki wares" were produced in the Arita kilns. About the first year of Meiji 1868) Eizayemon Fukugawa of Arita began the manufacture of ceramic wares in the foreign concession of Nagasaki. These wares consisted of, among other things, flower vases of immense size with wide trumpet mouths, decorated with a poor quality of Imari red and gold lacquer colours. They were made in pairs and are typical of a class of merchandise made in all Oriental countries. The manufacturer is convinced he is making things "foreign fashion" to please his customers while his customers are equally certain they are buying "typically Oriental" goods. Actually the things represent neither Oriental nor European taste.

Some of the lesser known kilns which are in or around Arita are "Uchiyama," which includes the kilns in the town of Arita, Izumiyama, Kamikochi, Nakataru, Otaru, Motokohei, Shirakawa, Okaiye, Nakanohara, Hikoba and Ewayagawa; "Sotoyama," which includes the kilns outside of Arita, Kuramuta, Ohozan, Oyama and Ichinoseyama; and "Osotoyama," which includes Tsutsuyama, Yuminoyama, Odachiyama, Shidaiyama, Yoshidaiyama and Uchinoyama.

In 1869 the Arita kilns began the use of oxidized cobalt, and the following year Dr. G. Wagner, a German technical expert came to Arita. Under his guidance the production of European style porcelains and pottery was developed, using modern factory equipment, coal-burning kilns, shaping in plaster moulds and European glazes. In this modernization of methods of production Arita potters took the lead, followed closely by those of Seto, about 1874. In this year also the still flourishing company of Koran sha was established.

Kin ri mono is the name of a ware, the output of a potter

Design in the center of an Old Imari bowl, purely Japanese in execution though based on imported Chinese idea. The association of pines and cranes is symbolic of good wishes for prosperity and longevity. The design is in colour on a white ground. The pine trees are *waka matsu* (young pine) traditionally associated with the New Year. The crane is developed in red, aubergine purple and black; clouds outlined in black and shaded in a very light red.

named Tsugi Kiyemon or Kizayemon who occupied himself exclusively in the making of wares for the personal use of the Emperor. After the Taisho Period (1912 to 1926) these wares became known as Tsugi sei. About the middle of the seventeenth century a Tokyo merchant by the name of Imariya Gorobei went personally to Arita and procured some of Tsugi Kizayemon's wares for Lord Date. The record continues that after 1774 the makers of this Tsugi ware took the name of Hitachi Daijo every second generation, though no reason is given for this change.

Flower Basket Design on Old Imari.

Nabeshima Wares

Nabeshima wares were not made for sale, in fact their use was prohibited to the common people. They were made for the personal use of the clan lord and the best ones were given as presents to his friends and superiors. The entire yearly production was limited to about five thousand pieces. These wares were made at the Okochi kiln some time between 1716 and 1735. Before that the location of the kiln was changed several times in

PLATE XX

Nabeshima *Sometsuke*, Blue and White Plate

Deep plate about eight inches in diameter. The Nabeshima potters were very fond of this style of article which is neither bowl nor plate but a cross between the two.

In colour a beautiful indigo blue the design pictures the *fuyo* or hibiscus flower. Note on the outside of the plate the typical Chinese coin design, only Nabeshima potters used this; also the so called "comb design" on the footrim.

Nabeshima potters differed from those of other kilns in their method of applying colours. The method in common use elsewhere was to daub on the colour and then draw the outline in black or other colour. On Nabeshima wares the outline is very carefully drawn in the under-the-glaze blue and the colour washed in with a full brush or very carefully lined in with a very fine brush.

order to safeguard the secrecy of the production methods. The first kilns were established about 1598 when Lord Nabeshima returned from the Korean expedition, bringing with him hundreds of potters among whom was one Ri Sampei, or Ri Sanpei, who is credited with discovering clay suitable for the making of porcelain. Although kilns were built and work undertaken at this time, it was not till half a century had passed that any progress in true porcelain making was apparent. It was the second generation of Korean potters, born in Japan, who finally succeeded in making porcelain. Excavations at these old kiln sites have revealed that even the shapes went through a process of development, first Korean, then Chinese and finally Japanese.

Although the Nabeshima porcelains were made of the same materials as the other Arita wares, more care was taken in the preparation of the biscuit then in the case of the others which were destined for a lower economic class of people and for export. They were confined pretty much to one shape, a low flat bowl of exquisite curves on a rather high footrim (*kodai*), although they were produced in many sizes. They may be distinguished by a meticulously drawn "comb" pattern on the fo trim and medallions formed by groups of the Chinese coin design on the outside, or back, of the bowl. Occasionally this coin design is replaced by an arabesque of chrysanthemum leaves and flowers.

The Nabeshima kilns made celadons (*Nabeshima seiji*), under-the-glaze blue and white wares (*aiye* or *sometsuke*) and wares with coloured enamel over the gl ze decoration (*iro nabeshima*). Of these Iro Nabeshima, which was made at the Okochi kiln, are considered the best. A fourth class of wares known as *makusoto* or "beyond the curtain" were wares which did not measure up to the high standards set for Nabeshima wares and were therefore thrown away or "beyond the curtain." These were put on sale at the public markets and some found their way to Europe. But Nabeshima porcelains remained practically unknown outside of Japan until some pieces were sent to the Paris Exposition of 1867.

Nabeshima designs are quite distinctive, usually a free naturalistic drawing of two or three blossoms which almost covers the inner surface of the bowl. One of the ceramic designs that originated in China is that of a low fence, often arranged in zigzag fashion. For some reason or other this design seemed to appeal to the Japanese potters and it is found on many wares. It is an excellent example of how the Japanese potters alter and adapt what they receive from abroad, because in Chinese designs this

fence is but a part of a complicated architectural design. The Nabeshima potters were very fond of this design which they altered into a purely Japanese rush fence. Coloured geometric patterns, bold and simple, sometimes cover the whole surface of the bowl. An almost startling design is a group of water pots arranged in an attractive pattern. The pots are simply outlined in under-the-glaze blue, there is little shading or other colour.

The colours used on Nabeshima porcelains are confined to under-the-glaze cobalt blue; a beautiful bright, yet soft and appealing iron red; a soft vivid green; a thin pale translucent yellow; and a thin lilac purple. A very few pieces have a turquoise blue enamel colour or black.

Nabeshima colours differ from Kakiyemon's in that where his colours are jewel like and are raised above the surface of the glaze, easily perceptible to the touch, Nabeshima colours are more like water colours and are a part of the glaze rather than stand out above it. If one examines specimens of the two wares one will find that while they both outline the designs in fine brush lines of cobalt pigment the method of firing produces different effects. Kakiyemon (and his followers) drew his designs on the glaze after it had been subjected to a low firing. He then filled in the design with the desired colours and the piece was again fired at a low temperature. This process failed to bring out the blue of the cobalt outline and it remained black. These parts of the design destined to be in red or yellow were outlined with a red pigment. On the other hand, Nabeshima designs were outlined with cobalt directly on the unglazed biscuit, then glazed over and fired at a very high temperature. This method produced a beautiful blue outline, soft and inconspicuous.

Old Imari *Sometsuke*

Chinese landscape design in under-the-glaze blue and white. The central design is a copy of a Chinese original but the border could only be produced by a Japanese.

Such designs were made only for export and were never popular in Japan. Date of piece perhaps early eighteenth century.

Nabeshima glaze is without any blemish or imperfection, of a somewhat bluish cast. Nabeshima wares are easily distinguishable from the ordinary Imari porcelains because of their fineness. The only ware that approaches it is the Hirado

porcelains, but Hirado never made the typical Nabeshima shape. There is a ware, *Kaga yaki*, which is an imitation of the true Nabeshima but if the two wares are placed side by side, there is no difficulty in distinguishing them.

When first produced Nabeshima porcelains were made under strict clan supervision and both design and colours had to be officially approved. Later when the clan control was abolished the quality dropped as was inevitable when the various stages of making and decorating were entrusted to different specialists with no centralized control and when quantity was of more value than quality. Nevertheless even today the Nabeshima kilns are producing artistic wares in excellent taste.

Okochi Kiln

This is the name of one of the kilns that produced Nabeshima wares. The supervision of these kilns was placed in the hands of the Okochi family by Lord Nabeshima. The name is sometimes written Okawachi, sometimes Okawaguchi. Other than the Nabeshima bowls this kiln made plates of all sizes and tea cups. The wares are divided into three classes:

Celadons (*okochi seiji*).

Old Okochi, *ko okochi*, decorated in under-the-glaze blue and white (sometsuke). They have no kiln seal and the footrim has a design like the Nabeshima wares.

Some nishiki, also called *nabeshima akaye* in which the design is outlined in cobalt blue and colours similar to Kakiyemon's are used.

Pine seedlings, a purely Japanese design, are often used in decoration of the Okochi wares, also the chrysanthemum, and the orchid; the Chinese lion-dog (*kara shishi*) is often modeled as a *tokonoma* ornament (*okimono*).

Center design of Old Imari bowl, very carefully drawn. The center flower drawn and shaded in under-the-glaze blue, leaves in under-the-glaze blue and green and turquoise blue enamel; clouds in turquoise blue, green and purple enamel over the glaze colours.

Hirado

Hirado (or Hirato) wares were initiated by Matsura Shizunobu, Lord of Hirado, when he brought back with him from Korea a Korean potter (1598). The kilns were located on the

island of Hirado and it was not until about 1751, when good clay materials were found at Amakusa that porcelains were made. It was the grandson of the original Korean potter who first made the fine white porcelain for which these kilns are famous. Hirado wares were not made for sale, the products of the kilns were the property of the successive feudal lords, that is, until the Restoration of 1868. Previous to that the wares consisted of small cups, wine bottles and especially small figures of men, animals and flowers. Between 1750 and 1830 the kilns turned out some of the finest porcelains ever made in Japan. The biscuit is a fine hard porcelain with the property of producing a beautiful clear blue in under-glaze decoration. It is not a showy ware, the blue is too soft and the outlines tend to blur, but its appeal is the result of its exquisite fineness and elegance. Pieces of old Hirado ware are rare and are the prized possessions of their owners.

Hirado Sometsuke

Under-the-glaze blue and white small dish. Design shows five Chinese children playing under pine trees. This plate is not more than eighty years old. The blue is pale but clear, the drawing most carefully done.

After 1868 the kilns were operated as a business, still producing a beautiful fine porcelain decorated in under-the-glaze blue. It was about this time that the much talked of (abroad, not in Japan) design of Chinese children playing under pine-trees was produced, but no Japanese seems to know that the quality of the porcelain was indicated by the number of children pictured, and the design is not popular in Japan.

Hirado potters produced a great many small ornamental objects such as birds, branches of flowering shrubs and pieces decorated with designs pierced, carved or moulded in high relief either in all white, blue and white or in a peculiar slate-purple blue enamel glaze.

Seal of the Mikawauchi kiln at Hirado

PLATE XXI

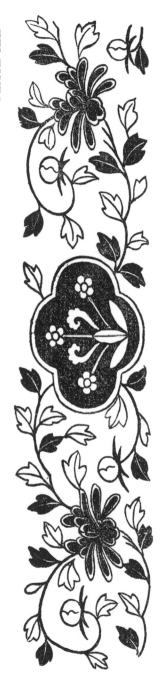

Decorative border on the outside of an Old Imari bowl, conventionalized lotus flowers in red, vine arabesque in gold and leaves in a very light thin green enamel on a white ground. The medallions is red with green and yellow flowers and leaves. *Ko imari nishikide,* brocade style Old Imari.

Repeat pattern in Kakiyemon style, sometimes in blue and white only sometimes in colours, found both incorporated into the surface design and also on the backs of plates and bowls as a repeat.

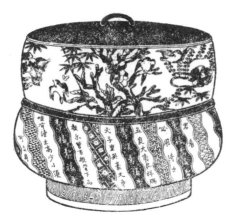

Shonzui *Mizu Sashi* or Water Bowl
Typical design of the style attributed to Shonzui.

The Shonzui Tradition

Whether or not such a person actually existed is still an unsolved problem, but there is a persistent tradition that a Japanese potter by the name of Gorodayu Go Shonzui went over to China in the last decade of the sixteenth century and learned the art of making porcelain. Even the name assigned to him is the subject of much discussion, for the Chinese character with which the Go is written is the same as that for the Yu Province in South China, and Shonzui may be a corruption of the Chinese name Hsiang jui.

As proof that Shonzui was a real person, not just a name, the Jingu-ji Temple of Ise Province offers a Chinese poem dated "the first day of the sixth month in summer" of the year 1513, written as farewell to Gorodayu; and there is a blue and white (sometsuke) porcelain water pot (mizu sashi) which also bears his name in an inscription which is part of the decorative design. Many other porcelain wares ascribed to him have a seal reading "Made by Gorodayu Go Shonzui" (*Gorodayu Go Shonzui tsukuru*), or simply a Ming seal. They are articles such as can be used by the Japanese and which have a strong Japanese feeling.

It is usually accepted that Shonzui lived at Matsuzaka-gun in Ise Province and that his family name was either Ito or Yamada and that he took the name of Gorodayu Go Shonzui because he was so great an admirer of the Go Chinese porcelains. This is a very common practice in Japan and one which makes the

John Dewey Library
Johnson State College
Johnson, VT. 05656

foreign student of Japanese art considerable trouble for a man may use several names, simultaneously or consecutively, and Japanese potters are among the most troublesome in this regard.

Some say that this Yamada was a lumber merchant dealing with China and that on his many trips to that country he brought back these wares and that his name appears on them because he ordered them to be made. To substantiate this story is the fact that porcelain clays were not discovered in Japan until almost a century after his time.

Another story says that Shonzui was sent to China in 1513 to study the making of porcelain and of glazes for pottery. After a stay of five years he returned to Japan and settled at Arita in Hizen Province. Supposedly he brought back with him quantities of porcelain clay but when that was exhausted the production of porcelain wares in Japan came to a stop until about 1605 a Korean potter named Ri Sampei found porcelain clay at Arita.

To complicate matters still more, it is thought that Shonzui may have traveled up to Kaga Province and worked at a Kutani kiln. A certain Marusei Seigoro of Komatsu-machi in that province has in his possession a large flat bowl (*hira hachi*) which is marked with the Gorodayu Go Shonzui seal.

The wares ascribed to Shonzui are beautifully potted, the paste is fine and white and the colour good. The designs are Chinese and include the vine-like meander pattern of "*kara kusa*" with reserved panels decorated with landscapes, or birds and flowers and geometrical designs.

Repeat pattern in Kakiyemon style, sometimes in blue and white only sometimes in colours, found both incorporated into the surface design and also on the backs of plates and bowls as a repeat.

Seto Kilns
and Potters

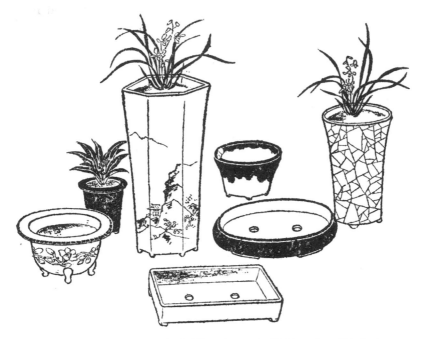

Products of Seto kilns, pots for holding plants, the flat tray-shaped bowls are for *bonsai*, dwarf trees, of which all classes of Japanese are fond.

Seto

Seto is the name of a geographical locality rather than a kiln name and it includes the foothills and valleys surrounding the present town of Seto in the Province of Owari. It is stated in old records that any place which produced pottery wares was called Seto. It is possible that the present way of writing Seto 瀬戸 (meaning rapids door) s a mistake for *Sueto* 陶戸 (meaning pottery door) because it is known that in olden times the place where a kiln keeper 陶 lived was called *Sueto*. Seto is perhaps the oldest pottery center in Japan. There are written records of a survey of this district ordered by the Imperial Court at Kyoto in 815 to report on the condition of the kilns then in existence there. Even at this early date there seems to have been a system of teaching (or training) and after finishing a prescribed course the potters became low-grade government officials.

The first ceramic wares to come to Japan were those of the T'ang dynasty, but it was the celadons (*seiji* in Japanese) which had the most direct impact on Seto. The Chinese

celadons were valued alike by Court nobles, samurai and feudal lords and many attempts were made to produce them in Japan. Pieces of pottery unearthed at the various abandoned kiln sites in and around Seto show that Seto productions were well potted and have traces of glaze. The articles, bottles, bowls, ritual wares and scripture (*kyosu*) case or tubes, some dated 1294, show embossed desi ns of flowers or very primitive decoration of incised lines. The glaze was yellowish-green with a decidedly blue cast where it has settled thickest.

Ki Seto or Yellow Seto Bowl

Modern production of Seto kilns showing method of applying glaze leaving much of the biscuit uncovered. Greyish mustard in colour with traces of green.

This yellowish-green glaze, at first the result of incorrect firing in the attempt to produce the jade celadons of China, came to be admired for its own sake and became known as Yellow Seto (*ki seto*). When Kato, usually spoken of as Toshiro, founder of glazed pottery at Seto, returned from his stay in China in 1225, he at first produced wares using the materials he had brought with him. In 1227 he found suitable clay near Seto and started an industry there which eventually made the Seto district one of the most important ceramic centers in Japan. Even today the common term for ceramics in Japan is *setomono* and a pottery store is called *setomonoya*. He was followed by a long line of descendants who took as names as Toshiro the second, Tojiro, Chojiro, etc. The wares which are believed to have been made by Toshiro the first have an opaque brown glaze streaked or overlaid with black ; and a chestnut brown glaze splashed with golden brown.

Yellow Seto (*ki seto yaki*) is used to designate all varieties of Old Seto (*ko seto*) which are covered with a yellow glaze, regardless of their texture or the time in which they were made. The first Yellow Seto made by the Toshiro family had a semi-opaque muddy yellow glaze over a rather coarse grey paste. A second type of Yellow Seto, attributed to an amateur potter, Hakuan, in the fifteenth century has a transparent glaze, usually crackled. The potters of Seto broke away from tradition and decorated their wares with bold brush strokes of dark brown under the glaze, in conventional patterns of grass or reeds.

A kind of *cha ire*, or small jars for holding powdered tea with four small handles set close to the neck of the jar and glazed with a metalic looking dark amber or dark brown colour are known as *Shunkei*

Seal used by Seto potters.

PLATE XXII

Modern *Sometsuke*, Blue and White Imari Plate

Plate about fourteen inches in diameter developed in under-the-glaze blue, no other colour. The landscape design is basically Chinese but the distant mountains show the Japanese touch.

The design is blue on a white ground, the border white on a blue ground. Such dishes as these are made by the hundreds yet every one is just a bit different from the others. They were made for the display of cooked foods at the many small stores selling such things or for the display of fish at the fish mongers, the Japanese version of the modern white enamel trays used in other countries.

cha ire, from their maker Shunkei. They are imitations of Ming wares.

The oldest Yellow Seto (*ki seto* included two outstanding types of glaze called by the names of the objects first decorated with them.

Gui nomi de (which may be roughly translated as "one gulp" style) wares were rather large wine cups for serving the unrefined *sake* of those days; and the various articles used by cha jin.

Ayame de (Iris pattern style) were very thin, beautifully potted bowls and cups with an oily sulphur-coloured glaze, closely resembling gold-dusted lacquer, covering the surface; with sketchily etched iris designs and scattered dots of iron brown and copper green under the glaze.

With the gradual decline of the craze for utensils for cha no yu and the lessening of the influence of the cha jin the Seto kilns turned their attention to common everyday kitchen wares and a ware called chrysanthemum plate style (*kiku sara de*) came into existence.

During the period between 1550 and 1640 the Seto kilns flourished but after that decline set in.

In 1574 Oda Nobunaga appointed six master workmen among the Seto potters as official makers of pottery wares for cha no yu.

In 1584 Furuta Shigeyoshi, known also as Oribe, set a new style in Japanese pottery by ordering sixty-six tea jars (*cha ire*) in all manner of bizarre shapes, roughly painted with purely Japanese designs such as plum blossoms, cranes, etc. He also appointed ten potters to make cha no yu articles for him.

In 1659 a naturalized Chinese named Chin Gempin made at Seto an imitation of Annam pottery, a grey stoneware with a soft crackled glaze with enamel decorations of paintings or Chinese poems in indigo-blue.

About 1807 Kato Tamikichi, who had spent some years studying at the various kilns in Hizen, came to Seto and started · the production of porcelain, as distinguished from pottery. Seto porcelain glazes are more glassy than those of Imari and the paste coarser. The decorations were mostly under-glaze blue. The best period for porcelains was between 1830 and 1860.

Most Seto wares properly should be described as faience, not porcelain. About 1868 Seto potters combined the two crafts of pottery and cloisonne, with but modest success, as most authorities seem to think that the hybrid was not pleasing; although

the writer has in her possession a small piece beautiful in shape, design and colour. In general, Seto productions tend to be large and include flower pots for dwarf trees, garden ornaments such as the Chinese lion-dog (*koma inu* or *kara shishi*) and lanterns. In the town of Seto potters of that district erected a monument to Toshiro, a large upright plaque of which the base measures 12×15 feet. They also made an immense water basin (*chozu bachi*) and there is an amusing story in connection with this. The potters of two small villages of Seto, Akatsu and Shinano, entered into competition in the making of this basin, the winner was to be appointed official Tokugawa kiln of Owari. Other more orthodox means failing, the potters of Akatsu resorted to praying for rain. The gods were on their side apparently because the rains came and a flood washed away the Shinano kilns and Akatsu became the official kiln.

By the middle of the nineteenth century many famous potters had settled at the various Seto kilns and a high grade porcelain decorated with under-the-glaze blue designs was being made. Among them must be listed :—Sosendo, who died in 1866, his real name was Kawamoto Juhei. Kato Shuntai, born 1802 died 1877.

The use of oxidized cobalt for under-glaze blue wares was inaugurated about 1877.

Shino Yaki

At the end of the fifteenth century a cha jin Shino Soshin, who is also credited with originating the game of

Shino Yaki Tea Bowl

Called *Ruson shiro gusuri* or white over-glaze of *Ruson* —inspired by Sung potteries similar to Korean E-gorai wares.

incense burning (or incense guessing contests) had the potters of Seto make for him certain articles to his own designs. The kiln known as Shino was put into operation about 1590. Furuta Oribe's influence on Shino wares is quite discernible, although Kagenobu Shirouyemon is considered the originator of these wares. Shino glaze is thick and soft and almost opaque white, and may almost be likened to white jade. The ware was a very great favourite with the cha jin who had special names for every least variation of paste, glaze or design. The designs were always very sketchily drawn in iron pigment on the biscuit and were often exposed by the glaze failing to cover the whole surface of the article. These wares are known as *e seto*, or " picture Seto."

Shino wares are made of a heavy coarse paste with a thick semi-opaque greyish-white glaze which tends to bubble

or to gather into heavy soft crackles, much like certain thick-skinned Japanese citrons, with an unintelligible suggestion of painting in blue or brown oxide pigment. A distinguishing feature of this ware is that the glaze is wiped off of a portion of the article exposing the brown iron pigment design sketched on the body. Though the demand for these wares fell off with the waning of the popularity of cha no yu, they have been made in small quantities continually down to the present day.

Grey Shino is made by first coating the biscuit with an iron glaze and carving the design in this glaze, then the thick white glaze is applied, making an effect of white inlay on a grey ground.

Akazu Yaki

A kiln at Akazu, near Nagoya, which made a kind of Seto ware was already in production in the fifteenth century. The wares were of Seto stoneware glazed dark brown with opaque white splashes or with various shades of yellow and brown. In the period between 1600 and 1650 a white glaze streaked with blue was developed.

Sobokai Yaki

This kiln was originated about 1630 by Tokugawa Mitsutomo, feudal lord of Owari, when he engaged a potter to build a kiln for him in his castle (Nagoya Castle, destroyed in one of the air raids in 1945). The name of this potter is given as Kato Kagemasa, in some accounts; as Kato Tozaburo who was said to have been accompanied by his brother, Tahei, in others. Whoever the potter was he used clay brought from Sobokai and the productions were known as o niwa sobokai wares. The kiln continued in operation for some time, was discontinued and reopened in 1805. In 1825 Tokugawa Seiso began the production of a ware known as O fuke (or O buke). The body paste, or biscuit, was of a greyish white colour and not as hard as that of Akazu. The glaze was clear, almost transparent, and creamy in texture with a distinct crackle, very like Shino yaki, produced by one firing in the kiln: another type, resembling Oribe yaki the result of two firings, had a glaze opaque and soft, brown in colour shading off into blue-green and rich red, with splotches of white.

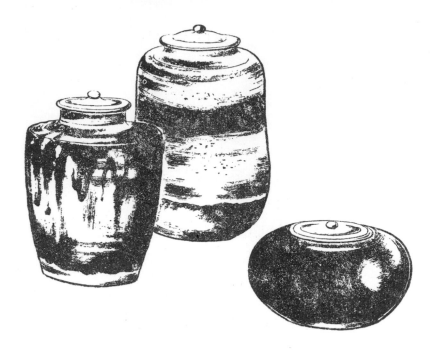

Cha Ire or Tea Jars

Small brown unglazed jars used for holding the powdered tea for
cha no yu. The covers are always of ivory.
It is this kind of pottery jars that the Toshiro line of potters first made.

Stories of Famous Potters

Toshiro

To determine who was the founder of ceramics
in the world would be like searching for the first baker of bread.
Some form of pottery is found all over the world and its origin
may be as old as the invention of fire. So it is in Japan. According
to the usually accepted tradition, Kato Shirozayemon Kagemasa,
called Toshiro for short, is said to be the first maker of Japanese
pottery in the Chinese style. Moreover, he worked just at the time
of a second influx of Chinese civilization into Japan. The first wave
of Chinese culture came to Japan during the T'ang dynasty, seventh
to tenth centuries. Examples of T'ang pottery and porcelain may
be found in the Shoso-in at Nara and this influence is evident in the

PLATE XXIII

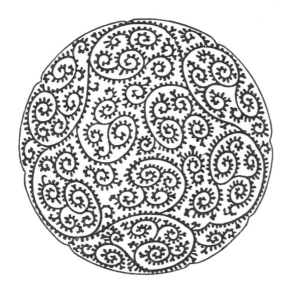

Sometsuke or Under-the-glaze Blue and White

This design, known as kara kusa or Chinese grass was very popular in the first quarter of the nineteenth century. It is always developed in under-the-glaze blue; used alone as on this dish, or as a background for medallions decorated sometimes in blue sometimes in colours. This design is found usually on strong thick porcelain wares, and was classed as *geta mono* or folk art. There are many variations of this design, especially on the common every-day kitchen wares.

This dish is about 8 inches diameter, a flat bowl shape with an abruptly upturned edge not quite an inch deep.

various kinds of porcelain mentioned in literature as manufactured in Owari (present-day Seto and its vicinity) and at Nagato in the western end of Japan. Toshiro represents the second inflow of Chinese culture, this time that of the Sung dynasty of about the twelfth century.

Kato Shirozayemon Kagemasa seems to have been born into a family of low estate but he was very fond of making earthenware articles and he conceived the desire to go to China to study this art. To this end he entered the employ of a certain Katoji Kagekado who was an important retainer of the Shogun Minamoto Yoritomo (1146–1199). There is a story about this time in his life; that he made a pottery jar in the shape of a bird for the son of his master who was fond of these little songsters. This greatly pleased his master who brought him to the attention of the Shogun.

It was at this time that the custom of tea drinking was introduced from China, through the instrumentality of the Zen Sect of Buddhism. This quickly became popular and gained many adherents among the military classes. It was the beginning of cha do, or the cult of cha no yu, which was to exert so great an influence on all forms of Japanese art but especially on the art of ceramics. At this time tea was scarce and proportionately precious. The Shogun was accustomed to present his *daimyo* followers (feudal lords) with small quantities of tea as a token of gratitude for their loyal services. Toshiro was commissioned to make suitable containers for such tea. His pottery jars received much praise and in recognition and appreciation of his skill he was granted the family name of Katoji, that of his employer. This was a signal honour because only daimyo and certain of their followers (samurai) were allowed to use family names and the granting of a name was equivalent to an English knighthood.

In 1223 he at last succeeded in going to China. He went there in the retinue of Priest Dogen who was the son of his old employer. He stayed six years in China where he investigated the clays of various places and made a study of glazes. There also he learned the art of making true porcelain. On his return he brought with him special clays with which he made small jars. These he presented to Priest Dogen and to Hojo Tokiyo i, Regent and Administrator for the Shogun. After that he went from place to place searching for porcelain clays. At Seto his search ended and he settled down about 1237, here he started an industry that eventually made Seto one of the most important ceramic centers in Japan. Here he is venerated as the founder of porcelain in Japan.

Modern research, however, has tended to break down this tradition and scholars today think that a potter named Toshiro did make beautiful *cha iri* (small pots or jars to hold powdered tea), but that he lived at a much later date than tradition assigns to him. Kato Tokuro, a recognized authority on the history of the Seto kilns, thinks that Toshiro in reality was the name of a potter family who controlled the production of all the kilns of that district and that the jars (cha iri) were not the work of one man but of various potters working at the different kilns.

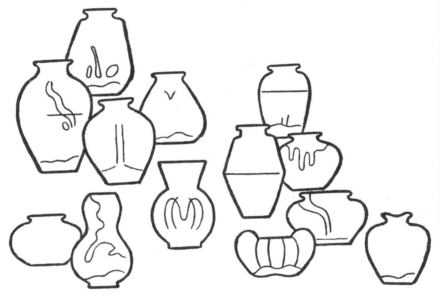

Various types and shapes of *cha ire*. The originals of these were Chinese made common pottery oil and drug bottles without lids. For use in *cha no yu* lids of ivory were made. In colour they range from a very black-brown to mahogany and golden brown. What appears in the drawing to be design on the jars shows how the glaze was applied. Heights—2 to 5 inches.

Whatever version of the story we accept the present claim of the descendents of this Toshiro line of potters to be the twenty-fourth generation of one uninterrupted family cannot be historically correct. It is more likely that the potter family who brought the art of kiln firing to Seto and the different experts in making cha ire have become confused with stories, which originated in the Edo Period, of famous potters resulting in what scholars now term the *Toshiro Monogatari*, that is, Tales of Toshiro. The history of the manufacture of pottery dates much further back than that assigned to Toshiro.

Toshiro's tea jars are covered with a streaky brown and black glaze, or rather streaks of brown glaze over a foundation glaze of black, or black glaze streaks on a brown glaze. Some of the best liked pieces are a chestnut brown with golden brown streaks suggestive of waterfalls.

Some authorities ascribe the invention (?) of *ki seto* (yellow glaze Seto) to Toshiro's son. His grandson also called Toshiro founded a kiln on Mt. Kinkazan in Mino Province, and a great-grandson, Tozaburo, made wares known as *Chuko yaki*; Chuko being his artist name.

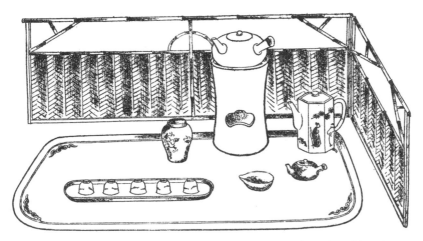

Utensils for the making and serving of *sen cha*, brewed tea. For this style of tea things made in China are considered best. On the mat or carpet top row left to right: porcelain jar with air-tight cover for holding tea leaves: small unglazed white clay *kanro* (portable fire place) with pot for heating the water; extreme right not a tea pot, but pot for holding cold water with which to replenish the hot water as used. Lower row, left to right: small unpainted white wood tray with five very small (not more than three tablespoon capacity) very fine porcelain tea cups, small bowl for cooling the water which has been brought to the boil (only luke-warm water is used for the best tea); tea pot. Both tea pot and pot for hot water are usually of hard red pottery ware.

Tamikichi

All of the great influence of cha no yu and of the tea masters has always been thrown into the balance for pottery, especially that type of faience known in Japan as *raku yaki*, but the march of progress was not to be stopped by even so powerful an obstacle. Porcelain wares have the advantage over pottery in their strength and wearing qualities, they do not discolour with use nor do they chip as easily as pottery articles. With the rise of the cul-

tural living level of the peoples of Europe and America came the demand for porcelain eating utensils, this made itself felt even in far off Japan. It is a strange fact that although it was China that developed the art of making and decorating porcelains, it was the productions of the infant industry of Japan that left the strongest impress on European porcelains. The designs of Kakiyemon, one of the first makers of porcelain in Japan, were copied by both Chinese and European potters. The designs of the Chinese craftsmen with their wonderful manual skill and their fertile imaginations were beyond the ability of the European potters, while Kakiyemon's designs were simple and natural, birds and flowers, and comparatively easier to copy. It was Kakiyemon's art of arranging and spacing of design that was of value to the Europeans.

Kakiyemon lived when the art of porcelain making was being introduced and in a district where excellent porcelain materials were first discovered in Japan, and where teachers from Korea and China easily found their way. Not all the pioneers in porcelain making were so fortunate. Of the three outstanding potters that have been selected as representative of hundreds of unknown and unsung contributors to the art of porcelain making; Kato Shirozayemon (Toshiro, for short) who lived in the second half of the twelfth century and who is credited with being the first maker of porcelain in the Chinese style; Kakiyemon, who flourished during the first half of the seventeenth century, and is credited with being the first to decorate porcelain wares with enamel colours; and Kato Tamikichi, who lived at the end of the eighteenth and the first quarter of the nineteenth century to whom is given credit for the dissemination of the method of manufacturing porcelain: it was the last named who had the greatest obstacles to overcome. His life coincided with a great cultural change in Japan.

The cult of cha no yu was on the decline, it was being superceded by the craze for *bun jin* art, the art of the Chinese literary scholar and the Ching dynasty culture of China. A new form of serving tea came into popularity. This tea was brewed from tea leaves, not whisked up from powdered tea. *Sen cha* was an active revolt from the formalism of cha no yu, and Chinese articles, not the over-simplified Japanese potteries, were in demand. The finest of porcelains for tea cups and an iron hard Chinese earthen ware for tea pots became more desirable than the soft thick raku yaki used for cha no yu. Cultural unrest was reflected in the nature of the local ceramic demand. While cha no yu flourished pottery makers flourished but with the decline of cha no yu pottery makers fell on evil times. The kilns of Hizen Province (the Imari

PLATE XXIV

Stylized waves following the Chinese originals, found as bands or incorporated into the main design on Japanese ceramics.

kilns) had supplied not only the demand for export porcelains but also the local markets. The pottery productions of other districts were more than the market could absorb, with the inevitable result of unemployment. The market for ceramic articles vanished.

To remedy this situation the Tokugawa feudal lord of Owari instituted a hereditary system, that is, he allowed but one of a family of potters to continue at that type of employment. Where, heretofore, all the sons of a potter had carried on the trade of their father, now only one son was allowed to do so, the others must make their living in other ways. The Tokugawa officials also, in a further attempt to alleviate the unemployment situation, established a production control. But neither limiting the number of workers nor restricting the amount of articles manufactured was to any avail, unemployment grew and became a serious problem.

At this time a certain Tokugawa official, Tsugane Bunzayemon by name, had reclaimed from the Sea of Atsuta a large tract of land, which became known as the Atsuta Shinden. A number of unemployed and their families were established here as farmers in order to increase the food supply of that district. But when Tsugane, who had been appointed governor of the Shinden, made a tour of inspection, he found the agricultural returns scant and the general conditions unsatisfactory. Calling the workers together he learned that many were potters from Seto who had been barred from their accustomed work by the new production control laws. Now Tsugane was himself a maker of porcelain and with his encouragement the ex-Seto potters set to work to experiment with porcelains at Shinden. They succeeded in making about ten different articles. The fame of this new porcelain kiln spread in the neighbourhood and it came to the ears of an influential landlord of Seto who was also himself a potter. He knew that the potters of Seto who did not know how to make porcelain were suffering and he feared the added competition of a porcelain kiln so close at home. With the approval of Governor Tsugane he petitioned the Tokugawa authorities to allow the potters of the Atsuta Shinden to return to Seto. This was allowed and the manufacture of a kind of porcelain was got under way at Seto. However, it was evident to all that their productions were not good, so a young man, Kato Tamikichi, second son of Kato Kichizayemon who had acted as leader of the group of Shinden potters, was delegated to go to Hizen in Kyushu to study the latest method of porcelain production.

To us of today with the international exchange of scholars in art and science this seems a simple matter. But in

the year 1804 in Japan a rigid feudal system existed and matters were not so simple. Permission to travel must be obtained from the Tokugawa officials and the secrets of making porcelain in those days were almost as closely guarded as the secrets of the atomic bomb are today. Aided by Buddhist priests who, as it has already been noted, were often themselves artists and patrons of artists, Tamikichi made his way on foot from Seto (not so far from modern Nagoya) to Kyushu. How long the journey took him we do not know, we next hear of him employed as a workman potter under Uyeda Motosaku at Amakusa in the ceramic center of Kyushu. But here he had no opportunity to learn that for which he had come so far, so on the pretext of visiting a religious festival he ran away. Lest our readers think we have taken the simile of the atom bomb too lightly we will follow Tamikichi a little further.

After leaving his first employer Tamikichi again sought the aid of a priest and was given a letter of introduction to Imamura Ikuyemon, a Government official in charge of the Nabeshima clan kiln at Mikawauchi. But before he had time to get established here he was ordered to move on by another official who did not like the idea of a stranger being in a position to spy on the local kiln methods of production. Again and again this happened, until at last, at Sasamura, he was employed by a Fukumoto Nizayemon at a small kiln. Here he was well liked, so well liked that after he had learned all he could and wished to return his master was reluctant to let him go. It took the intervention of his priestly friend to obtain his release. In January of 1807 he started on his return journey to Seto. On the way he stopped at his first place of employment and apologized for running away. In true Japanese fashion Uyeda not only forgave him but in token of his admiration of Tamikichi's perseverance in the accomplishment of his assigned task freely gave him the secrets of enamel over-glaze decoration, which he had before so jealously kept from him.

Tamikichi returned in triumph in August of 1807 and set about teaching the Seto potters what he had learned. Tamikichi deserves praise for his efforts to establish the making of decorated porcelains at Seto but praise must also go to his fellow potters for their co-operation and to the enlightened attitude of the officials of Owari Province.

Suzuri, or ink stone made of a hard fine-grained white porcelain, decorated in under-the-glaze blue with Chinese landscapes, a very early Otokoyama piece.

Written seal found on Maruyama wares.

Inuyama Kilns

The date of the founding of these kilns is uncertain. About 1751 they were producing sometsuke, or under-the-glaze blue and white wares and the name of Matsubara Kumabei appears. In 1835 a potter named Dohei made articles in *gosu akaye* (red and green enamel colours on a white ground) which became known as *Inuyama gosu*.

About 1836 Naruse Masazumi, feudal lord of Inuyama, inaugurated the making of wares decorated in enamel colours in a very distinctive design of maple leaves and cherry blossoms known as *unkin* (cloud brocade). See Page 45.

The productions of the Inuyama kilns are also known as *Maruyama yaki* or Maruyama kiln wares because the kilns were moved to this location about 1830.

The wares have a coarse hard biscuit covered with a colourless translucent glaze decorated with enamel colours of emerald green, russet red, dark reddish brown and black with the addition of a thick white glaze-like slip.

Typical small sometsuke plate showing symbols of felicitation; bamboo, rocks, crane and tortoises. The larger of the two tortoises is known as "mino-game" and the design is called "tsuru kame."

Kutani Kilns
and Potters

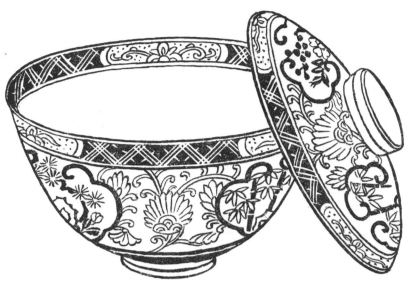

Kutani Rice Bowl

Kutani

The productions of the Kutani kilns, which greet one on every side, in department stores, in the small neighbourhood shops or in any of the many curio stores which have sprung up overnight since the occupation, include all sorts of articles. Plates, large and small; bowls of all sizes; vases; incense burners; images of men and animals and numberless small articles all attest the activity of these kilns. However, very few of the older wares were known abroad, and again the explanation is geographical. The Imari kilns in Kyushu lay in the natural path of commerce, and they were already established when the first European traders came. Kutani kilns were located about the middle of the main island of Japan and on the Japan Sea away from all European contacts and they were not opened up until the middle of the seventeenth century by which time the trade with Imari was well established. So we have the analogy of the Imari wares well known abroad and of little account in Japan, and the Kutani wares almost unknown abroad but well liked and highly prized in Japan.

Kutani wares may be roughly divided into two classes, those which resemble Imari wares to such a degree that considerable study is necessary to distinguish them if they are not marked as productions of Kutani and those wares undisputably Kutani in colour and style of design. It is with the second class

that we will deal at length, dismissing the first class with the passing remark that they can sometimes be distinguished by the shade of red used in the decoration, otherwise they are identical with Imari productions.

A peculiarity of Kutani wares is that (unlike Imari wares which had no potters' signs) with the exception of the very oldest pieces, ornamental objects, plates, bowls and cups bear the character *"fuku"* or Happiness in a square drawn in black with a brush, washed over with yellow or green glaze; later the characters for Nine Valleys (*Kutani*) were written with a brush in the Japanese *kanji*; later still the name of the maker was added. This is perhaps due to the fact that from the first these kilns were established as a business venture, they were never the private kilns of the feudal lord of that district as were the Nabeshima, Hirado or Satsuma kilns; although they were fostered and encouraged at their inception by Mayeda Toshiharu, feudal lord of Kaga.

| Painted mark "Fuku" meaning happiness or good fortune, usually in black washed over with green. | Japanese characters reading "Kutani"—painted in black inside the footrim of Old Kutani wares. | One form of written seals, reading "Kutani Eizan," Eizan being the name of a potter. | Another form of written seal, reading "Kutani Ryozo." |

The earliest record of pottery making at Kutani-mura (village of nine valleys) is that in 1628 Tamura Gonzayemon had established a kiln there and was making articles for cha no yu which resembled Seto wares. Priest Otani (of Hongan-ji, Kyoto) owns a hanging wall vase with an inscription to the effect that it was made on the 26th day of the 6th month in Meireki 1st (1655) by Tamura Gonzayemon. And many pieces bearing that date have been found in the ruins of the old kilns of this locality. Morikage, a pupil of the great Kano Tanyu, came to this little village and drew designs which Tamura used to decorate his wares. A Persian blue-green, a purple which merged into brown, a yellow varying from lemon to a faint brown, a vivid cobalt blue and an iron red supplemented by red-brown (*beni ye*) used on the edges of articles, made up the palatte of colours used on these first pieces. They are known either as Old Kutani (*ko kutani*) or Green Kutani (*ao*

PLATE XXV

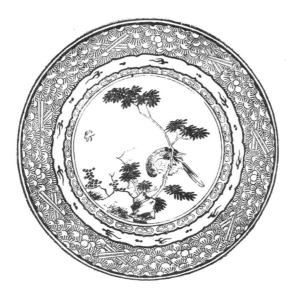

Large Green Kutani Deep Plate or Shallow Bowl.
(diameter about 15 inches)

The green border on the curved rim of the bowl extends over the back, which has also the green *fuku* seal. The design of the border is very interesting, being the sho chiku bai or pine, plum and bamboo of good omen. Fans are not only themselves symbols of ever increasing prosperity but they are made of bamboo, thereby furnishing the first of the trio. Thus we have the bamboo of the fans superimposed on a background of pine needles and plum blossoms. The idea of good fortune is further carried out by the border of jooi heads which signify "may things be as you wish."

The center of the dish has been left white. Next to the outer Persian green border (transparent green enamel over black line drawings) is a band of cloud forms in blue, purple and tarnished-gold or mustard yellow enamels. The band of yellow jooi heads is in a blue enamel irregular border on the outside, with two under-the-glaze blue lines bordering the center design. All the designs are drawn in bold black outline and filled in with colour.

In the center an aubergine purple and yellow bird is perched on a tree trunk of the aubergine. All the leaves are green. Two of the rocks are in blue enamel, one in yellow and one in purple. The butterfly is yellow.

This is considered a good example of Old Kutani.

Small Dish of Old Kutani.
The design is typical of the earliest Kutani wares, a Chinese landscape done in enamel colours on a milk-white background glaze. The pine tree and grasses and low bushes are sketched in black and washed over with a Persian blue-green. The little house and one rock in a brilliant dark indigo blue; the lowest rocks and hill at the right as well as the trunk of the pine tree are in aubergine purple. The smaller tree has red leaves and a yellow trunk. Two Chinese figures, one in blue one in green, stand on a yellow rock. The small design on the upper left side of the dish seems to fore-shadow the Kutani style of carrying the decoration of a plate over to the back but in this case the back is not decorated except with four groups of two pine needles in red. In the center of the back of the dish is a brush drawn seal reading *fuku*, in black washed over with the dark green enamel colour. The edge of the dish has a fairly wide line of reddish-brown, the so-called "*beni ye*" edge many old pieces have.

kutani). Up to 1664 only plates were made. The decoration consisted of, for the most part, birds and flowers, lightly drawn Chinese landscapes often with tiny figures just indicated, and various diapers in borders. Old Kutani designs were paintings on porcelain using a white background. Green Kutani (ao kutani) had large portions of the surface covered with boldly drawn vine arabesque in black washed over with a transparent blue-green glaze. A characteristic of Kutani wares has always been the attention given to the back of plates, often the surface pattern appears to bend over the edge and continue on the back. Old Kutani plates are flat, sometimes a bit convex, with a "pie-crust" raised edge outlined in a reddish brown (beni ye) which accentuates the thickness of the biscuit as well as furnishes a splendid colour contrast to the design proper. Pieces of Green Kutani (ao kutani) or Old Kutani (ko kutani) are hard to come by. They have always been held in high regard by the Japanese and their owners are loath to part with them. Kutani wares have no exact Chinese prototype, they are as Japanese as Mt. Fuji.

In 1650 clay materials suitable for making porcelain were found in this neighbourhood and in 1652 to 1654 Takeno Sho o or Jo o established a kiln for making utensils for cha no yu.

Kutani porcelain wares vary in quality as much as they do in colours; ranging from a coarse granular paste almost like pottery through what in Europe is known as faience, and a thick heavy true porcelain, to fine almost transparent egg-shell porcelain The colours range through Persian blue-green, egg-plant purple, reds and pinks, yellow, cobalt blue, white, black, brown, violet-blue, under-the-glaze blue, and gold and silver enamel

or paint. The background glaze varies from a dirty grey with minute black speckles, through bluish or greenish white to a beautiful milk white. Perhaps only the productions of the first forty years were originals, after that the succeeding kilns copied the older wares. Unlike the Imari wares which were fairly uniform in character the Kutani wares include widely different types of design. Kutani potters working side by side made Green Kutani (ao kutani) with its deep rich purple, Persian green and egg-yolk yellow; kinrande, finely drawn gold designs closely covering the Indian red ground glaze; under-glaze blue and white (sometsuke), and dozens of other colour schemes and types of designs, including reproductions of old Chinese porcelains and the wares of Cochin China. The best that can be done in trying to date any Kutani article is to say that it could not have been made before a certain date.

Written seal of the potter Ishida Heizo of the Meiji Period. He made Green Kutani.

The first kilns established at Kutani under the patronage of the Mayeda family made only articles for use in cha no yu, which resembled the productions of Seto. But news of coloured decoration on porcelain reached here and Mayeda Toshiaki despatched Goto Saijiro, one of the best potters of Kutani, to Kyushu to study at the Imari kilns there. Goto left in 1656 but did not return for ten years. In those days each potter kept his methods of making pottery or porcelain secret so that it was not merely a question of cleverness in learning new methods, in every case the confidence and good will of the teacher had to be won. There is a tradition, how true no one knows, that Goto settled down and married a woman of Hizen, the daughter of his teacher, whom he deserted when he had accomplished his object. True or not, the story serves to show how seriously the workmen of that day regarded their trade secrets. When Goto died in 1704 he left no one to take his place and the quality of the kiln productions retrograded and the making of Old Kutani stopped.

Just when the productions of the Kutani kilns became Old Kutani is not certain, because the boxes whose contents are now considered Old Kutani (*ko kutani*) are marked New Kutani (*shin kutani*). The first record of Kutani productions is found in the diary of Nojiri Masakane Yozozayemon, an entry dated August 5th, 1720 which reads "about three o'clock I was called into the presence of the lord (Mayeda Toshiaki) and granted a Kutani ware water-container (*Kutani yaki mizu sashi*)."

After the death of Goto Saijiro for about a

hundred years the Kutani kilns continued to manufacture wares of a very inferior quality for the local demand. During the years between 1807 and 1817 Aoki Mokubei made different kinds of old Kutani wares at the Kasugayama kiln. His wares were of high quality.

Typical Chinese warrior figures used on Japanese ceramics. These were taken from an Old Kutani plate.

In 1810 Yoshidaya Denyemon, a rich merchant of Kutani, reopened the kilns which had ceased to work and made wares patterned after the Old Kutani of Kochi style. These productions are known as Revived Kutani (*saiko kutani*) or as Yoshidaya wares (*Yoshidaya yaki*).

Some pieces produced at this time are most excellently potted and the colouring beautiful, showing direct Chinese influence. At first glance these wares might be mistaken for Chinese with their generous use of yellow and purple glazes and the very characteristic figures of men and women drawn in fine red lines but a closer inspection reveals unmistakable Japanese touches.

Two forms of the character for Fuku used by potters at the Yoshidaya kilns.

Written seal of the Wakasugi kiln.

Written seal of the potter Yujiro.

Yoshidaya Denyemon 7th turned over his Kutani kilns to a potter named Miyamotoya Riyemon, who is credited

with being the first to produce Green Kutani (ao kutani) and also with being the first to use a seal to stamp "*Kutani*" on the Kutani wares.

In 1822 Hayashi Hachibei, a potter of Waka-sugi, on the advice of Honda Teikichi, who had been a potter at Arita, borrowed money from Lord Mayeda and began to manufacture articles in the Arita (or Imari) style. These productions are known as Wakasugi wares (*Wakasugi yaki*). Honda himself having discovered a deposit of excellent porcelain clay began to make wares in the Imari style in cooperation with Aoki Mokubei and three other potters. Unfortunately Honda died and the project failed. Lord Mayeda took over the kiln and sold it to Hashimoto Yasubei, a merchant of Kanazawa. Hashimoto reopened the Wakasugi kilns and one of his potters, Yujiro, became famous for his decorations in red and gave his name to a certain class of wares, *akaye Yujiro yaki* or Yujiro's "decorated with red" wares.

Among the many attempts to restore Old Kutani wares was that made by Matsuya Kikusaburo during the period 1850 to 1867. He, in conjunction with Aoda Senyemon, made

Three seals of the potter Shozo.

Green Kutani (ao kutani) at the Komatsu kiln in Nomi, employing as many as 200 workmen. Kutani Shozo who followed became famous for his cups decorated with the figures of Chinese sages. In 1830 Iidaya Hachiroyemon originated Hachiroye wares (*Hachiroye yaki*) using red both for designs on a white ground and as a ground for gold and silver designs. These wares are known by many names:

> *Akaye Kutani :*—Red designs on a white ground.
> *Akaji kinga :*—Red ground with gold or silver designs.
> *Hachiroye :*—A combination of the two above styles; also red ground decorated with gold outside and under-glaze blue inside.
> *Aka gosu :*—Red designs on a white ground with the sparing use of a bright green.

PLATE XXVI

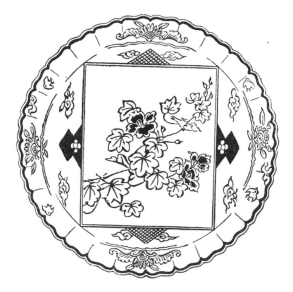

Old Kutani Plate

Ten-inch plate of excellent quality white porcelain of a slightly bluish cast, the fluted edge coloured brown. The dish is flat with one inch sharply upturned "pie-crust" rim; all the decoration is over the glaze.

The four floral motives on the rim, the four little birds as well as the triangular net and diamond shaped forms are developed in the typical "Kutani red" pigment showing the brush strokes. Three of the flowers (shown black in the illustration) are treated in the same manner.

The scattered clouds and leaves of the rim design are boldly outlined in black washed over with a transparent green enamel, with touches of pale canary yellow and violet, also transparent. The center design of bird and leaves is first outlined in black and the outlines filled in with transparent enamel colours. Three of the leaves and the head and breast of the bird are yellow. One leaf, the wings and tail of the bird and the stems of the flowers and leaves are in violet, as is the square border enclosing the center design.

The flower pictured is the *fuyo*, rose-mallow. For another treatment of the same flower see the Nabeshima plate.

The back of the plate has two groups of the double pine needles in red with the usual fuku seal washed over in green; and rather unusual for this type of plate two of the green leaves, those on the top and bottom of the plate as pictured, appear to bend over the edge of the rim, reminiscence of the earlier ao kutani (green Kutani). This plate is attributed to Yoshidaya.

Wazen, son of Nishimura Zengoro known as Eiraku, perfected Iidaya's *akaji kinga*, red ground with gold designs outside and red designs on a white ground inside.

 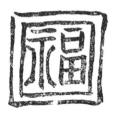

Three forms of Fuku used by the potters of Iidaya kilns.

Iidaya, who originated the Hachiroye yaki, which is known to Europeans as "Red Kutani" and at one time commanded high prices, had as his pupils several potters who afterwards became famous in their own right. Included among them were Kohachi, Seishichi and Zengoro.

Wazen (the thirteenth of the famous Eiraku potters) was invited to Daishoji in Kaga by Lord Mayeda of that district in 1875, and as instructor he contributed to the development of the Kutani kilns. His wares are usually marked "*Kutani ni oite Eiraku tsukuru*" or "made by Eiraku at Kutani." He sometimes decorated the inside of his bowls in under-glaze blue, covering the outside with gold designs on a red ground. His red is a bit lighter and more coral red than that of his father.

Seal of Zengoro Wazen of the Eiraku line of potters on the wares he made at Kutani.

Wazen was instrumental in developing the "Kaga red" wares, that is, designs in red on a white ground. Kaga wares sometimes have a roughly drawn comb design similar to the Nabeshima on the footrim, otherwise it is very difficult to distinguish them from Kutani wares. This difficulty is further heightened by the fact that porcelain wares from all over Japan are sent to Kutani to be decorated. However Kaga red wares are mostly of a soft poor porcelain, really a kind of faience.

Marks and Seals

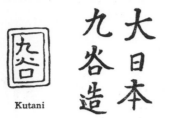 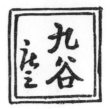

Kutani

Made in Kutani
of Great Japan

Shozo of Kutani

Josui of Kutani

Kaburagi of Kutani

As a rule the oldest Kutani wares have no mark of any kind. The first marks were in the form of written characters signing congratulatory phrases, such as *fuku* (happiness and riches), *roku* (food), *ju* (longevity), *sho* (felicity). Many of these old marks cannot be deciphered, because they are so carelessly (or ignorantly) written. The character for Fuku is still in use, usually written in black washed over with yellow, green or sometimes purple glaze. About 1850 the potters of Kaga began to sign their wares sometimes in red or black, sometimes in gold, occasionally in black washed over with green glaze. The brush written characters for Kutani (signifying "nine valleys") are still in use, apparently a contraction of *Dai Nihon Kutani Tsukuru* (made at Kutani in Great Japan) which does not date earlier than 1875. Present day Kutani wares are both signed and sealed and it needs must be a very poor cheap piece which does not bear the seal of the potter. Signatures are sometimes incised with a sharp pointed instrument in the biscuit.

The Kutani kilns have always been conducted along commercial lines. They were founded by the feudal lord of Kaga, Mayeda Toshiharu to give employment to his people. Although suffering vicissitudes from time to time, at the end of the Tokugawa Period more than 200 potters were employed. The revolution, or restoration, of the Meiji Period put a stop to all activities for a short time but by 1885 the business had revived and 2,700 people were employed.

PLATE XXVII

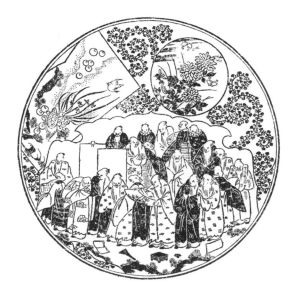

Red Kaga, fifty to eighty years old: all designs in red with touches of gold on a poor quality greyish white porcelain. This type of ware was made for export.

Small pre-war Kutani plate, a good quality bluish-white soft
looking glaze de rated in enamel colours; the large middle peony and
half open bud, the two cloud formations and the brush drawn border
in a pleasing orange-red carefully shaded. All the other flowers, buds
and leaves as well as the rocks outlined in black and filled in with
Persian-green, dark violet blue and aubergine purple. Back undeco-
rated except for two red lines on footrim and the brush written
characters 九谷 Kutani.

Ohi Wares

Ohi yaki is a kind of Raku ware. A pupil of
Raku Ichinyu, the fourth representative or generation of the Raku
family, named Mikawa Chozayemon was engaged by the Mayeda
family of Kaga as a potter. He established himself at Ohi and his
family has continued for eight generations. Chozayemon's wares, a
kind of pottery, were characterised by a deep brown glaze, his
successors used a brownish yellow. Ohi wares closely resemble Old
Kutani (ko kutani).

Kaga Yaki

Kaga wares resemble Kutani wares and are
scarcely to be distinguished; further, Kaga wares frequently have a
sort of comb design on the *kodai* (footrim) that can
easily be mistaken for the Nabeshima wares. Modern
dealers have been quick to capitalize on this similarity
and many so-called Nabeshima articles were made at
Kaga.

Seal of
Suisaka kiln

The first record of kilns at Kaga
is that during the reign of Empress Gensho (715-723)
they were producing a kind of pottery called *Gomado
yaki*. From 1335 to 1573 many kilns appeared all of
which made kitchen wares. During the twenty years
between 1624–44 *Suisaka yaki* was produced, from then
on the Kaga kilns turned out *Kutani yaki*. One Eiraku potter
produced his wares at Kaga and is known as *Kaga no Eiraku.*

The end of the nineteenth century saw the production of red Kaga (*Kaga akaye*). This is a quite distinctive ware; finely drawn Chinese figures usually in Chinese landscape setting, on a creamy white background. No colour except red is used and the designs entirely cover the article.

Ninsei at Soma

Seal of the Soma kilns.

Seal of Tashiro Gorozayemon, a Soma potter who studied under Ninsei in 1645 at Kyoto.

Soma *cha wan*, tea bowls for use in *cha no yu*. Note the unusual construction, the bowl was wheel-thrown perfectly round, then slashed into three sections and folded over to give irregularity. Each lap-over is held in place with three clay rivets. The general colour is greenish-greyish-yellow, produced by a transparent glaze over a tanish biscuit; the typical Soma horse design is drawn in iron pigment under the glaze which does not reach to the base of the bowl.

Nonomura Ninsei's reputation was known all over Japan and in 1645 Soma Yoshitane, feudal lord of Nakamura, Iwaki Province, sent one of his retainers, Tashiro Gorozayemon, to Kyoto to study under him. Yoshitane returned in 1648 and opened a kiln at Nakamura. Yoshitane continued his interest in the kiln and asked the artist Kano Naonobu to draw for him the design of a galloping horse, for that district is noted for its fine horses. This design was first used as a decoration on the kiln productions done in coloured enamels and to this day the design appears frequently on the Soma productions, the horses drawn with the utmost economy of brush strokes. Another mark found frequently on Soma wares is the Soma family crest of a large circle surrounded by eight smaller ones. See Page 13

Soma decorated wares show Ninsei influence in design and form. In another type the biscuit is a rather coarse greyish stone ware and the glaze a thin transparent brownish grey colour which shows traces of violet and red where it congeals thickly due to firing. The wares are well potted and sometimes decorated in high relief.

Kyoto and
Neighbouring Kilns
and Potters

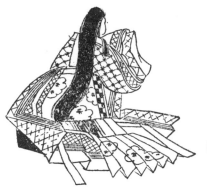

Japanese court lady wearing the *ju ni hitoye*, or twelve-fold kimono with her hair hanging free down her back.

Japanese court noble wearing the *e-boshi*, a kind of hat, lacquered black. Such figures as this are found on Kutani and Kaga wares also.

Kyoto Wares

Kyoto over a period of more than a thousand years has been the center of Japanese culture. A characteristic of the Japanese nation is that whenever a foreign culture enters Japan it creates a revolution in the indigeneous civilization but as this stream of foreign culture diminishes it becomes a part of the blood stream of the Yamato race and without fail a characteristically Japanese type of culture emerges. Kyoto has often been the scene of such a development; it was there that the Chinese art of weaving reached great heights and the uniquely Japanese arts of Yuzen dying and gold lacquer originated ; and it was there that the ceramic art of Japan flowered and artists of individuality and great ability produced masterpieces unsurpassed anywhere. These artisans and amateur potters made, and still make, elegant and exclusive pottery and porcelains.

Perhaps the lack of local materials and the fact that clays had to be brought from great distances prohibited large scale kilns but this resulted in a great variety of wares, the individual artist each developing his own blending of clays. The cultural level of Kyoto has always been the highest in the nation and a knowledge of the newest methods developed elsewhere swiftly reached there. Individual workers in their own private kilns developed specialities and took great pride in imprinting their names on their own wares. All this is in direct contradiction to the impersonal attitude of the potters of the various clan kilns.

Most of the oldest Kyoto kilns originated under T'ang cultural influences and T'ang influence is still strong in Kyoto wares. It is interesting to note that in these troubled times under foreign military occupation of their country Japanese potters are turning again to Chinese art for inspiration and T'ang and Ming designs are re-appearing on all classes of Japanese ceramics.

What are today called Kyoto wares (*Kyoto yaki* or *Kyo yaki*) originated about 1500. Raku yaki originated about 1520 when Chou, a son of the celebrated Korean potter, Ameya, was invited by Hideyoshi to Ju raku tei where he made tea bowls (*cha wan*) according to the design furnished by Sen no Rikyu, in red and black glaze on a soft pottery biscuit. This pottery with its soft feel and touch was most suitable for *cha no yu*. At first beautiful in its simplicity, under the corrupt taste of decadent cha no yu masters this ware became exaggeratedly and artificially simple and ended in becoming grotesque. Many Kyoto wares are similar to raku yaki.

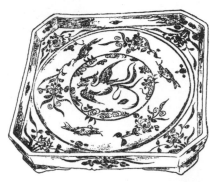

Gosu akaye square dish by Eisen of Kyoto. Design based on a Sung design developed in red and green on roughly pitted thick grey-white glaze. Very attractive because of its rugged strength and the sure firm brush strokes of a master hand.

About 1588 a soft refined pottery first made to the order of Sen no Rikyu developed and is still being made today, though the productions of today have not the beauty of the original wares. About this same time kilns were built at Otowa, Seikanji, Komatsudani, Kiyomizu and many other places in and around Kyoto. The war leader Hideyoshi's great cultural ambitions may be judged by this development of Kyoto as a center of ceramic art during his time and under his encouragement.

Awata Kilns

In 1624 Sammonjiya Kyuuyemon came from Seto to Awataguchi in Kyoto and began making pottery for cha no yu. The period between 1620 and 1700 was a time of peace and economic prosperity under the competent rule of the Tokugawa Shoguns. All forms of culture developed, life became elegant and clothing gorgeous. It was during this period that a purely Japanese

PLATE XXVIII

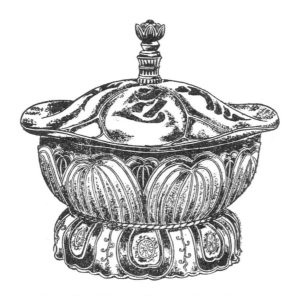

Lotus Shaped Incense Burner made by Ninsei.

Now in the possession of the Hokongo Temple and considered a national treasure. Its name "Kiriku Character Incense Burner" points to the probability that it was made for this temple for use on the altar.

About six inches in diameter, its total height equals its width. This type of pottery is known as Nishiki Kyo yaki, that is, brocade style ware of Kyoto. The predominant colours are a soft, dark red and an equally soft bluish-green picked out in gold-coloured enamel paint. The lid is a lily leaf, the bowl formed of lotus petals outlined and veined in gold. The bottom is the usual reverse lotus flower, red petals on a green base; the petals decorated with the Buddhist wheel symbol.

There are many articles called Ninsei yaki which are merely in the Ninsei style, but this pottery incense burner is believed to have been made by the original Ninsei himself.

type of culture had its beginnings, and for the first time the common people of Japan found self-expression in the cultural arts. The practice of flower arranging, and the art of gardening became the

activities of all classes of people; the unique, though plebian, art of wood-block prints developed; and in the world of potters Ninsei made his appearance. Ninsei was a man with a mission, to develop a Japanese style of pottery decoration independent of the Chinese, and he traveled all over Japan, teaching and demonstrating his theories.

Of Nonomura Ninsei's personal life little is known except that he worked first at a kiln called Otowa and also at one near the temple Seikan-ji both in the district of Omuro in Kyoto. Later his name is associated with Awata, Iwakura and Mizoro; also at Shigaragi, Akahada, Takamatsu and other places. Some of his wares known as *"Takamatsu Ninsei"* were produced under orders from the feudal lord of Takamatsu and today command a big price.

Modern Kyoto ware design in center of large flat bowl. Developed in rich red, shades of brown and green with gold clouds.

Ninsei's influence resulted in two new types of Kyoto yaki, Awata yaki and Kiyomizu yaki. Awata yaki is a soft looking ware with designs painted on a pale yellow glaze, with a profuse use of gold. Kinkozan Sohei and Obiyama Yohei are two artists who worked at Awata and whose wares are well liked abroad.

Ninsei

Nonomura Seibei (or Seiyemon), better known by his artist name of Ninsei, was a painter and amateur potter of Kyoto. He was born in 1595 and died 1666. His activities as a potter covered only the short space of ten years between 1630 and 1640 but his influence on Japanese ceramics is incalculable. The seal he used as a potter *"Ninsei"* was made up of the first syllable *"Nin"* from the name of his native village *Ninnaji-mura* and the first syllable of his personal name *Seibei*. As an artist he studied under masters of the two outstanding schools of Japanese art, the Tosa and the Kano. Ninsei studied under Kano Yasunobu and the Kano style of painting is plainly discernible in his pottery. Ninsei was under the spell of cha no yu and made articles for that almost exclusively, tea bowls, tea jars

Seal of Awata kiln

and water jars. He was among the first to resist the influence of foreign (Chinese and Korean) art and to draw in a more natural style, typically Japanese. His paintings are varied, some of dazzling brilliancy, others deeply quiet in tone.

As a potter he occupied himself chiefly with the making of utensils for cha no yu, tea bowls and water jars all of which show very effective potting and great delicacy of make up. He was one of the very first potters to apply the newly learned Chinese art of coloured enamel decoration to pottery and his name is associated with the unfortunate Aoki Koyemon who paid with his life for his ill-advised revelation to Kyoto potters of the secrets which Imari potters had learned through much tribulation.

Three forms of Ninsei seals.

Ninsei worked at first at kilns in the district of Omuro, Kyoto but later traveled about Japan wherever kilns were found, sometimes to practise his art, sometimes to instruct other potters. When it is considered that he worked at such widely scattered kilns as Shigaragi, Akahada, Takamatsu, Awata, Iwakura and Mizoro it will be more easily understood why we are told so many kinds of pottery are "*Ninsei yaki.*"

Some of his wares are known as Takamatsu Ninsei because made at the order of the feudal lord of Takamatsu. Some of his largest pieces were made for the Lord of Marugame and because they have been preserved in the store rooms (*mono oki*) of that family they exist today, undisputable evidences of the ability of Japanese artists three hundred years ago.

Ninsei's very first productions were influenced by Korean and Chinese styles according to the traditional or typical wares of the kilns he worked at. But after he learned the secret of enamel colours he created a style of his own, purely Japanese in feeling. He was most thorough in the manipulation of his clay materials and his biscuit was fine and hard and the crackles on his

glazes a regular net of almost circular mesh. He was fond of three glazes in particular, a cream colour, a pearl grey and a metallic black, this black glaze was laid on over a grass-green primary glaze. Many of his designs were painted in great detail and most elaborate; though it was in his style of decoration that he showed the influence of his Japanese art heritage, in his use of empty or undecorated spaces. Even while he was alive he had imitators by the hundreds and an authentic piece of his own work is among the greatest and most costly of rarities.

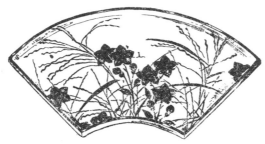

Cake dish by Kenzan, design of autumn flowers and grasses. Only three colours are used but the article is most attractive. Against a creamy-tan background Kenzan has drawn a spray or two of blue kikyo on stems of brown; the grasses are done in brown and faint green; only three curving blades of grass are done in a vivid grass-green by single sweeps of the decorator's brush. In the Japanese language no book on ceramics is considered complete without a reproduction of this dish. Both design and colouring are most attractive. Size about thirteen by six inches.

Next after Ninsei comes Ogata Shinsho, better known as Kenzan, born 1661, died 1742. He was a younger brother of the great artist Korin as famous for his artistry in lacquer as Kenzan in pottery. Kenzan was a poet before he became a potter and as subjects for pottery decoration he was inclined to keep to traditional classical (therefore Chinese) art motives. He often added a stanza of poetry to his ceramic designs and it is interesting to note that although as a potter he specialized in cha no yu articles he seems to have preferred a flat surface to work on and the small flat pottery trays ascribed to him are typical. In his old age Kenzan retired to the village of Iriya not far from Tokyo and some of his best work was done there. These wares are known as Iriya Kenzan. Kenzan's wares were extremely soft, much like Raku ware; and the glaze thin, allowing the irregularities of the biscuit to show through. His designs, always bold and sketchy, were brushed on with swift sure strokes. His works

Stamped seal of
Miura Kenya

— 143 —

are very distinctive and are still being copied. Kenzan left no heir so one of Ninsei's sons, Ihachi, assumed the role of the second Kenzan. Kenzan 3rd and Kenzan 4th were self-appointed successors to the title and what would have been the fifth successor was supplied by a potter, a native of Tokyo, named Miura Kenya (1821–1889), who though he did not use the name Kenzan made

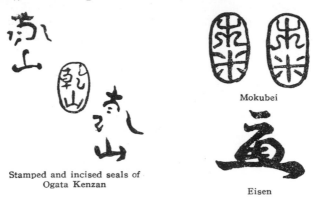

Stamped and incised seals of
Ogata Kenzan

Mokubei

Eisen

wares in the Kenzan style. He was a skillful potter and produced articles of excellent workmanship. His kiln was at Imado.

Kensai Uranowa a follower of Miura Kenya who became famous in his own right for the making of small articles in the style of Kenzan is also well known because he became the teacher of Bernard Leach, the English potter.

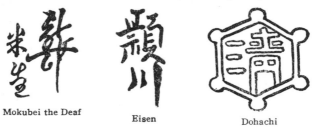

Mokubei the Deaf

Eisen

Dohachi

In the 1700's a potter named Seibei Yakyo who used the art name of Ebisei worked in the style of Ninsei. He had two famous pupils who were to establish him in ceramic history; Shimizu Rokubei, who was to found a long line of potters working in his quite distinctive style; and Okuda Eisen who in turn became the teacher of Takahashi Dohachi and Aoki Mokubei whose descendants are still producing outstanding pottery and porcelains. Mokubei was also known as Kiya Sahei, Kukurin and Hayaku-raku-sanjin. He died in 1834.

Okuda Eisen (1753–1811) was a wealthy man and amateur potter. He was a student of Chinese literature and in common with others of that time, he turned from the over-dominance of the cult of cha no yu to classical Chinese art for inspiration. He excelled in the imitation of the Chinese Celadons and gosu (blue under-glaze decoration on white porcelain) and gosu akaye (Ming designs of green and red on a white ground with bold touches of gold). It was he who established the first porcelain kiln at Kyoto.

The founder of the Dohachi line of potters was Takahashi Nawashuhei, second son of Hachirodayu, samurai of Kameyama. He lived in Ise. He was born 1737 and died 1804. At one time noted for his bamboo carvings, he turned to pottery and studied under Okuda Eisen. He established himself in a kiln at Awata and used the artist name of Kuchu as well as Dohachi. His favourite seal was in the shape of a tortoise with the character for "sei" written in it. This referred to the fact that he had been born at Ise with the family name of tortoise (*kame*) from Kameyama. He used six different seals on his wares.

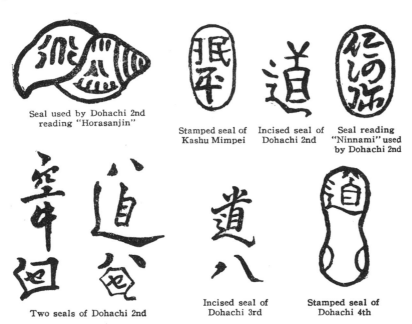

Seal used by Dohachi 2nd reading "Horasanjin"

Stamped seal of Kashu Mimpei

Incised seal of Dohachi 2nd

Seal reading "Ninnami" used by Dohachi 2nd

Two seals of Dohachi 2nd

Incised seal of Dohachi 3rd

Stamped seal of Dohachi 4th

Dohachi 2nd, whose name was Mitsutoki, was the son of the first Dohachi. He was born 1784, died 1858. He also was a pupil of Eisen and first became known for his copies of

Chinese blue and white (*sometsuke*) porcelain. Later he learned the art of coloured enamel decoration (*iro ye*), still later he made a kind of Raku ware. He visited the Mushiaki kiln at Bizen and Satsuma at the invitation of the feudal lords of those districts as instructor for their potters. He used also the names of Ninnami, Kuchu, Hosambun and Horasanjin. He, like his father, used six different seals. Under the name Horasanjin, which means "big-talker" he incorporated the counch shell (counch shell is *hora* in Japanese) into a seal. In his long life of seventy-three years he made many beautiful things.

A brother of Dohachi 2nd, the third son of Dohachi 1st, named Nawashuhei Mitsuyoshi, never took the name of Dohachi. He is known as Ogata Shuhei, Ogata Kichisaburo, Toyonosuke or simply Shuhei. He worked in porcelains, making both under-glaze blue and white and polychrome wares. He became the teacher of Kashu Mimpei and worked with him at the Awaji kilns. He died in 1828.

Dohachi 3rd, whose personal name was Mitsuhide was born 1783, died 1855. He turned from copying Chinese wares and produced purely Japanese things, imitating Ninsei, Kenzan, Eiraku, Hozen and Raku wares. He is particularly noted for his *unkin* (*un* cloud, *kin* brocade) also read *kumo nishiki* meaning clouds of cherry blossoms and brocade of maple leaves. This ware is easily confused with Inuyama productions. He also used the name Kachutei, for which name he used two seals; for Dohachi he used a simple easily read seal.

A pottery *jooi* in the possession of the author is made of a hard close-grain yellowish biscuit with a very Chinese style dragon pursuing a ball surrounded by flames against a background of conventionalized clouds. The dragon in high relief is glazed with a white glaze roughly mixed with cobalt under-the-glaze blue colour; the background clouds with a transparent greenish-yellow glaze. The reverse of the jooi has an oblong dab of white glaze with "*Dohachi*" brush written in under-the-glaze blue.

Dohachi 5th became the President of the Kyoto Potters' Association.

The Awata and Kiyomizu kilns, although their production was never large, have been far reaching in their influence.

Kiyomizu

Okuda

PLATE XXIX

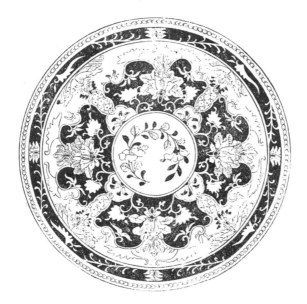

Kyoto-ware Plate

A very interesting example of the intangible effect of European art on Japanese art design. Judging by colour only the plate would fall into the category of Old Imari; but although every detail of the design is Oriental yet the general effect is European not Japanese.

The part which shows black in the illustration is in Imari red, the designs on it developed in a very grainy gold paint. The four band-like medallions which separate the red into four divisions are in a vivid turquoise blue-green enamel; otherwise the decoration is in under-the-glaze blue on a white ground. The chain-like design on the rim of the plate is in red on a white ground, the whole edged with gold. The design on the back is also typically neither entirely Japanese nor European.

In shape it is like a large saucer with a very narrow flat brim. 9-inch in diameter. It is one of a set of matching plates, cups and bowls. These matched sets were popular for a while in the last quarter of the nineteenth century. Tokyo people very soon reverted to the Japanese love of variety and contrast, as evidenced in dinner sets of every dish of which is different in material, colour and design; and such sets are now found only in the country where wealthy farmers and village headmen still treasure them.

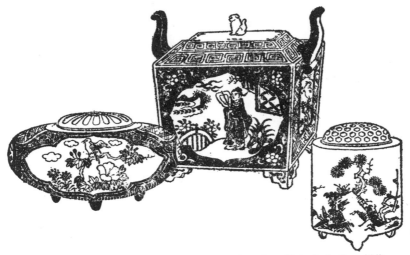

Typical *koro*, incense burners. That on the left made at Kutani; in the middle made by Dohachi of Kyoto; on the right a Kakiyemon design.

Kiyomizu Kilns

Kiyomizu yaki gradually developed into *some-tsuke* (under-glaze blue and white). The best known artists of this ware are Seifu, Yohei and Shimizu Rokubei.

Shimizu Rokubei, 1740-1799, was a potter who came from Settsu to Kyoto at Gojozaka. He was the son of Koto Ro uzayemon. He took the art name of Gusai and is said to have used eight different seals for his productions; one, which he always used on his *cha wan* (tea bowls) was called "*roku me*," six sided

Seals used by Rokubei.

with the character for "sei," first written for him by his friend Priest Keishu of Tenryu-ji; another, a seal he received from his teacher Seibei which reads *Kiyomizu* (but which may also be read *Shimizu*). He was a potter of exceptional ability and made wares with mono-chrome glazes, sometimes with coloured enamel decorations in reserves

and under-glaze blue and white. He was a personal friend of Maruyama Okyo and of the younger artist Goshun and he used their designs for his wares. Some time between 1764 and 1772 Rokubei built a kiln at Gojozaka in collaboration with a certain Wake Kitei. A pupil of Wake Kitei, Mashimizu Zoroku, became noted for his excellent celadons (*seiji*).

His son Seisai who became Rokubei 2nd died in 1860. Seisai was famous for his sometsuke (under-glaze blue) wares which he signed with his father's seal. He used, also, the names of Shoun and Guami. Seisai's eldest son worked under the name of Shichibei.

Rokubei 3rd, known as Shoun or Guami or Shichibei, was the nephew of the second Rokubei (some say son).

Rokubei 4th was known as Shorin; he died in 1920.

Rokubei 5th is at present continuing the family business, working both in pottery and porcelain.

Akahada

Design on dish made by Mimpei of Awaji closely following Chinese models of the Ching dynasty. Soft shades of brown, pink and green on a buff coloured background.

The Akahada kilns were among the seven best liked by Kobori Enshu. The wares produced were mostly those suitable for cha no yu. The biscuit is white with a greyish white glaze characterized by small black pinhole spots.

About 1575 a potter from Tokoname, Yokuro by name, was ordered by the Dainagon Yamato Hidenaga to make tea things, but by 1591 the kiln was discontinued. Production stopped until sometime between 1644 and 1648 when the famous potter Nonomura Ninsei of Kyoto came to reopen the kilns and to teach the potters how to make cha no yu utensils according to his fancy. This project also failed and the kilns were reopened for the third time by Yanagisawa Gyozan, feudal lord of Koriyama town about 1730.

When the potters produced an article that pleased Lord Gyozan he allowed them to use his personal seal " *Gyozan* " (堯山) on it. The Akahada wares are marked with two other seals; one, used simultaneously with the Gyozan seal, the two Chinese

Stamped seal of Akahada kiln

characters aka (赤) hada (膚) and another with three characters aka (赤) ha (ハ) da (ダ).

The name of Kashiwaya Buhei, known also as Mokuhaku, is associated with these kilns, Kashiwaya, born 1799 died 1870, was a potter best known for his imitations of Ninsei wares. About 1830 to 1844 he worked at Akahada and used as his seal two characters reading moku (木) and haku (白), because these two characters combined make up the Chinese character for his name Kashiwaya. Mokuhaku made mostly imitations of Ninsei but also okimono, decorative figures to be used as ornaments for the tokonoma.

Makuzu Wares

Makuzu ware vase made by Miyakawa Kozan for the 1936 exhibition of the Imperial Academy of Fine Arts.

The first of the Makuzu line of potters was born at Kyoto in 1797. He was known as Yukansai and was a samurai, follower of Lord Asai of Omi. Nothing is known of his son, but his grandson Chokansai established himself as a potter at a kiln in the compound of Chion-in Temple, Kyoto. The record of this family is very confused, for the reputed ninth generation, Chobei by name, was the uncle of the celebrated Kyoto potter Mokubei and Mokubei was actually older than Yukansai, the founder of the line. This is a very good illustration of the difficulties encountered when an attempt is made to trace a line of potters. Because of the system of adopting the cleverest workman to carry on the name of a master craftsman, regardless of blood ties, it is practically impossible to do this. All that can be safely said is that there certainly existed what the Japanese themselves call a *"densetsu"* that is a tradition of the making of certain wares. The "tradition" may have originated eleven generations back but just who the potters were is not at all certain. One of the best known lines of potters simply lists the generations with dates, but makes no attempt to fill in the names of the potters of each generation. In the case of the Makuzu line of potters they perhaps come of a long line of potters who had their kiln at Makuzu ga hara in Kyoto. The family name of Miyakawa must have been assumed in the early eighteen hundreds. Before that they were known only as

Seal reading Great Japan made by Makuzu.

Makuzu Yukansai, Makuzu Chobei, Makuzu Chozo, meaning the potter Yukansai of the Makuzu kilns, etc.

All that is authentically known of this family of potters is that in 1869 two Yokohama merchants, Komatsu Tatewaki and Suzuki Sahei, set up a kiln for the manufacture of ceramics for the export trade. They established their kiln at Minami Otamachi and called from Kyoto a certain Miyakawa Kozan and his son as potters and designers. In Kyoto this Kozan was famous for his Awata style "Satsuma" wares. Both Kozan and his son were excellent craftsmen. In 1896 Miyakawa Kozan was made a member of the Imperial Academy in Tokyo.

Seal of Miyakawa Kozan of the Makuzu line of potters.

Today Makuzu wares include both pottery and porcelain, almost always of excellent workmanship and frequently most artistic. However they appeal to the Westerners rather than to the Japanese.

Iga and Shigaragi

Shigaragi Flower vase. Greyish green glaze applied on the top section and allowed to run down in irregular streaks over the rough biscuit.

The productions of the kilns of Bizen, Shigaragi, Iga, Tokoname and Tamba were of the type called in Japanese "*sueyaki*," that is unglazed. An alternate name for this type of wares is "*yakeshime.*" Bizen yaki, a kind of yakeshime, is dealt with at length elsewhere.

The kilns of Iga and Shigaragi are located in the same district, not far from Kyoto, Iga on the south slopes and Shigaragi on the north slopes of the same mountain range. It is known that these kilns have been in operation since the early half of the eighth century and it is remarkable that in their long history of more than a thousand years no change has taken place in their method of potting. Unlike the kilns at Seto or Karatsu where various methods of production have been used, Iga and Shigaragi have remained untouched by the march of time. This is due to the fact that the clay is heavy and coarse and heavily mixed with fine quartz particles, and cannot be thrown on the potter's wheel. The ancient crude and simple, yet effective, method of kneeding the clay by hand and forming it into thin rolls or ropes is still used. These

Stamped seal of Iga kilns

ropes of clay are spiralled one on top of the other into the desired shape and the surface smoothed as well as possible, with the hands and bamboo spatula. When fired the clay suffers certain chemical changes and a natural glaze comes to the surface, as do also the particles of quartz that were imbedded in the clay. The clay of Iga develops a clear blue-grey glaze with scorched and greenish spots, while that of Shigaragi develops a dark blue glaze shading into brown with spots of yellow and red.

The oldest productions about the thirteenth century were jars of various sizes used by the ancients for the storage of seeds. These wares are known as Old Iga (*ko iga*) and Old Shigaragi (*ko shigaragi*). When cha no yu developed these wares became prime favourites with the cha jin, for though they were sturdy and uncouth and could hardly be considered artistic, they furnished an interesting contrast to finer pottery and to the black lacquer so well liked by the cha jin. Their popularity has never waned, today they are still being manufactured or the old wares imitated. They are used for flower vases, or for holding cold water during the cha no yu.

These wares first attracted the notice of Takeno Jo o, a cha jin, about the middle of the sixteenth century, and he had articles for cha no yu made for him at the Shigaragi kilns. These things became very popular and many cha jin ordered things made to their designs and later famous potters went there and made their own wares; so we have Jo o Shigaragi, Rikyu Shigaragi, Sotan Shigaragi, Shimbei Shigaragi, Enshu Shigaragi, Ninsei Shigaragi and others. No Iga wares seem to belong to an earlier date than 1334. In the middle of the sixteenth century two potters Jirodayu and Tarodayu under the patronage of Todo Takatora, Lord of Iga, restored the Iga kilns to production after a period of stagnancy. Wares were made under the direction of Kobori Enshu, but an artificial glaze was used. These are known as Todo Iga (*Todo Iga yaki*). Modern Iga and Shigaragi works are artificially glazed.

Tamba—Tokoname

Tokoname and Tamba wares are less well known but share with the above wares the fact that they were *yakeshime* wares, that is, no artificial glaze was used. In each case they were of a coarse reddish brown earthen ware with a natural glaze which developed in the firing. A speciality of Tamba wares is the so-called *usukumori*, or crouching flower vases. These are vases for the display of flowers at cha no yu which have crumpled

down out of shape under the heat of the kiln. They are great favourites of the cha jin.

Modern Tamba wares have a reddish brown biscuit with chocolate or mahogany coloured glaze or bluish-black, often the pieces are splashed with yellow; also an unglazed grey biscuit decorated with coloured enamels in simple bold designs.

Koto Yaki

These wares were produced at the eastern end of Lake Biwa at the beginning of the nineteenth century. They are hardly known abroad but they have their place in the historical development of Japanese ceramics. The kilns are modern as Japanese kilns go, having been established about 1829. In 1840 they came into the possession of Naosuke Ii, Lord of Hikone. This was before the arrival of Commodore Perry and at a time when Chinese things were in high favour with the rulers of the country and the influence of cha no yu on the wane.

Seal on Koto wares.

Lord Ii in an attempt to revive the prosperity of the kilns invited famous potters from kilns all over Japan to come and instruct his potter workmen. Among the many who came was Zengoro Hozen of the Eiraku line of potters. He taught the Koto potters his specialities of *akaye* (red pictures) and *kinrande* (gold pictures on a red ground). A distinguishing feature of the Koto designs is the preponderance of Chinese landscapes with tiny sages contemplating the beauties of nature in them, on the akaye. They also made faithful copies of the Chinese *gosu akaye*: this term includes both blue designs under a white glaze (known usually in Japan as *sometsuke*) and designs in enamel colours on the glaze, crude, sketchy, but exceedingly attractive designs of flowers and birds done in red and green. Often large spots of red (in the design known as *horaku*) were covered with actual gold dust dusted, not painted, on.

The most productive years of the kilns were between 1844 and 1853 when they turned out many beautiful things, mostly copies of the Manreiki Period in China (1573 to 1619). In 1860 Ii fell at the hands of assassins, a martyr to progress for he met his death because he had dared to sign treaties with the "outside barbarians" thus playing an important part in the modernization of Japan. After Ii's death the productions of the kilns deteriorated and in 1896 the kilns were closed down.

PLATE XXX

Koto yaki design on outside of covered bowl, patterned after Chinese Ming polychrome wares, known as *akaye*. Conventionalized lotus flowers with scrolled leaves.

Colours:—White ground with under-the-glaze blue with yellow, red, green and purple enamel colours on the surface of the glaze.

Date:—First half to middle of nineteenth century.

Old Imari *kinrande* border design of conventionalized flowers and balls surrounded by ribbon streamers. The ball with steamers is an attribute of the lion in Chinese and Japanese art.

This border was found on a bowl the central design of which depicted the dragon and the *hoo* bird. The lion is the king of beasts on earth and the *hoo* and dragon are celestial beings.

Colours:—The balls are under-the-glaze blue with white (reserved) ribbons on a red ground. The flowers are yellow with green ribbons on a white ground enclosed in under-the-glaze blue circles.

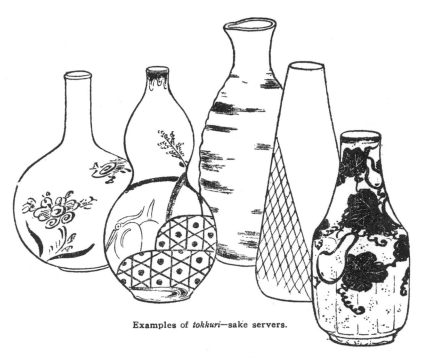

Examples of *tokkuri*—sake servers.

Awaji Kiln Products

In the last quarter of the eighteenth century a potter named Kashu Mimpei found suitable clay materials at Awaji and in 1831 he began making reproductions of *gosu akaye*, under-glaze blue and white in combination with red over-glaze decoration and of Ninsei's works. Mimpei had as pupil and co-worker Ogata Kichisaburo, the younger brother of Dohachi 2nd. He was a wealthy cha jin and remained always an amateur. He used the names of Shuhei and Toyonosuke also. Though many of his productions are only with difficulty distinguishable from Awata wares, he also was exceedingly skilful in making single colour glazes such as the Chinese imperial yellow and apple-green.

Ogata Kichisaburo, often known only as Shuhei, worked at Gojozaka in Kyoto the latter half of the eighteenth century, where he at first made reproductions of Ming china similar in style to the Eiraku productions. His chief claim to fame is that he worked with Kashu Mimpei. See illustration on Page 148.

Awaji wares were exported in great quantity to Europe and were received very favourably there.

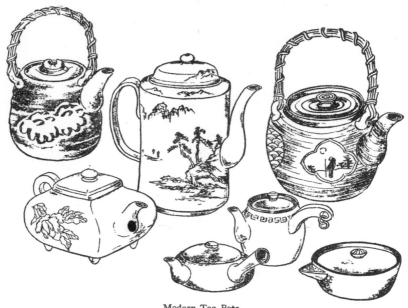

Modern Tea Pots

Stone Ware

The Japanese use the term stone ware somewhat differently from European usage. They have a stone-ware which they call " *sekki* " (or stone). It is a heavy unglazed pottery, literally as hard as stone and the things made of it are chiefly large containers or pots (what Europeans term " crocks "). Bizen yaki which Europeans class as stone ware is not so considered by the Japanese.

Buccaro is the name given by the Portuguese to a reddish-brown or chocolate coloured thin hard unglazed stone ware made at Yi-hsing in China at the beginning of the sixteenth century. It was copied in Europe, especially by the famous potter Bottger. Bottger produced exact replicas of the Chinese wares by making molds of the originals and casting his native materials, which, however when fired were harder than the Chinese. The Chinese clays were very ductile and frequently the only decoration of an article was the imprint of the potter's finger tips. Again some pieces were finished smooth as glass and others elaborately decorated with applied ornaments. In Japan small tea pots (*kyusu*) are highly prized for the making of tea, and are still being imported despite the fact that a ware very much resembling the Chinese is made at the Banko kilns in Ise Province.

PLATE XXXI

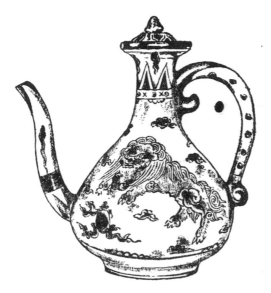

Old Banko Wine Pot

Typical Ko Banko production; soft, thick almost porous pottery with a soft cream coloured glaze, crackled in rather large very shallow crackles. The design shows a crudely drawn Chinese lion sporting with a ball surrounded by fire-forms. The body of the lion and the flame-forms are in green. The mane and curly tail of the lion, as well as the ball and the mouth, handle and snout decoration are in red.

Banko

Present day Banko wares are being turned out in quantity, chiefly the small tea pots above mentioned and covered tea cups and small bowls. The knobs on the lids are cleverly executed amusing small animals ranging from the traditional fabulous animals of Chinese folklore to the domestic cat or mouse. Rapid sketches of the graceful bamboo or the angular plum branch with its blossoms are engraved as decoration on the body of the object together with a line or two of Chinese poetry. Occasionally they are sparingly decorated with coloured enamels in floral designs. Other kinds of this ware have medallions of under-the-glaze blue and white on the unglazed background. This glaze is always greyish white and the background which burns reddish or bronze-brown on the best pieces shows signs of manipulation on the potter's wheel. Sometimes the outside of a bowl is unglazed and the inside of the lid or the entire inside of the bowl is decorated with a carefully drawn Chinese landscape in blue under a greyish white glaze.

Design on Banko ware.
Fifty to eighty years old.

But these brown stoneware articles are but one class of Banko productions. From the standpoint of fine art and in the consideration of Japanese ceramic connoisseurs a totally different type of pottery is brought to mind at the mention of the name Banko. In the middle of the eighteenth century Numanami Gozayemon, a wealthy merchant and amateur potter, living in Kuwana near the great Ise Shrines began to make raku wares copying Ninsei and Kenzan. His fame spread to Tokyo and in 1785 the Shogun Iyenari summoned him to Tokyo as official potter. Under Iyenari's patronage Gozayemon made copies of the Chinese famille verte and famille rose, even copies of the Delft wares of Holland. Gozayemon worked alone and his productions

Two forms of seals found on Banko wares.

— 155 —

are collectors' items only. He left no successor, but **thirty years** after his death (1830) a certain Mori Yusetsu found the Banko formula for making enamel colours and bought the Banko seal from the grandson of Gozayemon. The factory he established is still in existence. Besides the easily recognizable brown wares, bowls, bottle-like vases and a kind of " tea pot," (really **old wine ewers**) made of a soft grainy clay glazed in a cream glaze with large irregular crackles and designs in red, known as *akaye,* or under the glaze blue (*sometsuke*) are the best known.

Lacquer on Ceramics

A little known ceramic ware consists of pottery and porcelain articles decorated with lacquer. There seems to be no happy medium in these wares. They are either small trays or cake bowls, beautifully decorated in the best Japanese manner with gold lacquer, or large heavy vases and covered jars for export. These export pieces are completely covered with a thick layer of lacquer, in black or dark red green or brown, which in its turn is decorated with coloured lacquers or inlaid with mother-of-pearl in Chinese landscapes with figures.

A third type combines the traditional under-the-glaze blue with lacquer of various colours. The first and third types, intended for the use of the Japanese themselves are beautiful in shape, colour and design. But the export wares are bad in colouring, over-crowded in design and clumsy in shape. They were produced at widely scattered kilns, Tokyo, Kyoto, Kutani, Imari, but mostly at Nagasaki.

Tokyo Kilns
and Potters

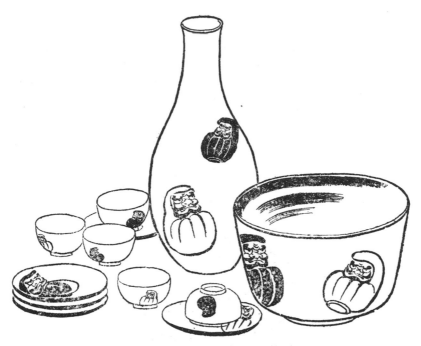

Set for serving sake at informal gatherings.

Tokyo Kilns

Imari, Kutani and Seto wares are so called because of the location of the kilns; they are also the oldest kilns for the production of porcelains, in the order named. In connection with these kilns very few individual potters' names are known. The opposite is true of the productions of the kilns in and around Kyoto where ceramic wares were known first by the name of the potters and later collectively by the name of the location of most of those individual kilns, *Kiyomizu yaki* (Kiyomizu wares); later still the term Kyoto yaki or wares of Kyoto came into use. It must be remembered that since pre-historic times kilns were in existence where there were natural deposits of suitable clays and that the knowledge of porcelain making was practically unknown in Japan till the sixteenth century. The end of the sixteenth century and the beginning of the seventeenth century was a time of cultural expansion all over the world, a time of adventure and material progress; Queen Elizabeth reigned in England; the first European settlements were being made in America; an Englishman, Will Adams, came to Japan in a Dutch ship. In Japan at this time two

strong influences worked upon the development of ceramics simultaneously, the demand for pottery things for use in the practice of cha no yu and the demand for porcelain articles for export to Europe. Kilns already in existence went into production on porcelains, resulting in increased activity in the district of Kyushu, Kanagawa and Owari. The demand for special and original pottery articles resulted in the establishment of many private kilns in and around Kyoto.

In 1868 the signing of treaties of trade and friendship signalized the change in political and social Japan from national seclusion and self-sufficiency to free international association and a swiftly increasing dependence on foreign trade. This time the United States of America, not England, took the lead in this

Small double bowl made by Miura Kenya.

international exchange of ideas. The ports of Kobe, Osaka and Yokohama, not of Kyushu, handled the bulk of all trade with foreign countries. The establishment of Tokyo as the new capital of the nation and the abandonment of Kyoto by the Emperor and his court focused international attention on Tokyo, and foreign diplomats and traders alike took up residence there.

Thus it came about that the old established ceramic kilns were obliged to open branch offices in Tokyo for the convenience of these foreign traders and enterprising potters and business men located their new kilns in the vicinity of Tokyo and Yokohama. There are instances of the individualistic potters of Kyoto, whose productions are known as " *densetsu* " or traditional wares coming to Tokyo and setting up kilns, but almost invariably these kilns were not financially successful and the potters returned to Kyoto where they were in a more congenial atmosphere. The

times had changed, cha no yu became neglected, the people wanted only new and preferably European things, and this intensified the demand for foreign style ceramics created by international trade. The kilns in and around Tokyo may be roughly divided into two types; those of individual potters who produce certain typical wares, potting, firing and decorating them in their own kilns; and so-called kilns which are really only decorators of wares produced elsewhere in Japan, the kilns being only muffle kilns with heating capacity sufficient only for fixing the decorations.

The productions of many of the Tokyo kilns must be classed as *raku yaki* because these wares may be fired at a comparatively low temperature, but they do not conform to the traditional idea of raku yaki. Sometimes the work of a master potter, which has caught the fancy of some buyer becomes popular abroad for a time but on the death of that potter or a slackening of the overseas demand the wares cease to be produced. In such cases the wares are far better known abroad than locally and the eager foreigner who brings a prized family possession in hopes of finding a mate or duplicate of it is doomed to disappointment.

Fan shaped cake dish made by Miura Kenya. The *sho chiku bai* design is developed in black, green, shades of brown and white on a creamy-tan background surrounded by a dark olive-green glaze. The dish is large twelve by fifteen inches and more than three inches deep and the pottery and glaze very pleasant to the touch.

The productions of the second type of kilns those which decorate articles made somewhere else are also much better known abroad than at home. Some are artistic, some are not, but all display a high degree of skill on the part of the decorator. The designs may be Japanese or European, more often a mixture of the two. At least one kiln specializes in making imitations of European paintings on ornamental plates and they can

faithfully reproduce the heavy rich appearance of an oil painting or the delicate soft tints of a water colour.

The range of colours used on the old or traditional (*densetsu*) type of ceramic wares was very limited, confined entirely to a dark, full blue which showed purplish black in places both under and over the glaze; several shades of a dark orange or brick red enamel glaze; a muddy yellow which sometimes shaded into a thin brown; a brilliant dark green, shading into peacock-blue and a beautiful turquoise blue; an aubergine purple which shaded into a muddy brown; and a bright black enamel to which must be added gold paint or sometimes gold leaf. Strong forthright colours, they were applied in broad unshaded splashes or as a background for the gold, beginning and ending abruptly.

Tile by Iriya Kenzan.

Modern ceramics use the full European scale of colours and shades of colours; pale (or baby) pink and blue; all shades of grass and leaf green; cerise; lavender; shades of brown and grey; Chinese yellow; red shading from maroon to cherry with none of the orange tints of the oriental colours; soft shades of rose; sky blue; reddish-orange; in fact a full palette of colours with which landscapes, portraits, trees and flowers can be realistically depicted. Such colours, subtile and elusive, are applied with the technique of the painter, not the potter, and shade off and melt into the background. A peculiarity that unmistakably distinguishes these modern European inspired decorative glazes is that they present a slightly rough, wholly disagreeable surface to the touch. Gold is used in abundance painted and even plated on; this gold is sometimes heavily plated and in its turn is decorated by an etching process.

There is one more type of ceramic wares that needs to be recorded, although Tokyo is the center of interest in such wares, not the place of manufacture. These wares are a revived version of folk-craft but they lack the artlessness and spontaneity of real art-craft for they are, in the most, obvious attempts to produce such spontaneity. However, their appearance in the world of ceramics is encouraging and at least in one case laudable. As was the case with the Seto kilns a hundred and fifty years ago (see the story of the potter Tamikichi) social changes brought economic distress to some old kilns. When modern Japan so enthusiastically adopted many new ideas and articles, kilns which had produced household utensils felt the competition of enamel wares and aluminum wares and fell steadily from one economic level to a lower. However, as has happened so often in Japanese history, the plight of the workers was noted by one of the heads of that district· Feeling sympathy with their distress and accepting his responsibility as their natural leader, a young man of one of the leading families set himself to remedy the situation. A man of good education he bent all his efforts to the study of more efficient methods of production and to consideration of a higher artistic standard for the wares. He studied the traditional folk-craft of Japan and its neighbours, familiarized himself with modern European tendencies in ceramics and succeeded in raising both the artistic standard of the kiln wares and the economic position of the potters. At the time of writing he is the leader of a popular movement in Japan and in high favour with the resident foreigners.

Today the bulk of ceramic wares, chiefly porcelains, is being produced in and around Nagoya, for with the introduction of modern kilns and imported fuel for their operation the location of a kiln is decided by transportation facilities and availability of labourers.

The production of ceramics in Japan is a growing industry. It was one of the very first industries to be re-established under the occupation. The demand abroad for Japanese porcelains is increasing steadily and the present writer leaves the recording of that stage of Japanese ceramics to other hands. Her interest has been primarily in the evolution of design, especially that of the Orient and she hopes that she has awakened the interest of some and strengthened the interest of others in the designs on Japanese ceramics.

Noritake and other "China-wares"

These wares, strictly speaking, have no place in a book such as this. Made in Japan they are neither Japanese nor Oriental, in shape, colour or design. Noritake China is produced by the Nihon Toki Kaisha at Nagoya. The company was established in 1904 and its entire output is destined for export. Its productions are no more Japanese than is the modern rattan furniture now so popular with European sojourners in Japan. The Okura Toen is an outgrowth and associate company of the Nihon Toki, but its designs and colours are modified by Japanese taste. Its factory is at Kamata, near Tokyo.

Rice Porcelain

This term is applied to certain wares through the mistaken assumption that they were made by inserting grains of rice in the paste, which were then glazed over, and were destroyed when the article was fired, leaving holes. Actually this was not so; the paste is carefully carved into the desired pattern which is then glazed and fired and decorated in any other manner desired. At one time, about twenty years ago, these wares were produced in quantity in Japan and exported to China where they were sold as Chinese wares to unsuspecting foreigners.

The French call these wares "grain de riz" and they are very similar to the Persian Gombroon wares.

Korean Wares
Brief Historical Outline

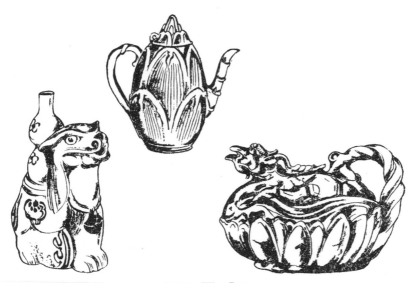

Korean Wine Pots
Left: under-the-glaze blue and white, almost eight inches high.
Belongs to time of Ri dynasty.
Top: celadon glaze over inlay decoration. Date unknown.
Bottom right: Korai dynasty celadon about five inches high.

Korean Ceramics

Continual reference has been made to Korean influence on Japanese ceramics, perhaps a brief outline of Korean wares is indicated here. The ceramic wares of China are of course the prototype of Japanese wares but the arts and crafts of China have been elaborately explained in many books and need no more than mere mention in a work of this kind. However, Korea was the agent for the transmission of Chinese art to Japan and Korean potters figure prominently in the history of Japanese ceramic wares. Very little is known of the history of this unhappy country; even as this book goes to press Korea is again a battle ground as has happened so often down the ages.

In the early centuries of the Christian era Korea was divided into three countries KORIO, Japanese *Kokuri*, *Korai* or *Koma*, Chinese *Kao li*; PEKCHE, Japanese *Hyakusai* or *Kudara*, Chinese *Po chi*; and SILLA, Japanese *Shinra* or *Shiragi*, Chinese *Sin la*. In the middle of the seventh century Silla (which was founded 58 AD) absorbed the other two countries and the peninsula now known as Korea became a single kingdom with a puppet government under the suzerainty of China with its capital at

Taiku. Under the cultural influence of Buddhism which entered Korea in 372 the country reached a high state of civilization. But in 935 Silla was overcome by Korio and the Korai dynasty was founded. The name Korio survives in the modern Korea. However, this dynasty came to an end in 1392 with the revolt of Yi Taijo who founded the Yi (or Ri) dynasty. The name of the kingdom was changed to Chosen (Chinese *Ch'ao hsien*) meaning "Morning calm," the capital was moved to Seoul and the country was completely dominated by the Ming dynasty of China. Of the Korean classical arts of the flourishing period up to 1392 noth'ng remains; but the art-crafts of the potter can be studied. For this we can thank the Korean custom of burying pottery vessels with the dead.

The earliest Korean pottery closely resembles the pre-historic pottery of Manchuria, parts of China adjacent to Korea, and of Japan and Saghalien. The first literary reference is found in the annals of Northern China Wei dynasty (386-549) in a description of Korean funeral rites. Wares of this period were found at Taiku and Fusan. The tombs of the Korai dynasty (935–1392) mostly in and about Songdo yielded excellent pottery wares.

In general it may be said that Korean pottery is quite distinctive in shapes, colours and decoration. Korean wares differ from both Chinese and Japanese in the evidence of the method of firing in the kiln, the whole of the base including the footrim is

Upper left: antique earthenware urinal covered with a blackish olive-green glaze. Date uncertain.

Lower right: *Richo sometsuke*, that is under-the-glaze blue and white made during the last Korean dynasty. This is a water pot; height five and a half inches.

often entirely covered with the glaze while the rim or mouth of the vessel is left unglazed; or irregular patches of grit show where the object was stood on little piles of sand in the kiln. The footrim, especially in the oldest pieces is very slight and thin, almost non-

existant, with a characteristic deviation from the usual making it crescent shaped, not full round.

Showing various styles of *kodai* or footrim, found also in Japan but originated in China and Korea.

The Koreans unlike their neighbours the Chinese and the Japanese are not tea drinkers, and what are called " tea pots " actually were containers for wine and the small typically Korean cups on high saucer-like stands were used for wine not tea. This peculiar type of cup and saucer are found only in Korea. The Japanese occasionally make the high saucer-like stands out of lacquer, but these are rare. The wine pots of Korea are unique to Korea, too, and take on weird shapes; the commonest resemble flowers or vegetables, oftentimes with an unexpected small animal as a knob for the lid or snake-like dragon handles. Other typically Korean articles are small boxes and bottles in matching sets, sometimes with large enclosing box, which were used for holding various preparations for a lady's toilette.

While the Korean potters did succeed in mastering many of the Chinese pottery styles, it is chiefly in the celadons and the T'ang and Sung wares; they never made the beautiful porcelains that Japanese potters did. Korean designs are of course based on Chinese models but the most characteristic Korean design is of small daisy-like flowers inlaid in the biscuit under the glaze, this seems to be confined to that country These flowers are depicted sometimes in small branching sprays usually in a circle but more often the rosette-like blossoms are set in rows without leaves. A design which the Koreans received from China but which does not seem to have been adopted in Japan consists of scantily clad children, very badly drawn, playing among scrolls of lotus blossoms. This motive illustrates the migrations of design for it has common origin with the decorative " putti " amongst the scroll work of Italian majolica wares and the Eros or Cupids of the Italian Renaissance in Europe. In Japan this motive never became

popular and when, very much later, the design of playing children re-appeared there, it took the form of fully dressed smal boys playing under realistic trees, sometimes palms sometimes pines, and was usually developed in colours on porcelain not under the celadon glaze as in Korean. Another typically Korean conception, ducks floating on water under, or flying above, very highly conventionalized willow trees among lotus plants also had little effect on Japanese ceramic design; but the Korean design of a kind of reed, found usually in the so-called painted Korean wares (*ye gorai* in Japanese) are in use in Japan to this day. One design found in celadons,

Typical Korean ceramic design, developed by engraving the biscuit and filling in the lines with white, black and green. This duck design never entered the Japanese stream of design although the reeds persist to this day at some kilns.

mishima type wares, and in colours on porcelains is called by the Japanese *un kaku*, cloud and bird design. This un kaku design is common to China, Korea and Japan on all types of wares both ancient and modern. Korean designs are almost without exception carelessly executed and only occasionally rival the Chinese models in vigour and freshness.

The author freely acknowledges her indebtedness to Bernard Rackham who in his "Catalogue of the Le Blond Collection of Corean Pottery" divides Korean ceramics into three types. 1. Indigenous Wares. 2. Wares of Uncertain Origin and 3. Imported Wares. Rackham states "The indigenous wares may best be classified by material and technique; there are no clues as to the localities in which the various types were made" but he follows this with the statement that "all the finest celadon wares are found in the neighbourhood of Songdo." It is the graves of the Korai dynasty that have yielded up the ceramics upon which we must

935, lasted until 1392 and this period roughly coincides with the Sung Period in China, 960 to 1278. The wares of Korai like the Sung wares vary greatly in weight and thickness and range from paper thin to almost an inch in thickness, and, strangely, the finest specimens are usually the oldest. Speaking in very general terms it may be said that the wares of the Korai period reached a higher standard than was possible for the potters who followed and as near as can be ascertained the best wares were produced during the one hundred and twenty years between 1050 and 1170. Most authorities agree that after 1392 very little of high artistic value was ever produced. The more than two hundred years between the downfall of the Korai dynasty and time of the Japanese invasion (1598) saw a steady deterioration of the Korean ceramic art. The unsophistication and artlessness of the wares produced during this period appealed to the Japanese cha jin (tea people); but it is the wares of the Korai Period that bring the highest prices and are prized as collectors' items by the Japanese. The wares of the Ri (or Yi) dynasty (1392-1910) are considered less desirable and inferior in workmanship.

Typical and purely Korean incised and inlaid designs. These small flowers are not found in China and exist in Japan only on wares showing strong Korean influence.

Detail of design in white inlay on a Korai dynasty celadon tea bowl, owned by the author.
Top: Korean variation of the Chinese vine meander.
Wide middle band: cranes flying among clouds, this design is called *un kaku* in Japanese.
Narrow middle band: a very common design, perhaps representing waves.
Bottom: variation of the *jooi* head pattern.

Indigenous Wares

These seem to have been of two types of celadons and, to again quote Rackham, "a beautiful pure white porcelain with a highly translucent body of granular sugary fracture; the glaze with which it is covered is soft and transparent, readily scratched, of decidedly bluish tone (suggesting the hue of an aquamarine) and full of minute bubbles; in exceptional cases it is crackled." The Japanese call these wares *haku ji*, or white wares, and they have never made any special effort to produce them themselves. The articles were mostly dishes, round boxes in sets and wine cups and were decorated with incised floral designs, moulded in relief or by the use patterns engraved in a thick slip under the glaze.

The celadons must again be divided into two types, the first a grey-bodied porcelaneous ware with a greyish blue or greenish jade-like soft thick glaze. These are decorated in the same manner as the white wares, as well as in the more distinctly Korean style of decoration called by the Japanese *mishima de*. The design is impressed in the biscuit with small stamps or dies, or incised with a sharp pointed instrument, and then filled in with

white or greenish black clay, sometimes alone sometimes in combination, the article is then covered with the celadon glaze. This method originated in China in the T'ang dynasty but the Koreans used it as their most characteristic ceramic decoration. The Japanese classify these wares into two types, one of which they call *Korai Mishima seiji* that is, "Korai period Mishima style inlay celadons" and *Korai seiji* or "Korai period celadons."

The best of these mishima Korai were produced between 1170 and 1274. A later ware with more crowded inlays and a glassy kind of glaze is thought to have been produced during the period 1250 to 1392.

Celadons decorated with paintings of thick brown or white clays in bold sketchy floral designs under the glaze are thought to have been produced between 1274 and 1350. The Japanese call this ware *ye gorai*, painted Korai wares.

Korean floral motives developed in iron pigment under the surface glaze.

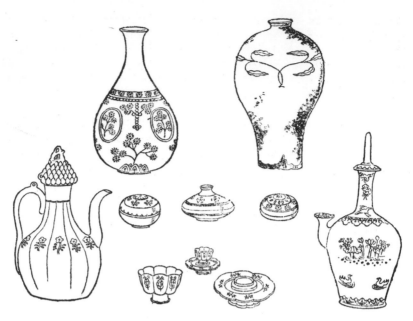

Typical Korean Shapes and Articles, mostly of the Korai Dynasty.
Top row : on the left *zogan Mishima* style, on the right, leaf design in white painted on brown slip under brownish celadon glaze.
Below : two engraved and inlaid wine ewers.
In the center : two small boxes for holding cosmetics and a low squat bottle for holding hair oil. Typical Korean stand cup (called in Japan *ba jo hai*) with accompanying high saucer.

Wares of Uncertain Origin

Wares imported from China are only with difficulty to be distinguished from Korean copies of Chinese wares. One very large class of articles, chiefly bowls and small jars, has a brown glaze derived from iron, these are generally known as *Temmoku* wares, although Warren E. Cox in his excellent "Pottery and Porcelain" prefers to call them simply "dark brown coloured pottery." They have been known in China since the T'ang dynasty and the paste varies from coarse earthen ware to semi-porcelain, some have a compact light buff-coloured body others greyish-brown or dark purplish brown. These wares were made at more than one kiln in China and were given the name of Temmoku by the Japanese, Temmoku being the Japanese pronunciation of the Chinese *T'ien mu shan*. The glaze is a soft oily looking glaze formed by a mixture of black and brown glazes with the black predominating ; the brown

appears in flecks and streaks giving rise to such names as "oil spots," "hare's fur" or "partridge feather" glaze. See pages 33 & 34. A variation of this type, a warm brown glaze verging into rust colour and olive green is called *kaki gusuri* or persimmon glaze by the Japanese. This colour seems to have no Chinese prototype so may be considered as a Korean development.

Another controversal ware is a white or cream coloured ware known as Ting ware but called *haku gorai* or *komagai* (White Korai) wares in Japan. These have been produced in China since the ninth century and were made at Chen ting fu and later at Ching te chen. They were either left plain or decorated with engraved or embossed designs under the glaze. Often the glaze covers the article very unevenly and in places gathers into straw coloured blobs—called "tears" by Oriental collectors. Such quantities of this ware have been found that it is reasonably certain they were produced in Korea.

Korai dynasty Korean incense burner, drawing reconstructed from a badly damaged original belonging to the author. Made of a very fine grained grey biscuit which burned reddish brown where exposed to the heat of the kiln it is covered with beautiful blue-green celadon glaze without crackle over typical white clay inlay cloud design on the base (not shown in the drawing). Each petal of the lotus flower top has been modeled separately and attached, then the entire article was glazed in one operation. The three feet are very strange, they appear to be the head of a water-buffalo because of the length and very pronounced nostrils. The drawing is not good, the article is most attractive both in form and colour.

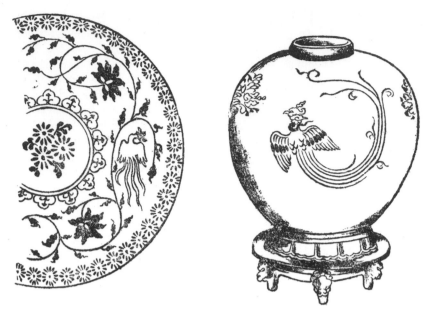

Korean ceramic art motives. Black and white inlay under greyish green celadon glaze, featuring two versions of the hoo bird.

Imported Wares

Under this heading Rackham lists a ware called by the Japanese ye gorai, these articles are decorated with vigorous floral designs in a dark molasses-coloured brown on the surface of a thick white or cream coloured engobe (or slip) the whole then covered with transparent glaze. Rackham says these must have been pre-Ming and thinks they came from China. However the Japanese assign these wares to Korean manufacture without question.

All authorities agree that the best Korean ceramics were produced during the period between 1050 and 1170. These wares were mostly celadons with a soft wax-like glaze with no crackles. They were decorated with inscribed or embossed designs under the glaze, the body very thin. The designs resembled those of the Northern Sung celadons, boys among flowers, ducks, fishes and lotus flowers. Unlike in Japan a great many bottle or vase shapes are found together with a peculiar kind of wine cup known as "*ba jo hai*," (literally "above a horse cup"). The cup always has a matching high stand-like saucer and the edge of the

cup does not flare out, but bends inward. This was to keep the
contents from spilling, often the cup and saucer were made in one.
These cups were used for offering wine to mounted guests. Within
historical times the Koreans have had neither the wealth to own horses
nor the energy to mount them, but these cups undoubtedly point
to a time when the Koreans were an active, horse loving race.
Among the earliest ceramic forms were wine pots in vegetable and
floral shapes. Neither of these forms are found to any extent in Japan.

A method of ceramic decoration used in
Korea since earliest days is called by the Japanese *hake me*
(brush lines). Rackham in his Le Blond catalogue makes no mention
of the ware but its influence has been great and lasting in Japan
for today it is again making its appearance in all kinds of wares.
During the Korai period "hake me" was applied to wares that
obviously had been glazed by means of a brush and differed from
other glazes in that much of the body biscuit was left exposed.
Korai hake me wares were further decorated by painted designs in
a dark coloured slip, or engraved in the mishima style, and, the
"*me*" or lines made by the coarse brush are often indistinguishable.
The Japanese development is very definitely a swift circular stroke
with the glaze flowing freely at the beginning and trailing off into
nothing at the end just before it touches the beginning of the stroke.
It is usually developed in a white or cream glaze on a dark back-
ground. *Neri age* (kneeded) and *uzura madara moyo* (partridge feather
pattern) are the Japanese names for a kind of marbled ware made
of different coloured clays pressed together and glazed with a
transparent glaze. These wares may be interesting but can not be
said to be particularly artistic or beautiful though similar wares are
found all over the world.

After the Japanese invasion and temporary
occupation of Korea there was constant communication between the
two countries and a constant interchange of ceramic workmen and
teachers. Korean potters emigrated to Japan alone, in groups, and
in families to escape the hardships of their war torn land. For this
there were two contributing factors; first, the knowledge of how to
make and decorate porcelain, unknown until this time outside of
China, was stimulated by the European demand for articles of China
ware and Japanese potters alone could not satisfy that demand:
second, the great popularity of the cult of cha no yu in Japan. For
some still unexplained reason Korean potters under Japanese super-
vision turned out better wares in Japan than in their home country.
Better, that is, in carefulness of potting, application of design and
firing. Very few true Korean porcelain wares found their way to

Europe although Chinese and Japanese potters were hard pressed to supply the demand of the European traders. But this very lack of careful finish held a strong appeal for the cha jin of Japan. Korean potters and their descendants in Japan from being mere able craftsmen in the making of export porcelains, in course of time, developed into artist-potters under the sympathetic encouragement of the cha jin. These cha jin, among them such famous teachers and art connoisseurs as Sen no Rikyu, Furuta Oribe and Kobori Enshu not only patronized the Korean potters in Japan but sent designs to Korean kilns to be manufactured there, and pieces of old Korean wares brought fabulous prices in such circles. A blue and white ware produced at Pusan was much liked and received the name of *go hon de*, honourable model style wares or *Ye go hon de*, pi tured model style wares. Later a certain Mizukoshi Yosobei of Kyoto became famous for his copies of these wares.

During the seventeenth and eighteenth centuries Korean porcelains were rather coarse in shape and materials, the blue of the under-the-glaze pieces was often of a very greenish cast and the background a dirty greyish white. Korean porcelains never equalled those of their teacher, China or of their pupil, Japan, but Korean potters must be given proper credit for their part in the development of Japanese ceramics of all types.

Japanese development of the Korean design on Page 166. This is found on an Old Imari blue and white (*sometsuke*) covered vase of the type made for export in the eighteenth century.

How to buy and appreciate
Japanese Wares

"It may be fragile, but better make a thing of earthenware than of wood. Don't make anything of metal that you can make of pottery. What you make wood, make of wood, and what you make of pottery make of pottery. Only make of metal what can't be made of anything else. Never make anything of metal that can be made of wood or earthenware because you think you can make money by it."

Akishino Yohei, 17th Century

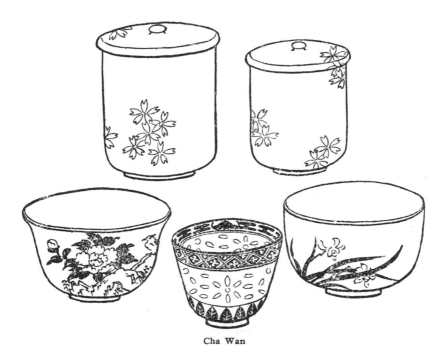

Cha Wan

Advice to Purchasers

We have tried to explain that pottery seems to be peculiarly adapted to express Japanese taste in ceramics and a Japanese artist when impelled to self expression through creative ability invariably chooses pottery, not porcelain, for that purpose. However, the urge to master a new means of expression was not to be denied and this led to the development of excellent porcelain. So it came about that two types of ceramic wares were under production side by side. One type, made for the devotees of cha no yu, may be considered typical of Japanese art. These wares were never sold in the open market but were kept for the use of the feudal lord of the district. Very few of those wares have ever gone abroad. They were and still are the most treasured possessions of their owners. There is another, most prosaic, reason for these wares not being known abroad. One must either be born a Japanese, or have lived in Japan a long time, to appreciate their beauty and charm. In this category belong the semi-porcelain fine grained pottery wares universally used by the Japanese for household purposes. At first glance, especially crowded and stacked on shelves in pottery stores, these wares seem clumsy in shape, heavy and dull

and uninteresting both in colour and design. Nor is the effect any better when the article is placed on fine white table-linen. They need the surroundings for which they were designed to display their very real beauties.

The second type of wares produced in those early days was true porcelain. These were made by workman potters at kilns operated for profit. At first they were as near exact copies of the Chinese models as the potters could make, later certain Japanese modifications crept in. It is these wares that went to Europe and are now known as "Old Japan" or "Old Imari." They consisted of plates, vases in pairs, ornamental figures, covered bowls, etc. for which there was no demand in Japan.

Although trade with European countries was prohibited, it was allowed with China and Korea, and the merchants of these countries resold them to European traders. The first shipment of Arita wares was from Nagasaki in June of 1646. Thus it came about that the porcelain wares of Kyushū were less influenced by Japanese taste than by European demands.

Later, in the middle of the nineteenth century when Japan again opened her doors and signed treaties of trade and commerce with the different European countries a new influence made itself felt. Porcelains were made to meet the demands of European traders and the sale of such wares was prohibited in Japan, because copyrighted by the purchaser. Things sent abroad and classified as Japanese art objects although made in Japan by

Showing the use to which the dinner size plates were used in Japanese households. For a feast to honour a guest the fish must be served whole.

Japanese potters were not in the least Japanese and have never been used by the Japanese people. And now again the same sorry story is being re-enacted. Matched tea sets, coffee sets and dinner sets are being exported. Gaudy colours and weird designs which belong neither to the Orient nor the Occident are making their appearance in the local stores and are bought by trusting strangers who think they are getting something Japanese because they buy them in Japan.

There is a bright side to this gloomy picture however, for the wares now being made for the local trade (as contrasted with the export trade) are featuring a revival of the good old Ming designs. The articles are carefully made, the shapes are varied, the colours good. One may select from pottery, semi-porcelain or fine egg-shell porcelain. And in the world of ceramics, as the

PLATE XXXII

Designs frequently used on Japanese ceramics, taken from the Chinese without modification.

In the center the Eight Diagrams or *Pa Kua* traditional arrangement of three broken lines and three unbroken lines, said to have been developed by the legendary Chinese Emperor *Fu Hsi* (2852 BC) suggested by the markings on the shell of an equally legendary tortoise. They are used for fortune telling both in China and Japan. These pa kua are found mostly on celadons, sometimes on the very early under-the-glaze blue and white.

On the right, top; A pair of fish representative of the Chinese betrothal present of two fish symbolic of harmony and connubial bliss. They are also a charm against evil. Below; Two Buddhist Scripture rolls.

On the left, top; A rebus symbolizing " May every thing be as you wish," a roll of paper, a writing brush and a scepter, with one end shaped like the sacred fungus or plant of long life. Below; The Chinese symbol of *Yin* and *Yang* (*in* and *yo* in Japanese), representative of the Negative and Positive principles of universal life.

writer suspects in other spheres too, the East and the West are meeting on the neutral ground of good taste for the present tendency toward coloured table linen and raffia or straw table mats is creating a background against which the Japanese style dishes can be seen in their true beauty.

Considered solely as industrial art productions ceramic wares should be of strong quality, cheap in price and available in great quantities. But these things are not important to the purpose of this book, it is not designed as a buyer's guide but for those who wish to purchase for themselves something typically Japanese which they can enjoy understandingly. True art is international and whether a thing is found in Tokyo, Pekin or Timbuctoo is immaterial, what is important is its aesthetic appeal to the purchaser.

The standard of art for the Far East was set by China centuries ago. Japanese artists have aspired to that standard but, whether they have followed it poorly or well, they have left the imprint of their Japanese individuality on everything they touched. The first reproductions of Chinese ceramics were made under the supervision of Chinese and Korean teachers. Once the method was mastered, Japanese artisans worked alone and a certain subtle Japanization took place which is unmistakable.

Father Time has set his seal of approval on such as he has allowed to remain. To own a piece of ceramic art of authentic age is a fascinating thing to think about, but not so easy to do. Falsifications abound, made with the deliberate intention to deceive. More difficult and confusing are the reproductions or replicas of old pieces made only for the personal satisfaction of the potter, to show his skill, and as a tribute to a great craftsman of old. And if the purchaser buys only for the joy of possessing a thing of beauty which appeals to his sense of aesthetics, what does it matter? It takes long years of study and experience to recognize the productions of centuries ago and the amateur had best seek the advice of such students before buying old wares, in Japan or anywhere else.

Paradoxical as it may sound, if you like an article at first glance, that article is, in most cases, good. An artistic article is good art whether it is old or new. Any ceramic article is good if it appeals to the taste of the owner. Ceramic wares, as with other forms of art, must be in conformity with one's own likes and dislikes. Concentrating on and loving any one style of pottery or porcelain will help to attain a knowledge of, and the power to judge, other styles. The true lovers of ceramics have within them-

selves an unfailing source of joy and an ever renewing interest, for the appeal of this art increases, not diminishes, with time. In handmade ceramics no two are ever alike, there are slight differences in design, in colouring and even in shape. The more closely a good piece of ceramic ware is scrutinized the more beauties are discovered.

At the risk of tedious repetition it must be stated that the Japanese standards of comparison or criterions of excellent ceramic wares differ from those of the Occidental.

First:—With regard to ceramic articles in general. In size, shape and colour they must be suitable for the purpose for which they are made and they must not appear to be what they are not. Whenever possible the Japanese avoid the use of metal, so that while they use metal (chiefly iron) kettles for heating water and boiling rice, all other utensils for the preparation or serving of food or drink are made of some form of ceramic ware, earthen ware, pottery or porcelain.

Second:—They prefer pottery articles to porcelain and have very little regard for the fine thin, translucent porcelain so highly regarded by Westerners. They term porcelain what in the West would be called only semi-porcelain. Their test for good porcelain is not an article's thinness and its translucency but the sound produced when the article is struck softly wi h the finger-nail.

Third:—The feel of an object when it is handled is of more importance than colour or design of decoration. Further, an article is not decorated to be beautiful in itself, but to be beautiful when holding the particular food for which it was designed.

Fourth:—What a Westerner would think imperfections in shape or glaze are considered highly admirable and desirable, and evidences of the method by which the article was made and the clay from which it was made a part of a thing's beauty.

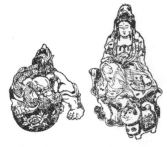

Kutani ware ornamental figures and incense box.

The *kara shishi* or Chinese lion is developed in the highly glazed peacock blue green so popular with Kutani potters thirty years back. He is playing with a purple ball pierced and decorated with mustard yellow peonies. The figure, Benten-sama, the Japanese goddess of mercy is seated on a brown rock, her robe is white with under-the-glaze blue kiri no mon design.

The amusing small dog is an incense box. Face drawn in black with red collar and red and blue ornaments on a creamy crackle background, resembling the so-called Satsuma ware.

PLATE XXXIII

Design on Inside of Five Colour Old Imari Bowl

Center design in under-the-glaze blue shows *kinko sennin,* a legendary Chinese sage, riding the waves on the back of a carp.

Outside border on slightly rolled back edge of bowl is developed in under-the-glaze blue with six medallions of red with flowers and streamers in pale yellow.

Side wall of the bowl is decorated with six large red balls connected by a tracery of red pendants with touches of light yellow and pale blue-green enamel colour. This design is known as *yoraku* or the necklace, and is based on the jewels worn by Buddhist personages.

Inner border enclosing the center design is in red enamel colour with dots of the green enamel in the center of the half-flowers.

This bowl has been reproduced very often and the design is still popular.

A Word about Colour

Although the potters of Japan had no pioneering work to do in the development of coloured decoration on ceramic wares because they had but to follow in the footsteps of the Chinese master potters whose wares came freely to Japan, their technical ability to copy these models was comparatively slow in development. The art of decorated porcelain began and developed in the southern island of Kyushu and spread from there first to Kutani, then Kyoto, Seto and Tokyo, because then China was the source of inspiration. Today the movement is reversed and Tokyo and Kyoto lead.

The first successful method of decoration on porcelain wares was more or less faithful copies of Chinese under-the-glaze blue on a clear white ground. This technique mastered, the next step was the use of enamel colours on the surface of the glaze and with this came the Japanization of method, colour and design.

Some of the earliest Imari porcelains sold abroad used three colours only; under-the-glaze blue and red enamel surface decoration, with gold paint drawn freely on these two colours. In Europe these wares later became known as " Old Japan " wares. The blue was a dark muddy indigo blue put on in large unevenly covered or mottled masses with white reserved places. These white reserves were in turn decorated with an orange-red opaque enamel colour. This enamel was of a very thin consistancy and when shaded off or applied thinly enough produced a sort of rosy-pink. Gold paint was used to paint designs in outline or diapers on the blue parts and in combination with the red on the white reserves. Simple as this colour scheme was it produced surprisingly rich effects.

The next colour to be mastered was an enamel of a colour which varied from a robins-egg blue to a light turquoise green and with the use of this colour came more detail in the drawing of the designs. The under-the-glaze blue was used for outlines; or perhaps it would be better to say that over the glaze enamel colours were added to the blue and white style first perfected. The exact order in which further enamel colours were put into use is not known but it is approximately ; a violet-purple, thin and watery, which shaded from a very light purple into a thin brown often difficult to distinguish from yellow; and a glossy opaque black. With the exception of the red and black enamel colours which were opaque the earliest Imari enamel colours were transparent and

variable in colour quite unlike the Kutani colours which developed a little later.

But before the Kutani colours came into existence a potter working at various Imari kilns developed excellent opaque enamel colours. Kakiyemon's wares are easily recognizable because of design, not colour; he used the same colours as other Imari potters of his time but he prepared them more carefully and even his under-the-glaze blue was more carefully drawn and shaded. He used very little gold and no purple, black was used only for outlines of leaves or flowers.

The use of gold on the edges of dishes began very early, as did the use of a brownish pigment called *beni ye*. The beni ye edge on any article is of no help in determining the age as it has always been used, and still is being used.

Besides the Kakiyemon colours there are two other easily distinguishable early Imari types, those of Nabeshima and of Hirado. Nabeshima wares are decorated in a fine, clear, under-the-glaze blue, almost sapphire in colour, and the usual Imari enamel colours but the materials are so finely prepared and so carefully applied that the appearance of these wares is quite different from the ordinary Imari wares. One infallible test is to run the fingers over the surface of the article. Nabeshima wares are soft, almost velvety to the touch, and the decorated places indistinguishable from the undecorated surface. Ordinary Imari wares are quite different, not only can you feel the edges of the different colours but old Imari (of the same period) frequently has the design raised or embossed in the porcelain biscuit itself. Hirado wares are also all most carefully made, the under-the-glaze is a delicate grey-blue but the lines in the design are soft or fuzzy not sharply defined as the Nabeshima lines. Hirado also put out a peculiar blue enamel colour called *ruri*, a slate coloured purplish-blue quite unlike the blue of any other wares.

In course of time Imari colours changed slightly. The red became more opaque and of a darker shade, more of a brick-red; the robins-egg blue was replaced by a very light turquoise green; black is no longer used at all; the purple developed into an opaque violet and is used very little. Imari wares for the last hundred years have used chiefly a good cobalt blue under-the-glaze colour; a heavy opaque brick-red enamel often decorated with designs in gold paint; and very sparingly turquoise green, lemon yellow and purple enamel colours.

The colour of the under-the-glaze blue wares has also varied. Speaking in very general terms the very oldest

pieces use a soft grey-blue, then comes a clear sapphire blue and about eighty to a hundred years ago a very dark purplish blue. The blue of modern wares differs from these shades and is not so pleasing.

About the turn of the twentieth century a great many reproductions of earlier wares were made. These reproductions were faithful copies, correct as to design and colour, and are a pitfall for the beginner. They answer all the tests of an authentic old piece, but they are too perfect. The charm of old pieces is their slight variations and imperfections; the reproductions are without flaws of any kind, the glaze too perfect, the general colour effect beautiful but not appealing. It was about this time, too, that white enamel glaze became popular, chiefly in raised dots on other coloured enamels.

Kutani colours were at first quite different from the Imari colours but as the ceramic industry developed the two wares came to be very much alike, due to the exchange of workmen and the gradual eradication of sectional restrictions among the kilns of Japan.

A peculiarity of Kutani wares is the colour of their porcelain. The very earliest Kutani wares were of a good white quality, though never as good as Imari wares, and later and present day wares are of excellent porcelain, but there was a period when Kutani wares were thick, and of a dirty grey colour. The style of decoration known as *ao kutani*, that is, Green Kutani, is used on this poor porcelain and today commands a much higher price than good standard porcelain.

The Kutani kilns have from time to time produced under-the-glaze blue decorated porcelains but in a very small quantity. The best examples of this type of decoration are found in the wares of the Eiraku potters and then only in combination with red enamel over-the-glaze decoration. The under-the-glaze blue of Kutani wares is quite distinctive, a clear dark blue with none of the soft elusiveness of the Imari blues.

The first Kutani decorations were paintings in enamel colours on a white ground. It was not till later that reproductions of Chinese wares were attempted. Like the Imari enamel colours, Kutani enamels were at first transparent and they were:—a very distinctive green, with Persian-blue shadings; a strong aubergine or egg-plant purple; a yellow which tended to shade into tarnished-gold; black used almost entirely for outlines or over-the-glaze designs; and a pleasing dark-blue enamel colour. From the first the red enamel colour used at the Kutani kilns was opaque

and while practically like the Imari red, verged more toward a cherry-red, rather than the orange-red of Imari. It is known as Kutani red.

The oldest Kutani wares are very easily distinguished from those of Imari; floral or landscape designs were drawn in black outline and the colours washed in. In the case of ao kutani large portions of the article were covered with a very beautiful Persian-blue green over black repeat designs; the other colours were purple and old gold. Later imitations of the Green Kutani are easily detected, the green is a grass-green and the purple and yellow colours too clear and beautiful in themselves. The earliest Kutani wares used no gold whatsoever and the edges were often accentuated with brown (beni ye).

Fifty to a hundred years ago Kutani potters used an orange-red pigment to draw designs on the white glaze. Gold was used on these wares. Foreigners call these wares "Kutani red porcelains," though they are known by the names of the potters to the Japanese. About this same time a pretty, almost violet-blue enamel colour was used, a later variation of the old blue enamel colour. Contemporary with these wares also, an opaque white enamel became popular. This white enamel was used dotted on to other colours or on the white ground.

Within the last fifty years the Kutani kilns have produced almost every imaginable colour. One kind of ware, typically modern Kutani, which the Imari kilns never made, is decorated with a surface colour, not enamel, but of some pigment with which the potters can get most any colour or shade of colour. To the touch it is very disagreeable, rough and scratchy, though pleasing enough to the eye. On these wares the colours are not, strictly speaking, Japanese but are designed to appeal to the European purchaser.

On the pre-modern, strictly Japanese wares the colours are applied as decoration on a white ground in flat masses, never shaded. Modern wares often first apply a coating of some colour to the white porcelain and on that colour in turn use coloured enamels and pigments for the decorative design, which is often shaded following European models.

Use of Gold

Gold in some form has been used by Japanese potters as a decoration on porcelain and later on pottery since the beginning of porcelains in Japan. On the earliest pieces of Old

PLATE XXXIV a

Old Japan Plate

Imari plate of about the same date as that illustrated opposite page 92, but showing more careful workmanship and a much more profuse use of gold, with a correspondingly greater amount of white glaze background exposed.

The center design, hana kago, or flower basket, in the hands of the Japanese potter-decorator has become a stylized Japanese flower arrangement in a Japanese flower container instead of the bamboo basket of carelessly arranged flowers of its Chinese prototype. This applies also to three of the designs on the brim of the plate. The other three motives show a mixture of the Japanese delineation of the chrysanthemum and the Chinese delineation of the lotus blossom.

All the flower baskets, the border surrounding the center motive, and all leaves and stems are in under-the-glaze blue of a rather poor purplish shade. All blossoms are outlined in red, filled in with the same red shaded into a pinkish-orange, or with gold paint. All the under-glaze blue has been outlined heavily with gold paint; some of the leaves are veined in gold but some have been painted over entirely with the gold paint and the veins scratched in, exposing the underlying blue colour.

The broad blue band about the center flower basket is outlined in gold, and has the usual trellis and flower diaper in gold; the six sets of two cherry blossoms, reserved in the blue, have each one blossom filled in with gold paint and one shaded with the red enamel colour, all are heavily outlined with red. The small flowers and buds in the large flower basket are plum blossoms, heavily outlined in red with three of the blossoms filled in with gold, the large flowers are peonies, one shaded red, one white and one gold. The smaller flower baskets have each two gold and one red peony. The plate has a rather wide gold edge outside an under-the-glaze blue line.

PLATE XXXIV b

Reverse of Old Japan Plate

The back of this plate has also considerable gold. Under-the-glaze blue has been used for the four bands, the leaves and branches of the floral sprays and the geometric diaper band on the footrim, as well as the concentric circles on the inner and outer edges of the plate brim and inside the footrim. The cherry flowers of the floral spray and the plum blossoms of the center potter's mark are outlined in red, about half of them filled in solid with the red enamel colour and half with the gold paint. Gold paint is also used for the stylized lotus blossom design on the blue bands.

Unlike the plate opposite page 92, which shows signs of having been formed on the potter's wheel by hand, this plate shows signs of having been molded or pressed into shape.

Imari or Old Japan wares gold paint was used freely, even in the rough sketchy designs on the backs of plates and in the flower symbol or trademarks of potter or kiln. On these wares the masses of under-the-glaze blue and over glaze red were applied carelessly and the design drawn in gold in careful detail on these masses of colour. On the oldest pieces this paint has a rough appearance because particles of gold dust had been incorporated into the paint; but also at this time the potters developed a thin yellow enamel colour which is at times difficult to distinguish from the metallic gold paint.

Gold has never been held in very high esteem in Japan and is no criterion by which to judge the value of Japanese ceramics. Many of the best pieces of Old Japan wares had gold dust dusted onto to a surface of colourless glaze to hold it. Export wares always had considerable gold in their decoration. Imari and Kutani porcelain decorators used gold for highlighting their designs, but the potters of Kyoto experimented with masses of gold-dusted colours even on pottery. Ninsei used not only pure gold dust but also gold foil, for his decorative effects on ceramics as his fellow artists used them on lacquer wares. Note the Ninsei cloud on page 12 on pottery not porcelain.

Eiraku artist-potters use a gold paint which is quite different from that found on Old Imari. The Eiraku gold paint is in effect gold plating and may be polished like any other gold plating. The present Eiraku master is most skillful with his use of gold as background for enamel colours, quite different from the traditional Eiraku *aka ji*.

The gold paint used on Satsuma wares is again different, more like a gold colour enamel.

Modern Kyoto potters can produce large surfaces of metallic looking gold enamels, soft and beautiful with an appearance of depth, while modern commercial potteries can produce any European form of gold decoration on porcelains including wide bands of etched gold. The gold, paint or enamel, used on true Japanese wares is not always strong enough to withstand wear but in colour it is always dull, not shiny, soft and beautiful. The gold on modern mass produced porcelains is hard, bright and shiny but durable and able to resist any amount of use.

Old pieces of Japanese and Chinese pottery and porcelain are frequently found mended with gold lacquer. The Japanese connoisseur not only makes no attempt to hide a crack but often accentuates it with the gold, which is of a soft and dull colour that it in itself is inconspicuous and actually enhances the

other colours of the mended article. The author treasures an old piece of Oribe ware in which more than two inches of a turned up edge has been built up with the gold lacquer, on which in turn a small pattern of conventionalized waves has been drawn in gold of a lighter shade. The piece is now more beautiful, because more interesting, than in its original perfect shape, but it takes a master hand to do such a thing. Many cha jin delighted in such work, sometimes taking years to find exactly the right piece of pottery to replace a lost or chipped-off piece or even to make a new cup out of bits of old ones with the joinings all carefully outlined with gold to furnish the pattern of decoration.

A Word of Warning

Most old Japanese ceramic wares are hand decorated that is, the artisan is given a model and reproduces the design more or less faithfully. As in China, many different individuals may work on one piece, one man being skillful at sketching in the design, another at laying on the colours; but quite frequently one man will confine himself to one design on one type of article. This applies to both under and over the glaze decoration.

Quite early in the eighteenth century they began to use a sort of stencil for diaper backgrounds and repeat outlines, especially borders. These can be recognized by a certain fuzziness of the lines. In the cheaper wares the entire design was stenciled and in a little better grade stencil and hand work were combined. Frequently the under-the-glaze design is stenciled while the over-the-glaze pattern is brushed on by hand. It is rather surprising to find among the better class wares that the Nabeshima potters used a stencil to outline their designs in order to produce many pieces exactly alike; and the cha jin Oribe was fond of using ordinary kimono stencil for some of his designs. Later still, with the advent of European methods, the complete designs with colours were transferred bodily unto the finished article.

PLATE XXXV

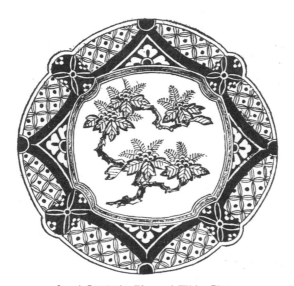

Imari *Sometsuke*, Blue and White Plate

Eight-inch dinner plate with broad raised rim, made 30 to 50 years ago. Plates of this type were used as serving platters by restaurants and hotels and were manufactured in great quantities.

Thrown on the potter's wheel they show slight irregularities in shape. The design is drawn freely and the under-the-glaze blue is of a most pleasing shade of dark indigo and blends beautifully with the bluish white of the soft thick glaze.

The central design, a branch of the loquat tree varies slightly on every plate.

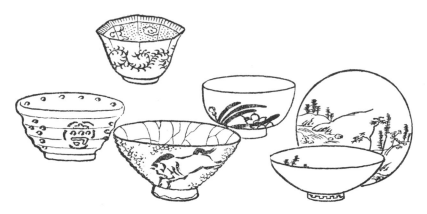

Sakazuki—small bowls from which sake is drunk, the largest not more than three inches in diameter.

Typical Japanese Forms

Bowls.

Wan is the general name for any bowl shaped article, especially *cha wan*, tea bowl. The first porcelain things that came from China to Japan were small bowls which, although they had been used for the serving of rice in the country of their origin, were used for tea ; consequently cha wan at one time meant any porcelain article and even today there is no other name for rice bowl. Literally translated, a rice bowl is a *gohan cha wan* or "tea cup used for rice." Larger bowls usually with covers are called "*domburi*" and a still larger size, without covers, used for cakes or fruit are called "*hachi*." *Sake* cups are known as "*choku*" or "*sakazuki*." Rice bowls are always of porcelain and although the very cheapest type comes without lids the ordinary kind has a lid that sets down into the bowl. Similar bowls whose lids set over them are used for serving boiled foods (*ni-mono*) while bowls smaller in diameter and taller in proportion and whose lids set over the bowl are used for steamed foods (*chawan mushi*). A third type, similar to the chawan mushi but smaller and more bell shaped is used for serving the sweet drink called "*o-shiruko*." The lids of these bowls (or cups) set down into the bowls. See page 193.

Sake cups are frequently of a very fine porcelain though they are sometimes of glazed pottery. Sake cups used for religious purposes are of unglazed, undecorated pottery. The ornately decorated trick porcelain or semi-porcelain cups on sale everywhere are mostly made for tourists. See page 157. Sake cups, like all other table wares in Japan are sold in sets of five. Potters, both

amateur and professional, are fond of making sets of sake cups no two of which are alike, to show their skill and versatility. Special sets of two matching cups made for presentation on special occasions are to be found also. Such cups are usually signed by the makers.

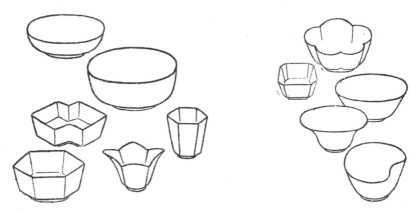

Types of small bowls used for individual servings of small portions of food.

Large covered bowls or ordinary serving bowls (*hachi*) are made of porcelain, but bowls for serving cake are frequently of pottery, partially or fully glazed. The cups used for cha no yu are mostly of a soft type of pottery glazed inside always but sometimes only partially glazed outside. Ordinary tea cups used for serving the Japanese green tea are of porcelain of all grades of fineness or of glazed pottery.

Flat plate shaped wares.

Sara, or more often *o-sara*, also covers a wide range of articles such as saucers, plates, and very shallow, even flat, dishes of all sizes and shapes. Plates with wide rims were made for export only, though export wares did include the saucer shaped plates used by the Japanese themselves. "O-sara" may be used for dishes two inches in diameter, when they are known as *o-kozara* (small plates) or for immense round traylike plates three feet in diameter, known as "*oh-zara*" (large plates). The Japanese use a great many odd shaped dishes on which to serve food, they may be in the shape of flowers, especially the plum and cherry blossom, and the chrysanthemum; or of leaves, of which those of the *icho* (maiden hair fern tree) and bamboo are favourites. Fish shapes are popular and, among birds, the crane especially in the angular form of a paper folding and the small *chidori* (plover). Shell shapes, abalone and clam, square or diamond shapes lapped

— 186 —

PLATE XXXVI

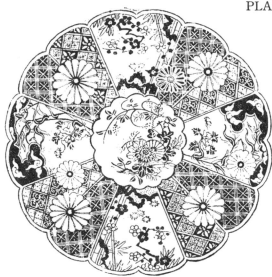

Large Old Imari Bowl

This is a flat sloping bowl, the diameter of the footrim is about eight inches, overall diameter about sixteen, very rich looking and attractive.

This type of decoration is known in Japan as kiku no mon, or chrysanthemum crest design, abroad as Old Japan. Although the export of Japanese porcelains was well under way in the later part of the seventeenth century, Old Imari dates from the beginning of the eighteenth century. As stated elsewhere the earliest Old Japan wares employed only two colours, unless gold is considered a colour, under-the-glaze dark purplish blue and an orange red over the glaze enamel colour. This bowl must belong to the second stage of Old Japan. The under-the-glaze blue is not improved over the old but the red is what we now call Imari red (a sort of brick red) thicker and more opaque than the earlier red; and turquoise blue, egg-yellow and grass green (which were applied thickly takes on the colour of the Old Kutani green), are added.

The central design shows decided European influence as does the use of the sixteen petalled chrysanthemum. During the Tokugawa Period this sixteen petalled form was, in Japan, kept exclusively for the Emperor and not used by the public in general. A careful inspection will reveal that each flower is of a different size. The two largest chrysanthemums are developed in turquoise blue on a background of blue decorated with gold lines in geometric fashion and a red and white diamond diaper with a fleur-de-lis; the double grouping shows the larger flowers in white, the smaller in red, while the fleur-de-lis pattern has been replaced by clouds drawn in black overlaid with the dark blue-green. One chrysanthemum, apparently growing on a corn stalk is in a pale shade of violet-purple. Of the two flowers in the center, the upper one is developed in red, the lower one in gold paint. Most of the wreath in the center is done in under-the-glaze blue with some of the leaves in green enamel, three in the turquoise blue.

Two of the white panels on the sides of the bowl show the sho chiku bai developed in under-the-glaze blue, red and turquoise blue enamel with five of the plum flowers in gold.

The remaining two panels show the Japanese cloud shape in red decorated with Chinese cloud shapes in yellow enamel. On a white ground an indeterminate grain stalk developed in under-the-glaze blue and green enamel overshadows a finely delineated peony flower, bud and leaves in natural colours.

one over the other, fan shapes, opened or closed, boat shapes, in fact most any shape except a perfectly round or regular shape of any kind.

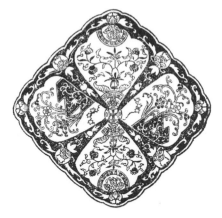

Old Imari Small Plate

The large round tray-like plates or flat shallow bowls which are today everywhere offered for sale may be roughly classified into three types.

1st. Large plates made for exhibition purposes to show the skill of the decorator and the maker. Such large plates are exceedingly difficult to make because they tend to sag out of shape when fired. To obtain one perfect specimen many must be rejected for blemishes in shape, glaze or decoration.

2nd. Plates ranging up to thirty inches or more in diameter. These were used in some parts of Japan at large gatherings on festive and formal occasions, such as weddings, New Year's, etc.; and in private families or for public feasts for villagers at the home of the head-man of the village on festival days. Food was piled high on these plates and served from them into individual small plates for the guests. This was also the custom at small wayside inns. The writer during a stay of more than thirty years in Japan has never had occasion to see such plates in use. Among the better class people and in the vicinity of Tokyo and Kyoto food is always served in individual small dishes on small trays placed in front of each guest. See page 17.

3rd. These plates were used for the display of fish and various kinds of cooked foods at shops selling such things. This was the most common use. These plates were turned out by the hundreds, all exactly alike. See end papers.

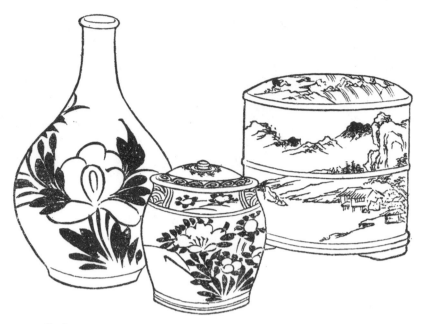

Bottle and covered container for food storage; to the right, covered bowl from which rice is served.

Jars or Vase-shaped Articles

Tsubo is the general term for any jar with cover or without, or very deep bowls with the edges curved towards, not away from, the center. Small pottery jars for holding powdered tea called *cha tsubo* are a prime necessity of cha no yu, but the deep bowl or jar-like container for the cold water is called *mizu sashi*, technically. See page 120.

Hana ike roughly translated means flower vase and is applied to any container capable of holding flowers, of whatever size or shape or material. Although under the stress of modern life decorated vases are pressed into service for the display of flowers, traditionally the Japanese use only undecorated containers. Gourd shapes or distorted cylindrical shapes of rough heavy pottery are best liked, perfectly round containers are modern and are due to foreign influence. Pottery is always preferred to porcelain for flowers.

In Japan, except in the very modern foreign-style homes, vases are never used for ornament only.

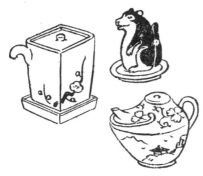

O-shoyu ire; Small covered pitchers or containers for shoyu sauce. Height three to five inches.

Tea pots.

Properly speaking, tea pots were not made in Japan till within the last three hundred years. Articles which today are called tea pots were not made for that purpose but originally were intended for sake, or in some instances for cold water. Such tea pots are now always of porcelain, though formerly they were made of pottery also. Today tea pots are known as *cha bin* or *cha dashi* if the handle is of bamboo; or *kibisho* or *kyusu* if the handle is in one with the pot, usually a hollow spout-shaped appendage at right angles to the spout. These pots are found both in pottery and porcelain. See page 154.

Ceramic pots for heating hot water are called *dobin,* but are not much used. They are usually of pottery, glazed.

A small tea pot, only a trifle larger than an ordinary tea cup, called *dobin* is used for serving mushroom soup in season. It has an accompanying saucer and its lid is formed by a small cup. These are always of a rather thin rough pottery slightly glazed.

Incense burners.

Called *koro* in Japan, are of every size and shape imaginable. Those that have perforated tops are easily recognizable, but frequently they are made in the shape of a bird or an animal, when a section of the back forms the lid. To use, these koro are half filled with a fine wood ash in which is embedded a small piece

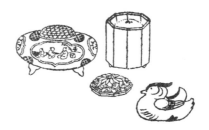

Koro; Different types of incense burners, two have pierced silver lids which allow the escape of the fumes. The *chidori* (plover) form is made entirely of porcelain, the wings lift off.

of burning charcoal which heats the incense sufficiently to drive off its odour, or lighted sticks of molded incense are set upright in the ashes. When these incense burners were used to perfume garments they were fitted with a sort of wire cage over which to drape the garment.

These koro range in size from tiny ones suitable for the scholar's desk to immense ones a foot or more in diameter and proportionately tall. While they are made in all kinds of ceramics those made of celadon predominate. Often they take the shape of an image holding a small bowl or basket or of a small human figure on the back of a large animal such as an elephant, bull or horse. Celadon koro are usually of classic Chinese shape, that is, a thick, heavy, deep bowl with two "ears" or small angular handles and three sturdy legs, often the legs are hollow and form part of the bowl. Such shapes are based on bronze prototypes. The celadon glaze may or may not completely cover the bottom of the bowl and legs.

Incense boxes.

These are known as *kobako* or *kogo*. They are always quite small and rather flat, never more than three inches in length and usually less than an inch in height. They are made both in pottery and porcelain and in shape range from square and round boxes, and open or closed fan shapes, through leaf and animal shapes to amusing representations of any of the seven gods of good luck or the *hina ningyo* of the girls' Doll Festival, etc. These are often found in the so-called raku yaki.

Tiered boxes (or sets of boxes one on top of the other).

Ju bako or sometimes *bento bako* in Japanese. They resemble the lacquer boxes used at New Year's time to hold prepared foods. They are also used for holding cakes or candies or for carrying food for an outdoor lunch. See page 93.

Hashi oki; Small ornamental porcelain articles on which the chopsticks are rested when not in use.

Hashi oki, chopstick rests.

These are small porcelain object made to rest the chopsticks on before and after a meal. They vary in length from one to three or four inches and are never more than half an inch thick at the most. They are made in the shape of vegetables, fruits, leaves, miniature books, fans, ships, fish, shell fish, dragons and even Daruma is pressed into service. They are practically always glazed.

Sui teki, water droppers for the scholar's desk. These are often made in the form of miniature tea pots, or animals or flowers. These are made in both pottery and porcelain, glazed and unglazed, sometimes they are beautiful little works of ceramic art.

Suzuri mono, stones on which the Indian ink is prepared. These are rather rare, usually made of a fine grained hard porcelain or hard tile-pottery. See page 127. They all have a flat, usually oblong surface with a slight depression at one end. Water from the suiteki is put into this depression and the cake of ink is dipped into this water and rubbed up over the flat surface. Eventually the flat surface becomes covered with ink ready for use with the Japanese writing brush, *fude.*

Gohan shakushi, rice ladles.

These are always of porcelain not pottery sometimes beautifully decorated in under-the-glaze blue designs. They are unusual but sometimes are to be found.

Chiri renge, porcelain spoons.

These spoons are called by the poetical name of "Lotus blossom petal" because to the Japanese their shape suggests that fancy. They are made either of celadon porcelain or under-the-glaze blue and white porcelain. They are often accompanied by a stand on which they are placed when not in use. About the only time they are used is in the serving of *gyunabe* or *sukiyaki.*

Shisoku or *Teshoku,* oil lamps.

These are of course obsolete but are sometimes to be found. They are usually of a hard pottery, sometimes glazed with a celadon, that is single colour, glaze. At one time they were in very common use but they are now rare and valuable. See page 68.

Aburazara, plates for under an oil lamp.

These are glazed crude pottery plates from four to eight inches in diameter. They were used in the Japanese *andon* under the oil lamp to catch any drippings. Being cheap and common they were not taken care of and are now museum items.

Flower pots.

Of all kinds sizes and shapes. Very flat shallow tray-like containers are made for holding bonsai, dwarf trees. Many times dwarf tree fanciers make their own trays as they consider each tree has an individuality and needs its own container. See page 115.

Hibachi, or braziers.

The "central heating system" of old Japan. Made of pottery porcelain or stone ware they are often things of great beauty and famous potters have not scorned to make and decorate these dainty fire-boxes. To use they are about half filled with a clean white wood ash (camelia or magnolia) and a handful of glowing charcoal is placed in the center. All kinds of wood may be made into charcoal of course, but cherry wood furnishes the best charcoal for heating purposes. The charcoal is never ignited inside the house, or for that matter in the *hibachi,* and the method of piling up the coals and adjusting the ashes about them to ensure a steady glow is a part of the teaching of cha no yu.

Hibachi come in all sizes from six or eight inches to two or more feet in diameter. They are usually round with a heavy rolled edge which curves inward; they are often made in pairs. Of necessity the biscuit base must be strong and unlike so many other forms of Japanese ceramics they are invariably entirely covered with glaze. Although occasionally brightly decorated hibachi are met with, as a rule they are either decorated in blue and white (*sometsuke*) or of a single colour glaze such as celadon green or a dark blue.

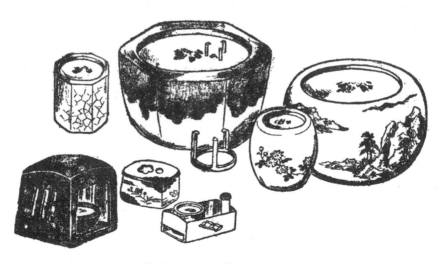

Various forms of *hibachi,* braziers.

Japanese Ceramics in
Religion and Superstition

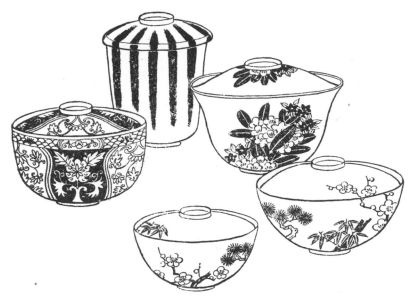

Covered bowls. The lids of bowls used for rice set down into the bowl. The lids of those used for steamed foods set over the bowl. Note the husband and wife rice bowls different in size but same in pattern.

Japanese Pottery in Religion and Superstition

It seems that from most ancient times Shinto shrines, such as Ise and Atsuta had official potters who made ritual articles for use in the shrine ceremonies, which were afterwards given to the followers of the shrine. These wares were always unglazed and frequently (orthodoxly) sun-baked only.

At Kato-mura, Oi-gori in Wakasa no kuni there is a shrine dedicated to potters' clay. It is believed that the gods pointed out the pottery clay deposits to the ancient Japanese, and this shrine is patronized by potters who come here to return thanks for the great blessing.

In Nima-gori at Mizukami-mura on the Japan Sea side of Japan there is a kiln which produces *mumyoi yaki*. Once a potter by the name of Kihara Kichiyemon was digging for a kind of clay called *mumyoi* when he noticed that a crane who appeared to have an injured foot came and stood in the upturned clay. The crane did this every day for a week and then flew away cured. Kihara got the idea that dishes made of this clay would have medicinal value. This is not an isolated incident for many shrines sell clay toys in the shapes of birds or animals for children, which

they are encouraged to suck, on the theory that the clay is a curative agent.

The Sumiyoshi Jinja, near Kobe, has a clay or potters' festival twice a year, in the spring and autumn. This festival commemorates the time Jimmu Tenno, the first human emperor of Japan, made pottery things of clay from Ama no Kaguyama. The head priest at Sumiyoshi, after due ritual purification, climbs to the top of Unebiyama and there digs exactly three and one half hand-fulls of clay while holding a piece of *sakaki* (the evergreen sacred to Shinto) in his mouth. This sakaki must be cut freshly from bushes growing on the mountain. Returning to Sumiyoshi, on the next day he makes a dish of the clay, this time holding in his mouth a piece of sakaki taken from a bush in the shrine grounds. This dish is then used for food offerings to the shrine.

Not connected with religion but still of considerable interest is the fact that during the Edo Period (1600–1868) the potters of Tokyo held a yearly fair or exhibition when they displayed historical tableau with the figures dressed in various ceramic productions. The figures were life size and the garments were made of innumerable small dishes in various colours, simulating brocades etc. These were very similar to those of the Tokyo florists who annually displayed such figures with garments made of living flowers, chiefly chrysanthemums.

It is also interesting to note a curious superstition regarding the intentional breaking of china ware, especially during the New Year holiday season. Formerly it was the custom at Kabuki, the traditional theatre of Japan, for the actors to stage a stunt at every performance during the New Year holidays, to symbolize their wishes for future prosperity for themselves and their audiences.

An actor, dressed in *kami-shimo*, or the formal dress used by all samurai people, came to the front of the stage and recited a monologue expressive of good wishes, then very elaborately and very formally drank to the health of the audience and immediately shattered the sake cup on the floor in front of him.

Out of one small cup he produced many pieces, a prophesy of future increase in wealth and worldly goods for all who witnessed the action.

The cup used was a rather large shallow unglazed saucer-like dish called *kawarake mono* and the ceremony was known as *hatsu shibai*.

But, although at New Year the breaking of china ware symbolized future prosperity, this did not hold good for wedding ceremonies, during which the breaking of anything would be considered prophetic of dire calamity. For this reason no china ware was included in a Japanese brides household effects.

And, in passing, let the reader decide whether this is superstition or scientific sanitary precaution. When a physician found it necessary to bleed a patient he called for a new sake cup which he broke in two and used the broken edge for a lancet.

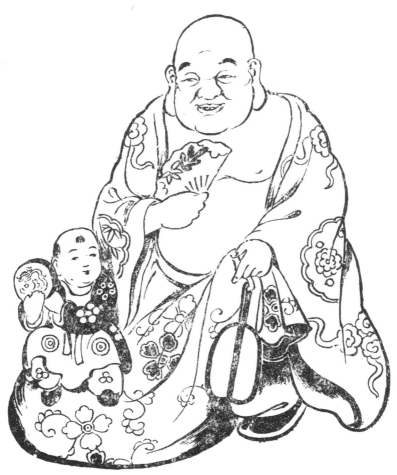

Hotei-sama

Ceramic Designs
and Symbols

If a Japanese artist has a space given him to adorn, he does not necessarily seek out the center and place his ornament there; for, although, that would be the obvious means of securing proportion, it would not satisfy a taste directly derived from a study of nature, where proportion is rather suggested than actually expressed.

From Audesley & Bowes's "Keramic Art of Japan."

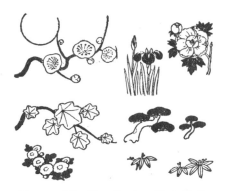

Flowers of the Four Seasons, Korin Style.

The Japanese pottery artist, or for that matter the Japanese artist in any line, is never at a loss for variety of design for his source is inexhaustible, Nature itself. All Japanese ceramic wares are made in multiples of five and no Japanese has ever been able to explain to the writer's satisfaction how they distribute over five articles the symbols of the four seasons or the flowers of the twelve months or the inseparable floral combinations of "The four friends," *shi kunshi*, or the trio of pine, plum and bamboo (*sho chiku bai*). Like the Japanese six-leaved screen each leaf of which is a complete picture, yet which when extended to its full shows only one harmoniously composed scene, Japanese dishes are decorated so that a set of five is complete yet several such sets may be used at one time still showing the basic idea of seasonal or topical decoration. Other than the flowers of the four seasons and the flowers of the twelve months, the Japanese artist draws upon certain time honoured floral combinations or bird and flower combinations for designs; or the accepted symbols of the *gosekku*, the five annual festivals; or he may base his designs on well known poems or historical episodes, or on some of the numerous series of famous beauty spots in the scenery of Japan. This habit of confining themselves to stereotyped subjects does not, as one is at first tempted to think, curtail the imagination of the artist but puts him on his metal to produce a new and individual interpretation of the old idea, resulting in a fertility of imagination unsurpassed elsewhere in the world.

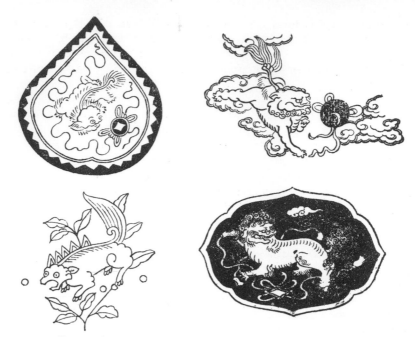

Four versions of the Chinese lion-dog. In Japan it is known as *koma inu*, Korean dog, and takes on Japanese historical associations and a slight change in shape. The design found painted on ceramics is always the Chinese form.

Note that in one picture the ball is shown in full, in the one to the left the ornamentation of the ball is stressed and in the third below the ball has disappeared only the ornamentation remains. In the fourth picture, the central design in a rice bowl made about eighty years ago, the lion seems to be playing with three quite small balls.

Animal Symbolism

Badger—

Tanuki in Japanese. Of all animals used in Japanese ceramic decoration the badger appears most often and the exact reason for this is difficult to understand. It seems to have caught Japanese potters' fancy and they appear to take delight in this small mischievous animal.

As a garden ornament outside small eating establishments or as a window display he is represented with a large protruded stomach, walking upright and carrying in one hand (paw) a large sake bottle and in the other an order book. Usually certain portions of his anatomy are much over developed and

Pottery badger. Such images are made in sizes ranging from two inches to six feet, usually unglazed. The larger sizes are displayed in the entrance gardens of small hotels, restaurants or other small shops, supposedly to attract customers. He holds in his paw an order book.

— 198 —

miniatures of this form are sold at some shrines. In this form he is an animal pure and simple and always made of unglazed pottery.

There is a story that on moon light nights the badger produces a drumming sound by pounding on his inflated stomach.

A similar form but less frequently met with shows the animal walking upright or asleep leaning on a *mokugyo*, a round temple drum. In this form he is dressed in priest's robes of bluish green or greenish blue glaze. His head and paws are unglazed. The badger is always whimsically presented and these images never fail to bring a smile to the lips of the observer. These images are often to be found in a secluded corner of a gentleman's garden.

Dressed in priest's robes the badger calls to mind the very much mixed up story of a tea kettle in the Morinji Temple in the Prefecture of Gumma. One version of the story is that the priest was a badger who assumed human form and who entertained all guests who came to the temple with tea from a kettle which he brought with him. This kettle was inexhaustible, no matter how much tea was poured out it was always full. But when the badger-priest was unmasked and disappeared the kettle became an ordinary one and is to be seen in the temple to this day. Once a year, the priests of the temple make use of the kettle in a sort of social ceremony.

The more popular version is that the kettle itself was the badger and there are many pictures showing the kettle changing into a badger (or vice versa). The kettle became known as the "*bumbuku cha gama*" or "fortune distributing tea kettle." Small pottery representations of this kettle with the legs, tail and head of the badger protruding are common everywhere in Japan and are used as receptacles for shoyu sauce or as tea pots according to size.

Japanese adaptations of the Chinese mountain and cloud motive.

Bats—

Komori in Japanese. As an ornamental art motive bats are strictly Chinese in origin and development. They are not used on Japanese ceramics except as a copy of Chinese originals and then only in a highly conventionalized form as a border design frequently distorted out of any semblance to the real. They are a symbol of good augury because the Chinese sound of their name is the same sound as the word for happiness.

Butterfly—

Cho in Japanese. Seldom pictured in a realistic manner on ceramics except in the "Thousand Butterfly" design where they are of all sizes and shapes, completely covering the object, on a certain class of Satsuma ware. In Japanese ceramic art they are associated with the peony flower and Chinese lion.

Cock—

Ondori in Japanese. Usually pictured with its hen. Perched on a drum it signifies peace. The drum in China is regarded as the symbol of good government. In ancient times one was placed in the temple yard to be beaten by anyone who considered he had suffered a wrong, as a signal to the magistrate of the district. In times of good government the drum stood undisturbed and cocks perched upon it.

According to an old Chinese legend the cock is a bird of "five virtues." He is said to have a crown on his head, a mark of his literary spirit; spurs on his feet, a token of his warlike disposition; he is courageous for he fights his enemies; and benevolent for he always clucks for the hens when he scratches up a grain; and faithful for he never loses the hour. The cock is associated with the blossoms of the hydrangea in Japanese art.

Dog—

Inu in Japanese or *koma inu* (Korean dog). Koma inu are often found as ornaments, usually seated erect on their haunches with their fore legs unnaturally elongated. They are interchangeable with the *kara shishi* as guardians before temples or shrines.

As a design on pottery and porcelain, dogs are depicted as small round puppies playing and tumbling over one another in groups of twos or threes. For beauty of composition and contrast of line they are often pictured playing at the base of bamboo trees.

Dragon—

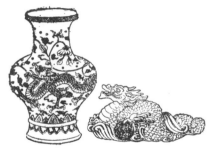

T. tsu or *ryu* in Japanese. A very favourite motive in both Chinese and Japanese ceramics; to them the dragon symbolizes spiritual aspiration. The crystal ball or pearl which they are pictured guarding symbolizes spirit or the divine essense of the gods. In Japanese art the dragon is never shown in its entirety, it is usually half hidden by clouds or water, often accompanied by lightening flashes, and is seldom found on Japanese ceramics except as a direct copy of Chinese models.

Vase made in Kyoto; under-the-glaze blue dragon and clouds in white reserve, on brick red enamel ground. Border design on the mouth of the vase and at bottom in blue. The dragon, lower border and flowers are molded in the biscuit and very beautifully shaded in colour.

Dragon ornament, Arita ware. White dragon rising from blue waves holding in its claw a pierced blue and white ball.

A common presentation of the dragon on Chinese ceramics is a long lizard-like creature, with legs; surrounded with conventionalized clouds and flames, often only angular dabs of colour. The dragons in high relief writhing over bowls and vases are made for export only and are never found on local productions.

Elephant—

Zo in Japanese. The elephant is associated with stories in the life of Buddha and is very seldom seen as a design on Japanese ceramics.

It is sometimes pictured with a small boy, when it refers to a legendary Chinese emperor who as a small boy was abused by his step-mother and forced to work in the fields. In pity for his miserable plight an elephant and some birds helped him at his labours. This

Kyoto porcelain bowl showing unusual Buddhist design of an elephant developed in under-the-glaze blue, orange-red enamel and gold.

is the story of one of the Twenty-four Dutiful Children well known to both Chinese and Japanese. An elephant with the boy sometimes only a baby, on its back is a common form for incense burners, or decorative object, especially in celadon (*seiji*).

Fox—

Kitsune in Japanese. The fox is associated with Inari Shrines, shrines to the spirit of the god of rice. Pottery images of foxes are set up before such shrines as guardians, replacing the lion images (kara shishi and koma inu) of Buddhist Temples and Shinto Shrines. Many stories are told of foxes bewitching people and playing harmless, though sometimes humiliating, pranks on them.

Porcelain image of a fox, usually developed in white with red mouth, nose and ears, seated on a red patterned base. These come in from two inch miniatures for household shrines to a foot in height for public shrines. In this form the fox is considered the messenger of Inari, the god of rice, and many are offered to every shrine, always in pairs.

Frog—

Kawazu in Japanese. On Japanese ceramics it is pictured in conjunction with a man, dressed in ancient robes, and a willow tree. This refers to the story of a Japanese nobleman in the ninth century, Ono no Dofu, who one day despaired of ever mastering the difficult art of writing Chinese characters. While walking along the bank of a river he noticed a tiny frog trying to reach a leaf on the hanging branch of a willow. The frog tried again and again and on the seventh attempt succeeded in reaching his goal. Ono no Dofu took this as a lesson to himself and returning home he set to work again. Result—he became one of the greatest calligraphers of his time.

Hare—

Usagi in Japanese. In ceramic art the hare is associated with waves, referring to the story of the Japanese mythological prince who took the form of a white hare. The picture of a hare pounding mochi in a wooden mortar inside the circle of the full moon is for children and is used only on wares intended for their use. But a small round hare crouched among waving pampas grass with just the suggestion of a full moon made by a single arched line is a favourite subject for ceramic artists for the decoration of art pottery.

Horse—

Uma in Japanese. A tethered horse kicking up its heels is the seal of the Soma lords of Fukushima and is found on the ceramic wares produced there.

The eight favourite steeds of the Chinese Emperor Mu Wang (1001-746 BC) are often pictured on Chinese

ceramics and copied in Japan. The Japanese are fond of depicting horses in all manners of positions, resting, galloping, or rolling on the ground, in the fewest possible number of brush strokes.

Lion—

Kara shishi in Japanese. The animal resembles the Chinese Chin dog more than a true lion. The Chinese delight in drawing this fabulous animal but as a design on ceramics the Japanese are apt to treat it in, to say the least, an unceremonious manner; frequently it resembles a hybrid creature part-fox, part bat-like creature. It is usually pictured playing with an ornamental ball with streamers.

When made in pairs, the mouth of the male is closed, that of the female open. Buddhist symbolism says the female is saying "Ah," the male "Om," the Alpha and Omega of Buddhist teachings. The male may have (though not always) a ball under his front paw and the female plays with a lion cub. As images these lions are always made in pairs. In China it is called the Dog of Fo (Buddha) and seems to have come from India. It is probably one of the oldest symbols of the sun; originating in Egypt, its migration westward through Europe eventuated in the lion of the English coat of arms. In its eastward migration it suffered more changes; in India it was pictured as a real lion; in China it took on the form of the curly haired toy lion-dog, while in Japan it assumes still another form, more on the lines of a mastiff dog and is known as koma inu or dog of Korea. However, it is the Chinese curly haired lion that is used as design on Japanese ceramics.

The Japanese version of this lion is frequently shown with the peony flower, the king of beasts with the king of flowers, and this combination is sometimes suggested by peony blossoms on a ground of scattered circles formed by short radiating lines. These circles are a conventionalization of the lion's curly tail, and they are also used to suggest the Echigo Lion Dance, a popular folk dance of Echigo. Children performing this dance with the aid of a lion's mask are often found as *okimono* (ornamental objects).

Center design on a Hirado ware plate, showing Chinese lion sporting among peony blossoms.
Colours: Under-the-glaze blue on white ground.

Monkey—

Saru in Japanese. Small images of three monkeys in a row, one covering its eyes with its paws, one its ears

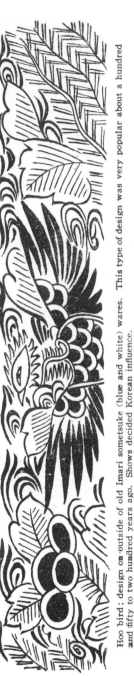

Hoo bird: design on outside of old Imari sometsuke (blue and white) wares. Shows decided Korean influence. This type of design was very popular about a hundred and fifty to two hundred years ago.

and one its mouth symbolize the secrecy necessary under a dictatorship (for they originated under the repressive measures of the Tokugawa Shogunate), "See nothing, hear nothing, say nothing."

Nightingale—

Uguisu in Japanese. Associated with plum blossoms in Japanese art and literature. This, to the Japanese, suggests the story of the Japanese lady of old whose favourite plum tree was taken to grace the imperial garden and whose poem

> "Because this is an imperial command I bow in compliance; but if the nightingale asks where its inn is, how shall I answer?"

so pleased her royal master that the tree was returned to her and the poem has come down in history.

Ox—

Ushi in Japanese. At one period quite popular as a design on ceramics, especially those of Imari. It is sometimes pictured drawing a nobleman's carriage under a blossoming plum-tree, when it suggests to the Japanese the story of Michizane.

Pictured being led by the nose by a small naked boy, or asleep with the boy asleep on its back it illustrates a profound Zen teaching. This subject is often used for an ornamental group in the round in white or celadon ware.

Phoenix—

Hoo in Japanese. The word means "male and female." Like the dragon this design comes from China but it has been adopted by the Japanese. It is to be found on all classes of Japanese

— 204 —

ceramics; at first a copy of Chinese design it has become a typically Japanese motive. Phoenix is a bad translation of hoo because it has no such association of ideas. To the Japanese thought the hoo is associated with the Empress, it is usually pictured with the "*kiri no mon*," the Empress's crest, the leaves of the paulownia tree. It was a favourite design of Kakiyemon.

Tiger—

Tora in Japanese. The tiger in Japanese and Chinese art is often pictured in a bamboo forest, never alone on ceramics. It is thought that the tiger's mortal enemy the elephant cannot follow him into the bamboo, therefore this design is considered symbolic of safety. In China the tiger is a symbol of strength; in Japan there is a saying that the tiger will travel a thousand miles in one day but he will return at nightfall. Frequently the same symbol is interpreted differently in China and Japan.

In China the tiger represents earthly powers in contradiction to the dragon which represents heavenly powers.

Tortoise—

Kame in Japanese. A tortoise with a long, wide tail is the Japanese symbol of longevity, it is then called *mino game*. It is usually shown with a crane, when the combination is known as "*tsuru-kame*" or "crane and tortoise." In ceramic art these two creatures are pictured associated with the pine tree, a symbol of congratulations. Sometimes the tortoise bears on its back the representation of a rocky island covered with pine trees, the abode of the immortals. The scales on the back of the tortoise furnish the Japanese artist with a host of designs.

Crane, tortoise and bamboo, symbols of long life and good fortune; paper folding of cranes, naturalistic bamboo leaves and conventionalized design derived from the carapace of the tortoise. Purely Japanese development of a Chinese idea, a wish that "Your days be as long as those of the tortoise and the crane."

Fish and Shell Fish Symbolism

Abalone—

Awabi in Japanese. The flesh of this shell fish was once used as an important article in the Japanese diet. Even today thin strips of the dried meat are used as symbolic of food at weddings, it is then called *noshi awabi* or only *noshi*. Representations of several strips of this noshi-awabi tied in a bunch are seen very often in ceramic designs. Dishes made in the shape of the shell are popular.

Carp—

Koi in Japanese. Symbol of perseverance and success in life and a very favourite subject for Japanese artists because of its dainty beauty and grace of motion. It is often pictured moving up stream, sometimes in a whirlpool, always in motion.

Fish of any kind—

Sakana in Japanese. To the Japanese fish represents food and abundance. Fish are a very old world-wide symbol and their funda-mental symbolism is life. The oldest

Dish centers of Old Imari often reproduced.
The man is Kinko Sennin.
The design with the fish is known as *ariso*.
Note the treatment of the sun in the clouds. These two forms are frequently interchanged.

representations of Jesus in the Catacombs show not a man but a fish. In the Orient they represent intellectual freedom because as a fish can swim about at will in water, so the mind of man is free in the intellectual sphere. In the ceramic world they are represented in pairs. They are used as handles and as incised or embossed orna-ments on celadon vessels both ancient and modern. The small trout (*ayu*) is sometimes pictured as a "still life" on a kind of bamboo leaves.

Lobster—

Ebi in Japanese. Frequently seen as a deco-rative motive on Japanese ceramic wares. It symbolizes long life and the wish that one may live so long that his back is as bent as that of the lobster. As red is the symbol of strength the red ebi symbolizes strength in old age.

Sea Bream—

Tai in Japanese. This is usually pictured as ready to be eaten, a bright red fish, curved with raised head and

tail. No feast in Japan is complete without a serving of tai, a small complete fish to each individual. As a food it is delicious but the Japanese value it because of its name which suggests the expression "*o-me-de-tai*" a phrase very difficult to translate but which seems to mean a situation or condition of affairs which are a cause for congratulations. This expression is used as a New Year greeting or on any happy occasion.

The tai is seldom or never pictured alive in water.

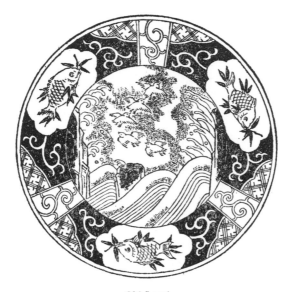

Old Imari

Small saucer dish, showing Japanese treatment of Chinese art motives. In the center the small birds *chidori* or plover, typically Japanese birds, are shown flying over Chinese conventionalized waves, but the spray is a Japanese development. On the rim are three white medallions showing the Japanese *tai* fish, symbol of congratulations and felicitations. The fish are shown laid on the leaves of the *sasa*, a kind of low growing bamboo.

Only four colours are used, under-the-glaze indigo blue, a light shade of green and a red enamel with some gold. The central design is developed in blue and white only. The sections surrounding the fish medallions are red. The fish and other designs are in red enamel colour, bamboo leaves and oblong panels in green.

This dish is crudely done and of no artistic merit, interesting only for design and colouring.

Showing a development of the *sho chiku bai* motive.
The dish itself is the Japanese conventionalization of a
branch of pine, the design shows a plum tree while the
panel at the bottom of the dish is a form of conven-
tionalized bamboo leaves.

Floral Symbols

Bamboo —

Take in Japanese. Bamboo is a very common
motive on Japanese ceramics. This tree, or plant, is often conven-
tionalized and it may be bent into unnatural curves, although
frequently it is depicted in its natural form. Symbolically it represents
strength in reserve, because though it may be laid flat on the earth
by the weight of snow, as the snow melts the tree resumes its
original upright state. It is often pictured weighed down by snow
in allusion to this. It also symbolizes uprightness, honesty, integrity
and faithfulness.

A leaf resembling the bamboo, but really
representing the "*sasa*" plant is associated with fish as a food.
Often the plate on which fish is served is made in this shape.

Cherry Blossoms—

Sakura in Japanese. This flower is found on
all types of Japanese ceramics, pictured now as a cloud of soft pink
colour rising above the gnarled trunk of a tree, now as scattered
blossoms and again as scattered petals floating on water. And
always it is the single variety, not the beautiful double blossoms of
the *yaye sakura*. The cherry flower is emblematic of the people of
Japan.

Four Noble Friends—

Shi kunshi in Japanese. This is a combination
of pine, plum blossom, bamboo and chrysanthemum, or pine, plum
blossom, chrysanthemum and orchid, sometimes bamboo, plum
blossom, chrysanthemum and orchid. This orchid is not the beautiful
purple flower loved by Europeans but a tiny green flower with an
exquisite perfume, whose chief beauty is the gracefulness of its long
grass-like leaves. This combination of shi kunshi is pictured some-

times in naturalistic fashion but more often in a highly conventionalized form.

Lotus—

Hasu in Japanese. This flower is associated with Buddhism, and therefore with death, in the minds of the Japanese and is not much used on any ceramic wares except as direct copies of Chinese articles and in a very debased form as a meander or arabesque pattern. It is not easy to distinguish the conventionalized lotus from the chrysanthemum and the peony blossom as they are pictured on ceramics, the artist never seems quite certain which of the three flowers he is trying to depict.

In Buddhism it is the emblem of purity because it rises unsullied from the mud; its eight petals symbolize the Eightfold Path of Morality.

Fat cherubic children playing among the lotuses growing in water, sometimes with the addition of cranes, is a motive on Japanese ceramics copied without alteration from Chinese and Korean models.

Typical Old Imari dish centers, two forms of the peony motive.

Orchid—

Ran in Japanese. A very common motive on all kinds of Japanese ceramics but especial'y on cheaper Imari wares in under-glaze blue. It is easily and quickly drawn, a refined elegant design. Symbolically it stands for modesty and hidden beauty.

Peony Flower—

Botan in Japanese. This flower is considered the king of flowers because of its luxuriant growth and gorgeous colours. On Japanese ceramic wares it is usually pictured alone but occasionally with a sportive lion and hovering butterflies. One of its highly conventionalized forms is hardly to be distinguished from either the conventionalized lotus or chrysanthemum.

Pine Needles

Pine—

Matsu in Japanese. To the Japanese the pine is symbolic of strength because it lives to a great age; its unchanging green suggests fidelity; and prosperity is indi-

cated by the rich green of its needles. Some species of pine have needles growing pairs which suggest unfailing devotion. The pine is a very common motive on Japanese ceramics where it is sometimes pictured in naturalistic form but more often very much stylized. Japanese artists have conventionalized the branches of the pine tree into a semi-circular form difficult for the uninitiated to recognize; and two pine needles still joined together as they fall from the tree is a common ceramic motive.

Pine, Plum and Bamboo—

Sho chiku bai in Japanese. This is a very popular combination of the pine, plum and bamboo. It holds all the symbolism of its three components and is pictured both in naturalistic and conventionalized forms. Sometimes a plate or bowl, shaped like a plum blossom, will be decorated with pine needles and bamboo leaves; or a dish shaped like a conventionalized pine branch will have a spray of plum branch as decoration together with some bamboo leaves. This design originated in China.

Early Imari dish centers, two different developments of the pine-plum-bamboo motive.

Plum—

Ume in Japanese. This flower is symbolic of womenhood in Japan; and strength in adversity, because it comes into bloom while snow is yet on the ground. In naturalistic form it is pictured as an old tree trunk sending out straight slender shoots with blossoms. Conventionalized, it becomes a five petalled flower almost circular in shape, in this form it is used on ceramics and plum-shaped dishes, bowls, boxes and cups are often met with.

The picture of a court noble under a plum tree, or associated with plum blossoms, refers to the story of Sugawara Michizane, who as Prime Minister under Emperor Daigo (898–930) was unjustly accused of treason and banished to Dazaifu in Kyushu where he pined away and died. He had left a favourite plum tree in Kyoto which, legend asserts, flew of its own accord to be with him in exile.

This same story is sometimes, especially on Imari wares, suggested by the figure of a bull resting under a plum tree.

The design of white plum blossoms on a blue ground is Chinese not Japanese.

Four designs, reproduced here from modern Japanese wares, based on old Chinese symbolism.

Top left; The Plant of Immortality, *Ling Chih* in Chinese, *kinoko* in Japanese, a species of fungus which grows at the roots of trees. It dries hard and woodlike and is used as a desk ornament. The fungus pictured here was done by a Japanese artist and is almost naturalistic. Chinese artists picture it so that it is almost indistinguishable from the *jooi* head, bat or butterfly design or one form of cloud formations. It is surrounded here by four forms of *shou*, the Chinese character for longevity.

Top right; The peach (*momo* of immortality.

Bottom left; Two pomegranates, symbolic of many offspring.

Bottom right; A kind of very fragrant citron which is thought to resemble a hand, called *To Shou* in Chinese, *busshukan* in Japanese, both meaning Buddha's hand. This fruit is an indispensable offering to the Chinese gods at New Year. It also symbolizes wealth.

Fruit Symbolism

Finger Citron—

Busshukan in Japanese This is a kind of citrus fruit, inedible, which the Chinese and Japanese think resembles the fingers of a closed hand, or, rather, one of the hand positions of Buddhist ritual. It is liked for its colour and its pleasing odour and is indispensable at New Year's time for decoration. As a decoration on Japanese ceramics it is often pictured with the peach and pomegranate, signifying promotion, years and sons. It is also developed in celadon or one colour glazes as an ornament.

Fungus—

Kinoko in Japanese. This is a kind of mushroom accepted as a symbol of long life by the Chinese and taken over by the Japanese. In ceramic art this is usually very highly conventionalized and often is difficult to distinguish from the Chinese cloud pattern.

Gourd—

Hyotan in Japanese. The dried gourd itself is treasured by the Japanese as a container of sake, especially when on cherry flower viewing picnics. Its influence on Japanese ceramics is far spread; in the decoration of many objects, it is frequently used as the shape of reserved panels; in the shape of bottles and vases, of dishes and covered boxes of all sizes; and as "*okimono*" purely ornamental objects.

It is used as a charm against stumbling for the very young and the very old because although round bottomed it is surprisingly stable. Geisha and gamblers carry gourd charms because when submerged in water the gourd "bobs up again."

In Japanese ceramic art it is usually pictured with a bit of the vine on which it grows. Pictured alone with a horse issuing from it in a cloud of smoke it symbolizes "the unexpected" to the Japanese. It is sometimes seen with a human figure in the smoke rising from it when it refers to the Chinese Li T'ieh-kuai of the Eight Immortals.

Peach—

Momo in Japanese. This fruit is often pictured on Japanese ceramics; and cups, bowls, boxes and plates follow its shape. It is considered a happy omen, symbolic of life and marriage. Chinese in origin, the symbolism of the peach has entered deeply into Japanese folklore. Momotaro, Little Peach Boy, is a favourite story with Japanese children and an alternate name for the girls' Doll Festival is Festival of Peach Blossoms.

In China the peach is symbolic of immortality. The peach tree of immortality, said to grow in the garden of Hsi Wang Mu (*Seio-bo* in Japanese), bears fruit every three thousand years and those who eat of this fruit will never die. The Chinese version of Momotaro is the God of longevity issuing from a peach. Peach wood is used for charms against the evil of sickness.

Pomegranate—

Zakuro in Japanese. This fruit, split open to show its many seeds, was a favourite motive of the Chinese ceramic artists of the Ming dynasty and is copied even today on Japanese ceramics.

Human Figures

Children—

$Kodomo$ in Japanese. As a design on ceramics, a number of Chinese boys playing about under pine trees, they are never represented as Japanese. They are pictured with amusing hair cuts, the most of the head is shaved, only tufts of hair here and there. The number of children pictured in the design has nothing to do with the quality of porcelain.

Daruma—

Usually pictured as a scowling face peering out of a pear-shaped red bag. This represents $Bodhidharma$, a buddhist priest who went to China and sat in meditation in the mountains for seven years, till he lost the use of his legs. The red "bag" is his priest's robe gathered about him; in this comic pear-shaped form Daruma is used as a design on dishes intended for the use of children and also on sake cups and bottles.

But Daruma has also a more serious side. The story continues that one day, much to his chagrin he fell asleep. To avoid any possible reoccurrence of this he cut off his eyelids and threw them away. The tea plant sprang up from his eyelashes, it is said. For this reason Daruma is associated with the serving of tea, and tea utensils used by scholars and literary men are often decorated with his figure. But in this case he is pictured as a stern-faced man with large black somber eyes, standing erect, still wrapped in his red robe and carrying in his hand a Buddhist fly-whisk.

A humorous and most unusual representation of Daruma, apparently as man and wife. The expression on their faces is very amusing. Made in Kutani the figures are wrapped in dull brick-red enamel robes; faces unglazed but touched up with black enamel eye-brows; eyes white porcelain with blackened holes for pupils.

The usual form of ceramic Daruma holding the Buddhist fly-whisk. Unless done all in unglazed pottery such images have dull red glaze or celadon robes, faces usually unglazed and with prominently marked protruding eyes.

Although Daruma was one of the teachers of Zen Buddhism and in pictorial art is associated with the Zen form of serving tea, the cha no yu, he is never pictured on any utensil used in that ceremony.

Pottery images of Daruma, standing wrapped in his red

robe and holding his fly-whisk are often displayed in the window or garden approach to small restaurants and tobacco shops, though why his scowling face should be considered as inviting customers is an unsolved problem.

There is in Tokyo today, despite frequent earthquakes and the devastating bombings of the last war, an immense image of Daruma made about thirty or forty years ago in some Imari kiln, of unglazed pottery, which must hold the world's record for a one piece pottery image for it is seven feet tall and proportionately sturdy. Made by a master artist it has a feeling of solemnity and repose hardly to be expected in a pottery image.

Eighteen Disciples of Buddha—

Rakan in Japanese. These are also known as Arhats. Historically they were the personal followers of Buddha. They are represented as skinny old men and can be recognized by the initiated but to the average layman they look pretty much alike. They are a favourite subject for Japanese ceramic artists today as they were three hundred years ago, especially on utensils for serving brewed tea.

These figures are often pictured on wares for export.

Fukusuke—

Fukusuke, used as a lucky symbol for small establishments. He is sometimes displayed along with *Otafuku*.

Fukusuke san, whose name means "good-fortune-man" is a small smiling man dressed in kami-shimo always bowing in invitation to customers to enter, and is often found displayed prominently in shops, restaurants or small hotels. He holds a fan, symbol of prosperity, and is usually seated. One of a group of half a dozen symbolic figures used interchangeably he is the only one about whose origin and development we are in total ignorance.

Hermit—

Kinko sennin in Japanese. Seen often as a center design in bowls or plates. A Chinese sage rising from the waves on the back of a carp or seated on a coral branch. His Chinese name is *Ch'in Kao*. See page 206.

Immortals—

Sennin in Japanese. These are usually drawn in a very sketchy manner but the attributes of each one are clearly indicated; sometimes only the attributes are pictured.

Emblems of the Chinese Eight Immortals. Often seen as repeat patterns on Japanese ceramics.

1 The sword of *Lu Tung-pin*
2 Castanets of *Ts'ao Kuo-chin*
3 Musical instrument of *Chang Kuo-lao*
4 Lotus of *Ho Hsien-ku*

5 Fan of *Chung Li-ch'uan*
6 Gourd of *Li T'ieh-kuai*
7 Flower basket of *Lan Ts'ai-ho*
8 Flute of *Han Hsiang-tzu*

There are Eight Chinese Taoist Immortals, originally Chinese they have been adopted by the Japanese and are used especially in the decoration of any object connected with the serving of brewed tea because that beverage came to Japan from China. Their symbolism is Chinese but all Japanese are familiar with their stories. Each one represents a different condition in life, poverty, wealth, plebianism, aristocracy, age, youth, masculinity and femininity. The Chinese have many stories connected with each individual but to the student of ceramic decoration only their attributes are essential.

1. *Lu Tung-pin;* said to have lived about 750 A D. He carries a Buddhist fly-whisk and has a sword slung on his back.

2. *Ts'ao Kuo-chin;* Lived 930–999 A.D. He is dressed in court robes because he was the nephew of the Empress

Tsao Hou of the Sung dynasty. He carries a pair of castanets in one hand, said to be derived from the court tablets (*shaku* in Japanese) authorizing free access to the palace. He is a patron saint of the Chinese theatrical profession.

3. *Chang Kuo-lao;* 7th–8th century A.D. He carries a peculiar musical instrument and is often pictured with a white mule which he keeps folded up and put away in his wallet, when he wishes to mount it he squirts some water unto the wallet and the beast appears.

4. *Ho Hsien-ku;* 7th century A.D. She is said to have eaten one of the peaches of immortality and thereafter wandered alone in the hills subsisting on powdered mother-of-pearl and moonbeams. Her emblem is the lotus, sacred to Buddhism, which she carries in her hand; or she is represented as standing on a lotus petal holding a fly-whisk.

5. *Chung Li-ch'uan;* said to have lived 1122–249 B.C. He is pictured as a fat man with bare belly holding a peach and a fan with which he is supposed to be able to revive the souls of the dead. Sometimes a Buddhist fly-whisk is substituted for the fan.

6. *Li Tieh-kuai ;* Pictured as a beggar leaning on an iron staff. His emblem is the pilgrim's gourd and he is sometimes pictured with a deer. Often he is merely suggested by his gourd with his spiritual body leaving it in a spiral of smoke issuing out of its mouth.

7. *Lan Ts'ai-ho;* Generally pictured as a woman but sometimes as a young man, dressed in a blue gown with one foot bare, the other shod. Her emblem is a basket of flowers and she is the patron saint of florists.

8. *Han Hsiang-tzu;* Lived about 820 A.D. He is believed to make flowers grow and blossom instantaneously. His emblem is the flute and he is the patron of musicians.

Momotaro and Kintaro—

Momotaro and *Kintaro*, pictured very much alike as sturdy round baby-faced boys are used as decoration on utensils designed to be used by very young children. Momotaro is the hero of a fairy tale teaching the virtue of gratitude to those who care for one in childhood. Kintaro's story is much the same except that it was his own mother who raised him. Momotaro is often pictured dragging a small cart laden with typical Japanese treasures, or just emerging from a peach. Kintaro is usually pictured overcoming a great black bear or branishing a battle axe.

Ono no Komachi—

 Ono no Komachi is pictured as beautiful woman in court costume. This is rather an exception for ceramic decoration because women's figures are not often used. Ono no Komachi was a court lady of Kyoto, about ten centuries ago, who was both beautiful and talented but who lost her beauty and died an unknown beggar's death. She is celebrated in Japanese art and literature.

Otafuku san and Okina san—

 Two symbols of good wishes for health and happiness. These are often displayed together on a fan shaped board-mount in hotels, restaurants and small shops of all kinds. Okina in a dance pose sometimes wears an *eboshi*, a peculiar high hat. This hat alone is often found on ceramic wares and carries the same symbolism of good wishes.

Uzume, Goddess of Mirth, in the ceramic form very popular with restaurants and small shops as a sort of mascot. In this form she is often spoken of as *Otafuku san*, which means Honourable-much-fortune. She also has a third name of *Okame*.

 Otafuku san is also known as *Okame san*. Otafuku literally translated means "honourable much fortune." Although she is usually considered merely as a good-natured woman, as Okame san there may be some connection with the mythological story of *Ame no Uzume no mikoto*, the goddess who danced before the cave into which the sun goddess had retired.

 Okina, represented as a benevolent-looking old man with white hair is one, sometimes the only, dancer in a dance performed at New Year or at the inauguration of a new project to insure good fortune and prosperity. This dance is common to Kabuki, the Noh and amateur interpretive dancing.

Rokkasen (Six Poets) or Sanju rokkasen (The Thirty-six Poets)—

 The full thirty-six figures are not often pictured on ce amics but the group of six are found frequently. See page 6. There is always one, sometimes two women, in the group but they are difficult to distinguish as all the figures are pictured as shaven-headed monks clad in gorgeous robes. Usually they are seated in a close mass inside a fan-shaped panel, though sometimes they are pictured alone with an appropriate background which gives a clue to their identity.

Seven Gods of Good Luck—

Shichi fuku jin in Japanese. There seems to be no other way of naming these personages than by calling them "gods," though the Japanese do not regard them as particularly sacred; they are a kind of mascot.

Their images are to be found in the homes of all classes of people. They are often pictured on pottery and porcelains as a group, but all seven images (or dolls) are seldom displayed at one time. The two who are associated with food, *Ebisu* and *Daikoku*, are usually to be found on the "god shelf" of merchants but will not be found in the houses of the educated or upper class people. They mean to the Japanese just about as much as a good luck horse-shoe over the door does to a European.

Benten :—The only woman in the group. She always carries a musical instrument, the "*biwa*" when she is pictured as one of the seven. When represented alone, she is often confused with *Kwannon*, the Buddhist Goddess of Mercy. If it is remembered that Benten wears her hair in a knot high on her head, while Kwannon wears hers parted like a madonna, there will be no confusion as to which is which. As one of the seven she is patron of music, art and literature and grants her devotees the gift of eloquence. She represents charity.

Bishamon :—He is represented by a vigorous young man clad in gorgeous armour. He holds a spear in one hand and a pagoda in the other. Although he is sometimes said to be the God of War, he is more often thought of as the giver of power and position. He represents glory.

Daikoku :—Happy god of wealth he holds in his hand a magic hammer which, when struck, will produce anything wished for. He is usually represented standing on rice bags. Together with Ebisu he symbolizes food (rice and fish) and therefore wealth. Images of these two gods are often displayed in the show window of small shops or small eating places.

Ebisu :—He is usually shown carrying an immense tai fish and his fishing rod and line. On ceramic wares he is often symbolized by his rod and line together with his fish basket or by a lively looking tai half in, half out of, the basket. He is the only purely Japanese creation in the group. He represents the daily food.

Fukurokuju :—A white bearded old man, with a very much elongated bald head. He is usually depicted without any head covering. In real life he was a Chinese Philosopher who scorned worldly honours and existed "on the mists of heaven and

the dews of earth." He is often accompanied by a crane, symbolic of long life. He is supposed to endow his admirers with great ability in their chosen walk in life.

Hotei :—The god of contentment. Pictured as a gross fat man, he actually symbolizes great spirituality. He is

supposed to be the Chinese incarnation, in the tenth century, of one of Buddha's followers, Maittreya. He had reached the point in spiritual understanding where he was about to enter Nirvana (the Buddhist heaven), but made a vow not to enter until all mankind had gone in before him. His large stomach represents great "bowels of mercy" as the Bible phrases it. He is often represented with Chinese children playing about his bag and playing tricks on him. Frequently he is pictured asleep on his bag. He represents content-

ment. Pottery, especially Bizen yaki, images of Hotei are often displayed in small shops or in offices of small hotels as he is somewhat of a mascot for those engaged in trade of any kind.

Jurojin :—He is very much like Fukurokuju, but wears a peculiar kind of cap. He usually holds a long staff with a roll tied to it, and is accompanied by a deer. He represents long life. He has no particular meaning for the Japanese except that he is a Chinese sage.

Shojo—

There is no English translation for this word. Shojo are little men with quantities of long bright red hair. They are often pictured on ceramic wares, especially on sake cups. Sometimes two men are making merry over a great wine jar; sometimes several are enjoying a picnic on the sea shore under pine trees. They seem to symbolize the joy of sake. In Japanese literature they reward those who are unassumingly faithful to their duty and play mischievous tricks on unkind, greedy people.

Takasago—

Emblem of successful married life—an old man and an old woman under a pine tree, usually accompanied by a crane and long tailed tortoise ; on the ground under the tree some bamboo grass and somewhere in the group a branch of plum blossoms.

No marriage ceremony is considered complete in Japan without the recitation of the following lines from the Noh play " Takasago."

"On the four seas still are the waves, the world is at peace.
Soft blow the winds, rustling not the branches.
In such an age blest are the very firs, in that they meet to grow
old together.
Vain indeed are reverent upward looks: vain even words to tell
Our thanks that we are born in such an age, rich with the bounty
of our sovereign lord."

<div align="right">Translated by W. G. Aston</div>

Miscellaneous Symbols

Buddhist Symbols—
These are not found on Japanese ceramics in
anything like the quantity they are on Chinese porcelains. With the
exception of the lotus flower, Buddhist symbols are pictured in a
very debased form, usually on the under side of Imari plates or as
scattered designs used as a form of diaper.

Comma-like Figures in a Circle—
Tomoye in Japanese, or *mitsu tomoye*. The
Chinese form, two comma shapes within a circle, is called Yin and Yang
(*in* and *yo* in Japanese). They represent shadow and light, negative and
positive, female and male. This symbol is borrowed without modi-
fication for ceramic designs. The mitsu tomoye, or three comma
design, is purely Japanese; when and where it originated no one
knows. The Koreans have a three comma symbol but it is quite
different from the Japanese. The Korean symbol is red, yellow and
green and the circle is entirely covered by the three commas, as is
the Chinese by its two; but the Chinese Yin-Yang symbol is pictured
in black and white (or on certain pottery forms all in one colour).
The Japanese tomoye is pictured usually in black and white (white
commas on a black ground), but unlike the other two symbols the
three commas of the Japanese tomoye leave an open space, which
in turn forms a three-prong mystic symbol. Perhaps all three forms
have a common symbolism, the elemental forces of nature.

Diapers—
This is the term used to denote small repeat
designs set close together to entirely cover the surface of an article.
Japanese ceramic artists do not crowd their surface designs as their
Chinese brethren do. Japanese artists are not afraid of open
spaces in their decorations and if they feel the need of closely

covering ("diapering") any part of the surface they avoid an exact repetition of the design; if using floral sprays, every spray is different, the number of leaves or the number of flowers varies; if they are using geometric patterns they will divide the surface to be diapered into odd irregular shapes with different repeat designs in each.

Eight Treasures—

 Happo or *hachi ho* in Japanese. These designs are found on all classes of ceramics, especially on the Kutani so-called *kinrande*, or *akaji kinga*. They are the coin, books, the stone chime, the artemisia leaf, the pearl, the lozenge, the mirror and rhinoceros' horns. The exact meaning of these eight

Symbols of the Chinese Eight Treasures. Gold coin, two books, stone chimes and an artemisia leaf. The coin symbol was used as a sort of trademark on old Nabeshima wares. The artemisia leaf is found very often on all classes of Japanese wares, sometimes part of the design, again as a mark of identification on the backs of wares.

Symbols of the Chinese Eight Treasures. The dragon pearl, lozenge, mirror and a pair of rhinoceros' horns. Of this group the last, the rhinoceros' horns, are used most frequently.

symbols is known only to students of the Chinese classics, but in general they symbolize wishes for wealth, wisdom, aesthetic pleasures

and bodily health. Vessels made of rhinoceros' horn were supposed to be a protection against the evil spirits of sickness. It is strange but the two superstitions of the artemisia leaf and the rhinoceros' horn were also current in Europe in the middle ages.

Of these eight symbols those of the artemisia leaf and rhinoceros' horns are most often found on Japanese ceramic wares.

Fans—

Suyehiro in Japanese. Suyehiro means broadening out, or wide, at the tip symbolizing future prosperity, and is considered an extremely lucky shape in Japan. It is used as a decorative motive on all classes of Japanese ceramics and is a favourite shape for dishes and boxes.

Feather Robe—

Hagoromo in Japanese. This symbol is often confused with the cloak of invisibility of the good luck symbols; but while that represents a cape of straw or hemp, hagoromo represents a many-hued feather robe. This feather robe is sometimes pictured hanging on a pine branch in allusion to the story of the angel who, lured by the beach at Miho with its view of Mt. Fuji across the water, came down to earth. While she was in bathing a fisherman stole her robe and refused to return it to her till she promised to dance for him. Reclothed, she danced for him on the white sands under the pine tree. This story has been dramatized many times and is a favourite subject for Japanese artists. On ceramics this story is often pictured by a beautiful woman clad in flowing garments under a pine tree.

Good Luck Symbols—

Takara mono in Japanese. Beside the borrowed Chinese symbols of good luck, the Japanese have developed some of their own. These are found on Japanese ceramics as repeat motives, especially on the reverse of plates of all sizes. See Page 8.

Hundred Antiques—

The group includes the Eight Treasures as well as the Four Treasures, symbols of the four fine arts, music, chess, calligraphy and painting together with conventional representations of sacrificial vessels, flowers, animal and many small decorative motives which cannot be classified otherwise.

These are Chinese in origin and have been borrowed by the Japanese.

Jooi, a Scepter—

Nyoi in Japanese. A sort of scepter with a peculiarly shaped head, symbolizing "As you wish" or "In accordance with your heart's desire." The head is a very common motive on Japanese ceramic wares used chiefly as a border repeat. It is usually so highly conventionalized as to be indistinguishable from the Chinese bat or cloud patterns. The jooi head is said to be derived from the sacred fungus or Chinese Plant of Long Life.

Rocks—

Ishi or *iwa* in Japanese. Large stones in the shelter of which grow small flowers, like the chrysanthemum or the orchid plant with its graceful long leaves; or great rocks from which grow large pine trees, are a motive often found on Chinese ceramics and the Japanese copied the idea. But the rocks are so highly conventionalized it is difficult to recognize them; in underglaze blue designs they are frequently a confused mass of dark blue and the Japanese artist has changed the pine tree into a palm tree (*sotetsu*). In designs following the Kakiyemon tradition the rocks are pictured in more detail.

Symbolically, large stones represent power and force of character, and indicate strength and good old age.

Treasure Ship

The Japanese Ship of Good Fortune (*takara bune*) is associated with the New Year festivities and Japanese porcelain wares intended for use at that time are often decorated with the ship itself or groups of the treasures it always carries. Ancient gold coins, coral branches, the lifegiving gem (or pearl), rolls of brocades, the ever-full purse, the hat and cloak of invisibility together with the key to the storehouse (an attribute of the Inari fox god) and the magic mallet of inexhaustible riches (attribute of Daikoku, one of the seven gods of good luck) with sometimes Ebisu's tai fish and fishing rod or fish basket make up the list of the treasures.

Takara bune—the Japanese ship of Good Fortune which for the Japanese comes in every year at New Year. It is piled high with treasures.

Whisk—

Hossu in Japanese. This object is pictured usually in combination with other Buddhist symbols but sometimes

alone. It is made of the tail of a Tibetan ox, or of white horse hair, and is carried by Buddhist priests as the symbol of their religious office. It is used to brush away small insects which might inadvertently be breathed in by the priests and so lose their lives. Not to take the life of insect, animal or man is one of the chief tenets of Buddhism. The whisk is a symbol of authority in China and the sages and saints of that country are often pictured with one. Daruma always carries one.

Conventional pattern based on the marking on a snake's skin.

Takara mono, precious things. Japanese adaptation of two of the Chinese Eight Treasures, the coin and rhinoceros' horns. These two designs are associated with the *takara bune* or Japanese Treasure Ship.

Inscriptions
on Ceramics

Chinese Dates Important in any Discussion
of Oriental Ceramics

The Japanese pronunciation of T'ang is To; of Sung it is So; of Ming it is Min; and of Ching it is Shin.

Han Dynasty	206 – 220 AD	
T'ang ”	618 – 906	
Sung ”	960 – 1279	
Ming ”	1368 – 1644	
Ching ”	1644 – 1912	

During the Ching dynasty the potters of

Kang Hsi	1622 – 1722
Yung Cheng	1723 – 1735
Ch'ien Lung	1736 – 1795

were very active producing beautiful wares.

The Japanese pronounce these names Koki, Yosei and Kenryu and it must be remembered that besides one name for the dynasty of successive rulers, such as T'ang dynasty, each individual ruler of the dynasty took a name for his reign, which was not his personal name rather an expression of his wish for his reign. The Chinese emperor who reigned from 1368 was named T'ai Tsu but his reign was known as Hung Wu, and Hung Wu means in English "Vast Militarism." But an emperor, Ch'eng Tsu, who reigned from 1403 to 1424, took as the name for his era Yung Lo or "Long Joy," a more acceptable name to us of these days. Yung Lo in name and seal plays an important part in Japanese ceramics for the Japanese pronunciation of Yung Lo is "Eiraku" a name very much in evidence in the pottery world of Japan today. The Chinese emperors were not referred to by their personal names but by the name of their reign even during their life time Japan has copied this custom and Japanese emperors are known in history by their reign names not by their childhood name. The present Emperor of Japan known to foreigners as Hirohito is spoken of as "The Emperor" by his own people. Showa, the name of the current era, meaning Enlightened Peace, expresses a pious wish rather than a statement of fact.

The marks on Chinese ceramics are incised, stamped or painted. Seal marks on Ming wares are rare, the usual mark is in ordinary Chinese script painted in blue on the biscuit under the glaze frequently enclosed in a blue square. Occasionally the mark is painted in over-the-glaze red. The characters are read from top to bottom beginning at the upper right hand corner.

The marks of Hsuan Te (1426-1435) and Ch'eng Hua (1465-1489), two Ming dynasty period names, were copied by Chinese potters of much later periods and also much used by Japanese potters. They are not to be depended upon for fixing the age of any piece, Chinese or Japanese.

A further complication arises in that the Japanese reading or pronunciation of any Chinese character differs from the Chinese reading and both are necessary in the study of Japanese ceramics and furthermore the Japanese say "Dai" or "Tai" indiscriminately.

The following list gives the dynastic title marks and seals most vitally connected with the development of ceramic wares.

Ming Dynasty

年 洪
製 武

Ordinary
Characters

㝵 㵄
㮤 武

Seal
Characters

Reading from upper right hand character.

Japanase				English
Ko	Vast
Bu	Militarism
Nen	Year
Sei	Made

Approximate English meaning:
Made in the reign of Hung Wu (1368-1398).
The emperor is known as Ko bu in Japan.

年 永
製 樂

Ordinary
Characters

㝵 㵄
㮤 樂

Archaic
Characters

Japanese				English
Ei	Long
Raku	Joy
Nen	Year
Sei	Made

Approximate English reading:
Made in the reign of Yung Lo (1403 to 1424).
The emperor is known as Ei raku in Japan.

德 大
年 明
製 宣
Ordinary Characters

南圈内
弱吉刚
Seal Characters

Japanese	English
Dai	Great
Min	Bright
Sen	Diffusion
Toku	Virtue
Nen	Year
Sei	Made

Approximate English reading:

Made in the reign of Hsuan Te of the Great Ming Dynasty (1426 to 1435).

The emperor is known as Sen toku in Japan.

化 大
年 明
製 成
Ordinary Characters

用成
帮以
Seal Characters

Japanese	English
Dai	Great
Min	Bright
Sei	Attainment
Ka	Civilization
Nen	Year
Sei	Made

Approximate English reading:

Made in the reign of Cheng Hua of the Great Ming Dynasty (1465 to 1487).

This emperor is known as Sei ka in Japan.

Note:—This seal was used on great quantities of porcelains exported from Japan in the 18th Century.

治 大
年 明
製 弘
Ordinary Characters

弘

治

Variation of first mark Emperor's name only

Japanese	English
Dai ...	Great
Min ...	Ming
Ko ...	Widely or expanded
Ji ...	Government
Nen ...	Year
Sei ...	Made

Approximate English reading:

Made in the reign of Hung Chih of the Great Ming Dynasty (1488 to 1505).

This emperor is known as Ko ji in Japan.

德 大 正
年 明 德
製 正

Ordinary Characters / **Emperor's name only**

Japanese				English
Dai	Great
Min	Bright
Sei	Righteous
Toku	Virtue
Nen	Year
Sei	Made

Approximate English reading:

 Made in the reign of Cheng Te of the Great Ming Dynasty (1506 to 1521).

 This emperor is known as Sei toku in Japan.

靖 大 嘉
年 明 靖
製 嘉

Ordinary Characters / **Emperor's name only**

Japanese				English
Dai	Great
Min	Bright
Ka	Auspicious
Sei	Peace
Nen	Year
Sei	Made

Approximate English reading:

 Made in the reign of Chia Ching of the Great Ming Dynasty (1522 to 1566).

慶 大 隆
年 明 慶
製 隆

Ordinary Characters / **Emperor's name only**

Japanese			English
Dai	Great
Min	Bright
Ryu	Prosperous
Kei	Congratulations
Nen	Year
Sei	Made

Approximate English reading:

 Made in the reign of Lung Ching of the Great Ming Dynasty (1567 to 1572).

 This emperor is known as Ryu kei in Japan.

曆　大
年　明
製　萬

Japanese		English
Dai	Great
Min	Bright
Man	Ten thousand
Reki	Calendar
Nen	Year
Sei	Sei

Approximate English reading:
> Made in the reign of Wan Li of the Great Ming Dynasty (1573 to 1619).
> This emperor is known as Man reki in Japan.

啟　大
年　明
製　天

Japanese			English
Dai	Great
Min	Bright
Ten	Heaven
Kei	Revelation
Nen	Year
Sei	Made

Approximate English reading:
> Made in the reign of Ti'en Chi of the Great Ming Dynasty (1621 to 1627).
> This emperor is known as Ten kei in Japan.

年　崇
製　楨

Japanese	English
Su ...	Reverend thankfulness
Tei ...	Congratu'ations
Nen ...	Year
Sei ...	Made

Approximate English reading:
> Made in the reign of Ch'ung Cheng (1628 to 1643).
> This emperor is known as Su tei in Japan.

大清順治年製 治年製 順清大

南順巾
暫恰精

Japanese				English
Dai	Great
Shin	Clear
Jun	Obedient
Ji	Government
Nen	Year
Sei	Made

Ordinary Characters Seal haracters

Approximate English reading:

Made in the reign of Shun Chih of the Great Ching Dynasty (1644 to 1661).

This emperor is known as Jun ji in Japan.

熙年製 清大 康

南霖巾
暫熨精

Japanese				English
Dai	Great
Shin	Clear
Ko	Peaceful
Ki	Peaceful
Nen	Year
Sei	Made

Ordinary Characters Seal Characters

Approximate English reading:

Made in the reign of Kang Hsi of the Great Ching Dynasty (1662 to 1722).

This emperor is known as Ko ki in Japan.

正年製 清大 雍

南雍巾
暫正精

Japanese				English
Dai	Great
Shin	Clear
Yo	Peaceful
Sei	Righteous
Nen	Year
Sei	Made

Ordinary Characters Seal Characters

Approximate English reading:

Made in the reign of Yung Cheng of the Great Ching Dynasty (1720 to 1735)

This emperor is known as Yo sei in Japan.

隆　大
年　清
製　乾

Ordinary
Characters

Seal
Characters

Japanese			English
Dai	Great
Shin	Clear
Ken	Positive
Ryu	Prosperity
Nen	Year
Sei	Made

Approximate English reading:
> Made in the reign of Chi'en Lung of the Great Ching Dynasty (1736 to 1795).
> This emperor is known as Ken ryu in Japan.

年　嘉
製　慶

Ordinary
Characters

Seal
Characters

Japanese		English
Dai	...	Great ⎱ on seal
Shin	...	Clear ⎰ only
Ka	...	Auspicious
Kei	...	Congratulations
Nen	...	Year
Sei	...	Made

Approximate English reading:
> Made in the reign of Chia Ching of the Great Ching Dynasty (1769 to 1820).
> This emperor is known as Ka kei in Japan.

光　大
年　清
製　道

Ordinary
Characters

Seal
Characters

Japanese				English
Dai	Great
Shin	Clear
Do	Way
Ko	Brightness
Nen	Year
Sei	Made

Approximate English reading:
> Made in the reign of Shung Chih of the Great Ching Dynasty (1821 to 1850).
> This emperor is known as Do ko in Japan.

		Japanese			English
豐年製	大清咸	Dai			Great
		Shin			Clear
		Kan			Universal
		Po			Riches
		Nen			Year
Ordinary Characters	Seal Characters	Sei			Made

Approximate English reading:

Made in the reign of Hsi'en Tang of the Great Ching Dynasty (1851 to 1861).

This emperor is known as Kan po in Japan.

		Japanese			English
治年製	大清同	Dai			Great
		Shin			Clear
		Do			Impartial
		Ji			Government
		Nen			Year
Ordinary Characters	Seal Characters	Sei			Made

Approximate English reading:

Made in the reign of Tung Chih of the Great Ching Dynasty (1862 to 1874).

This emperor is known as Do ji in Japan.

		Japanese			English
緒年製	大清光	Dai			Great
		Shin			Clear
		Ko			Brightness
		Cho			Beginning
		Nen			Year
Ordinary Characters	Seal Characters	Sei			Made

Approximate English reading:

Made in the reign of Kuang Hsiu of the Great Ching Dynasty (1875 to 1909).

This emperor is known as Ko cho in Japan.

Marks on Chinese Ceramics found on Japanese Wares

佳 玉
器 堂

Ordinary Characters

Japanese				English
Gyoku	Jewel
Do		Hall
Ka		Precious
Ki		Vessel

Inscription explaining use of article.
Approximate English:
Fine vessel for the Jade Hall.

佳 富
器 貴

Ordinary Characters

Japanese		English
Fu	Rich
Ki	Noble or Honourable
Ka	Precious
Ki	Vessel

Approximate English:
Fine vessels for the rich and honourable.

鼎 奇
之 石
珍 寶

Ordinary Characters

Japanese			English
Ki	Strange
Seki	Stone
Ho	Treasure
Tei	Vessel
No	Of
Chin	Jewel or precious, rare

Approximate English:
A gem among precious vessels of rare stone.

長 富
春 貴

Ordinary Characters

Japanese				English
Fu	Riches
Ki	Honour
Cho	Eternal
Shun	Spring

Approximate English:
A wish for riches, honour and eternal spring (or youth).

萬福
倣同

Japanese			English
Ban	Ten thousand
Fuku	Fortune
Shu	Collected
Do	Equally

Ordinary Characters

Approximate English:
A thousand happinesses embrace all your affairs.

順
祿

Japanese			English
Jun	Harmony
Roku	Good luck

Ordinary Characters

Approximate English:
Harmony and good luck.

師公
府用

Japanese			English
Shi	Government
Fu	Capital
Ko	Public
Yo	Use

Ordinary Characters

Approximate English:
For public use in the General's Hall.

惠
孟
臣

Japanese			English
Kei	Mercy
Mo	Loyal
Shin	Subject

Archaic Characters

Approximate English:
Commemorating " a loyal and loving follower."

天
全
珍
玩

Ordinary Characters

Japanese			English
Ten	Heaven
Zen	Complete
Chin	Jewel or precious
Gan	Trinket

Approximate English:
Heavenly complete jewel trinket.

Ordinary Characters

Japanese			English
Gan	Including or containing
Kei	Fragrance

Approximate English:
To contain fragrance.

珍
玉
雅
玩

Ordinary Characters

Japanese			English
Chin	Precious
Gyoku	...		Jade
Ga	Elegant
Gan	Trinket

Approximate English:
Precious jade elegant trinket.

慎 博
德 古
堂 製

Ordinary Characters

Japanese			English
Shin	Discretion
Toku	Virtue
Do	Hall
Haku	Comprehensive
Ko	Old
Sei	Made

Approximate English:
Antique made at Comprehension of Virtue Hall.

Japanese			English
Fu	Riches
Ki	Honour
Cho	Eternal
Mei	Life

Seal Characters

Approximate English:
Riches honour eternal life.

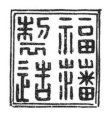

Japanese			English
Fuku	Fortune
Han	Hedge
Sei	} Made
Zo	

Seal Characters

Approximate English:
Made on the borders of Fukien.
Note:—Fukien is a coast province of China where all kinds of
ceramics have been made for centuries.

Japanese		English
Tan	Judus-tree
		Red or
Kei	Cassia-tree

Archaic Characters

Note:—" To pluck the cassia in the moon " means to obtain a high
place in the state examinations of old China.
This mark is often found on Chia Ching and Wan Li porcelains.

— 236 —

Development and modification of an E-gorai design,
found on Old Imari porcelain wares.

SELECTED BIBLIOGRAPHY

The following includes only the works in English consulted by the author, and makes no pretense of being a complete bibliography on the subject.

A Chronological List of Japan and China
 By Aisaburo Akiyama
 Pub. Tokyo 1942. Kyo Bun Kwan Book Store
A Few Words in Defense of Japanese Pottery
 By Dr. Eleanor von Erdberg Consten
 Pub. by the author. Pekin 1940
A Guide to the Pottery and Porcelain of the Far East
 Printed by Order of the Trustees, British Museum 1924
A History of the Japanese People
 By Capt. F. Brinkley, R.A.
 Pub. London 1912. The Encyclopaedia Britannica
A Manual of Historic Ornament
 By Richard Glazier
 Pub. London 1933. B. T. Batsford Ltd. 15 No. Audley St.
A Note on the Ishizara, A Kitchen Ware of Seto
 By M. Yanagi in Eastern Art Vol. III
 Pub. Philadelphia 1931. The College Art Association
A Sketch of Chinese Arts and Crafts
 By Hilda Arthurs Strong
 Pub. Peiping 1933. Henry Vetch

Art and Art Industries of Japan
 By Sir Rutherford Alcock, K.C.B., D.C.L.
 Pub. London 1878

Arts and Crafts of Old Japan
 By Stewart Dick
 Pub. London 1923. T. N. Foulis, Ltd.

Catalogue of the Le Blond Collection of Corean Pottery
 By Bernard Rackham
 Pub. London 1918. His Majesty's Stationery Office

Ceramic Art of Japan
 By Tadanari Mitsuoka
 Pub. Tokyo 1949. Japan Travel Bureau

Cha no yu, The Japanese Tea Ceremony
 By A. L. Sadler
 Pub. London 1933. Kegan Paul, Trench, Trubner & Co.

Cha no yu, The Tea Cult of Japan
 By Yasunosuke Fukukita
 Pub. Tokyo 1932. Maruzen Company Ltd.

Chats on Oriental China
 By J. F. Blacker
 Pub. London 1918 T. Fisher Unwin

Chinese Art
 By Stephen W. Bushell C.M.G., B.Sc., M.D. Vol. II
 Pub. London 1906. Wyman and Sons Ltd. Fetter Lane E.C.

Chinese, Corean and Japanese Potteries
 Descriptive Catalogue of Loan Exhibition
 Pub. New York Japan Society 1914

Chinese Porcelain
 By W. G. Gulland
 Pub. London 1898. Chapman & Hall

Chinese Pottery of the Han Dynasty
 By Berthold Laufer, Publication of the East Asiatic Committee
 of the American Museum of Natural History
 Pub. Leiden 1909. E. J. Brill Ltd.

Corea, The Hermit Nation
 By William Elliot Griffis
 Pub. New York 1897. Charles Scribner's Sons

Corean Ceramics of the Yi Dynasty
 By Kenneth Dingwall
 Pub. in The Antique Collector. April 1933

Decorative Motives of Oriental Art
 By Katherine M. Ball
 Pub. London 1927. John Lane, The Bodley Head Ltd.

Epochs of Chinese and Japanese Art
 By Ernest F. Fenolosa
 Pub. London 1912. William Heinemann

Gems of Japanese Art and Handicraft
 By George Ashdown Audsley, L.L.D.
 Pub. London 1913. Sampson Low, Marston & Co. Ltd.

Handbook of Japanese Art
 By Noritake Tsuda
 Pub. Tokyo 1938. Sanseido Co.

How to Identify Old Chinese Porcelain
 By Mrs. Willoughby Hodgson
 Pub. London 1920. Methuen & Co., 36 Essex St. W.C.

Human Elements in Ceramic Art
 By Kikusaburo Fukui
 Pub. Tokyo 1934. Kokusai Bunka Shinkokai

Japan and Its Art
 By Marcus B. Huish
 Pub. London. B. T. Batsford, 49 High Holborn

Japanese Art Motives
 By Maude Rex Allen
 Pub. Chicago 1917. A. C. McClurg & Co.

Japanese Art, Selections from the Encyclopaedia Britannica
 Pub. New York 1933

Japanese Ceramic Art and National Characteristics
 By Kikusaburo Fukui
 Private publication by author. Tokyo 1926

Japanese Pottery Oil Dishes
 By S. Yamanaka
 Pub. Philadelphia. Eastern Art, A Quarterly. Jan. 1929

Keramic Art of Japan
 By George A. Audsley and James L. Bowes
 Pub. London 1881. Henry Sotheran & Co.

Kojiki, Records of Ancient Matters
 Translated by Basil Hall Chamberlain
 Pub. by the Asiatic Society of Japan
 J. L. Thompson & Co. Kobe 1932

Masterpieces of Japanese Art Vol. III
 Pub. Tokyo 1948. Bunka Koryu Kurabu

Nihongi, Chronicles of Japan from Earliest Times to AD 697
 Translated by W. G. Aston
 Pub. London 1896. Kegan Paul, Trench, Trubner & Co.

Notes on Japanese Pottery
 By R. L. Hobson
 Transactions of the Japan Society of London. Nov. 20, 1930

Outlines of Chinese Symbolism and Art Motives
 By C. A. S. Williams
 Pub. Shanghai 1932. Kelly and Walsh Ltd.

Pointers and Clues to Subjects of Chinese and Japanese Art
 By Will. H. Edmunds
 Pub. London 1934. Sampson Low, Marston & Co.

Porcelain, A Sketch of its Nature and Manufacture
 By William Burton, F.C.S.
 Pub. London 1906. Cassell & Co.

Pottery and Porcelain, A Handbook for Collectors
 Translated from the Danish of Emil Hannover by Bernard
 Rackham
 Vol. I Europe and the Near East
 II The Far East
 III European Porcelain
 Pub. London 1925. Ernest Benn Ltd., 8 Bouverie At. E.C. 4

Pottery of the Korai Dynasty
 By A. I. Ludlow, M.D.
 Transactions of the Korea Branch of the Royal Asiatic Society
 1934–35

Prehistoric Japan
 By Neil Gordon Munro
 Pub. Yokohama 1911

Some Little-known Japanese Wares
 By Major W. Peer Groves
 Transactions of the Japan Society of London. Vol. XXXII, XXXIV

Some Notes on Pi-se yao
 By Sir Percival David
 Pub. Philadelphia. Eastern Art, A Quarterly. Jan. 1929

Studies in the Decorative Art of Japan
 By Sir Francis Piggott
 Pub. London 1910. B. T. Batsford, 94 High Holborn

Styles of Ornament
 By Alexander Speltz
 Pub. New York. Grosset & Dunlap

The A.B.C. of Collecting Old Continental Pottery
 By J. F. Blacker
 Pub. London 1913. Stanley Paul & Co., 31 Essex St. Strand W.C.

The A.B.C. of Japanese Art
 By J. F. Blacker
 Pub. London. Stanley Paul & Co., 31 Essex St. W.C.

The Book of Pottery and Porcelain
 By Warren E. Cox
 Pub. New York 1947. Crown Publishers

The Book of Tea
 By Kakuzo Okakura
 Pub. Edinburgh 1919. T. N. Foulis

The Collecting of Antiques
 By Esther Singleton
 Pub. New York 1937. The Macmillan Co.

The Economic Aspects of the History of the Civilization of Japan
 By Yosoburo Takekoshi
 Pub. London 1930. George Allen & Unwin Ltd.

The Potters and Pottery of Satsuma
 By William Leonard Schwartz
 Transactions of the Asiatic Society of Japan Vol. XIX

The Potter's Art (Written for "Chinese Art")
 By R. L. Hobson
 Pub. London 1935. Kegan Paul, Trench, Trubner & Co.

The Pottery of the Chanoyu
 By Charles Holme
 Transactions of the Japan Society Vol. VIII 1880

The Practical Book of Chinaware
 By H. D. Eberlein and R. W. Ramsdell
 Pub. New York 1938. Halcyon House

The Shoso in
 By Sir Percival David, Bert. M.J.S.
 Transactions of the Japan Society of London. October 23, 1930

The Wares of the Ming Dynasty
 By R. L. Hobson
 Pub. London 1923. Benn Brothers Ltd.

INDEX

(Numbers refer to pages)

Bottger, 154
Buccaro, 154

C

D

F

Faience, 61, 117, 123, 131, 135
Fish and Shell Fish Symbolism, 206-207
Flambe, 15
Floral Symbols, 208-210
footrim or kodai, 19, 33, 34, 44, 45, 47, 48, 74, 75, 84, 91, 109, 111, 130, 135, 137
Fruit Symbolism, 211-212
Fujina, 84
Fukugawa, 101, 104, 107
Fukumoto Nizayemon, 126
Furuta Oribe no Sho: (See Oribe)

G

Gandra, 6
garden kilns, 105 (See kilns)
glaze(s), 4, 6, 7, 8, 12, 13, 16, 19, 31, 32, 33, 34, 42, 43, 45, 48, 52, 54, 67, 74, 80, 82, 83, 85, 86, 87, 88, 89, 91, 92, 93, 95, 96, 97, 100, 101, 102, 103, 104, 107, 110, 111, 114, 116, 117, 118, 119, 121, 122, 123, 127, 130, 132, 136, 137, 138, 140, 141, 143, 146, 147, 148, 151, 152, 153, 155, 156, 164, 169, 173; black or kuro, 15, 95, 106, 107, 130, 131, 137, 139; blue, 93, 95; celadon: see celadon; coloured glazes (enamels), 6, 7, 13, 15, 19, 30, 37, 49, 51, 56, 61, 67, 71, 72, 74, 75, 76, 77, 78, 80, 81, 82, 84, 85, 86, 90, 94, 95, 98, 102, 103, 106, 109, 126, 129, 131, 142, 160, 171; formations, 33, 45, 48, 49, 50; nagare, 48; namako, 76; natural, 69, 151; transmutation, 15; white or shiro, 155; yellow 95
Gojozaka, 147, 148, 153
gold, 55, 56, 61, 80, 81, 91, 92, 94, 95, 141, 145, 152, 160, 179, 180, 182, 183; design, 12; Kono Senyemon, 81
Gomado yaki, 137
Gombroon, 162
Gorodayu Go Shonzui, 113, 114 (See Shonsui)
Goroshichi, 74, 75
Goshun, 148
gosu, 7, 93, 127, 145
gosu akaye, 94, 127, 140, 145, 152, 153; aka, 134
Goto Saijiro, 132
grain de riz, 162
Gyoki yaki, 67
Gyozan, 148

H

I

kaolin, 39, 40 (See ceramic clays)
Karatsu, 2, 4, 66, 73, 74, 75, 76, 77, 78; beiryo, 74; horidashi, 78;
 interior or oku, 74, 77; kenjo, 78; madara, 75; Mishima, 73, 76,
 77; old or ko, 73, 74; picture or e, 73, 77; Seto, 74; yone hakari,
 74, 75
Kashu Mimpei, 145, 146, 148, 153
Kasuga Shrine, 52
katade, 79
Kato Kagemasa, 119
Kato Kagenobu, 41, 42
Kato Kichizayemon, 125
Kato Shirozayemon Kagemasa, 120, 121, 124
Kato Shuntai, 118
Kato Tamikichi, 117, 123, 124, 125, 126, 161
Kato Tokuro, 122
Kato Tozaburo, 119
Katoji Kagekado, 121
Kawamoto Juhei, 118
kawarake mono, 68, 194
kenjo karatsu, 78
Kensai Uranowa, 144
Kenzan, 143, 144, 146, 155; Ihachi, 144
ki seto, 4, 87, 116, 117, 123
Kikutani River, 57, 58
kiln(s), 4, 13, 14, 19, 20, 21, 22, 23, 32, 39, 40, 41, 42, 43, 49, 51, 52,
 54, 56, 57, 58, 59, 63, 64, 65, 66, 67, 68, 69, 70, 71, 72, 73, 74, 75,
 77, 79, 80, 82, 83, 84, 88, 89, 91, 97, 98, 99, 100, 101, 103, 105, 106,
 107, 108, 109, 111, 112, 116, 117, 118, 119, 122, 124, 125, 127, 129,
 130, 132, 134, 137, 138, 139, 140, 141, 142, 144, 145, 148, 149, 150,
 152, 157, 158, 159, 161, 164, 176, 180, 183; baby crab or kani ko
 gama, 42; cave or ana gama, 40, 41, 42, 70; clan, 106, 126; coal
 burning, 107; community, 14, 39; firing, 16, 19, 43, 63, 70, 72,
 73, 76, 86, 92, 104, 106, 110, 116, 119, 138; fuel, 39, 41, 42; garden
 or oniwa, 105, 106; group project, 39; hon gama, 46; in series,
 42; ko gama, 42; large or oh gama, 41, 42, 43; nobori gama,
 41, 42, 70; official, 105, 118; round or maru gama, 42, 43; spirit
 of, 43; split bamboo or waritake gama, 42; sue, 70
Kin ri mono, 107
kinrande: (See decoration)
kinuta, 86
Kiyomizu yaki, 140, 141, 146, 147, 157
Kizayemon, 102, 108
Kobori Enshu: (See Enshu)

L

M

Maku, 33

Makuzu, 149, 150; Chobei, 150; Chozo, 150; Kozan, 149, 150; Yukansai, 150

Maruyama, 127 (See also Inuyama)

Maruyama Okyo, 148

Mashimizu Zoroku, 148

Matsuya Kikusaburo, 134

Mikawa Chozayemon, 137

Mikawaguchi, 91, 105

Mikawauchi, 112, 126

Mikazuki Rokubei, 72

Ming, 4, 20, 54, 86, 91, 93, 95, 96, 100, 113, 117, 140, 145, 153; blue, 93; design, 93, 140, 145

Miscellaneous Symbols, 220-224

Mishima, 166 (See types of decoration)

mishima seiji, 169

Miura Kenya, 143, 144, 158, 159

Miyakawa, 149 (See Makuzu)

Mokubei: (See Aoki Mokubei)

mumyoi yaki, 193; Kihara Kichiyemon, 193

mushi kui, 19

Myozen, 59

N

Nabeshima, 91, 93, 105, 108, 109, 110, 111, 126, 130, 135, 137, 180, 184; akaye, 111; coloured or iro, 91, 92, 109; comb design, 91; makusoto, 109; Naoshige, 104

Nagasaki, 2, 91, 101, 102, 103, 107, 156

Nagoya, 119, 126

names and marks: family name(s), 22, 57, 121; Japanese system of dates, 23; marks and seals, 16, 20, 21, 22, 23, 50, 52, 53, 54, 55, 56, 57, 58, 59, 60, 70, 72, 78, 99, 100, 101, 105, 116, 127, 134, 135, 136, 137, 138, 141, 144, 145, 146, 147, 148, 149, 150, 152; *Imari*, 99; *Kyoto, 23;* Marks on Chinese Ceramics found on Japanese Wares, 233-236; name(s), 22, 23, 46, 49, 52, 53, 55, 57, 59, 66, 72, 73, 74, 81, 84, 91, 100, 102, 104, 105, 114, 118, 121, 130, 149, 157; signature(s), 22, 23, 40, 100, 101

Nara buro or Nara furo, 52

Near East influences, 76; Corinthian, 7; Greece, 1, 6, 7, 8; Ionians, 3, 7; Mesopotamia, 6; Persia, 6, 8; Phoenicians, 7

nenuki, 74, 75

neriage, 173

Ninsei; as a potter, 22, 33, 40, 106, 141, 142, 143; at Akahada, 33,
148; copies or imitations, 78, 141, 146, 149, 153, 155; crackle, 88,
89; designs, 81, 82, 183; influence, 56, 144, 151; Nonomura
Seibei, 141; seal, 142; at Soma, 138, son of, 144; at Takamatsu,
141, 142

nishikide: (See decoration)

Nomi no Sukune, 65

Nonomura Ninsei: (See Ninsei)

Noritake (Nihon Toki Kaisha), 162

Nun's ware, 49

O

O buke or o fuke, 119

O niwa sobokai, 119

Ogata Kenzan: (See Kenzan)

Ogata Kichisaburo, 146, 153; Shuhei, 146, 153; Toyonosuke, 146, 153

Ogata Shinsho, 143 (See Kenzan)

Ohi, 137

Okawachi, 87, 111

Okawaguchi, 111

Okayama, 69, 70

Okochi, 91, 105, 108, 109, 111; ko, 111; seiji, 111

oku karatsu: (See Karatsu)

oku korai: (See Korea)

Okuda Eisen, 72, 89, 144, 145, 146

Okura Toen, 162

oni yaki, 84

oniwa yaki, 105

Oribe, 22, 32, 33, 34, 35, 36, 37, 40, 184; aka 37; ao, 37; copies or
imitations, 22; designs, 35, 36; influence, 22, 34, 117, 118, 119; at
Karatsu, 78; kuro, 37

Osaka, 65

Osaki, 84

P

Peach Bloom, 15

phoenix, 11

potter(s): festival, 194; guilds, 65, 66, 67; village, 65; wheel, 3, 43,
 44, 47, 49, 63, 67, 75. **Methods;** 16, 21, 43, 44, 45, 47, 48, 66, 67,
 75, 107, 126, 150; cast, 43; jigger shaped, 43; kai me, 75; mass
 production, 30, 43; molded, 71, 72; molds, 43, 77, 107; neri age,
 173; tataki zukuri, 44, 75; te zukuri, 44; uchi nami, 44, 75; wheel
 thrown, 43, 47, 64, 68, 70, 84, 138
pre-historic earthen wares, 64; pottery, 63, 64
production control, 14

R

Raku, 15, 20, 29, 33, 45, 46, 47, 48, 49, 50, 51, 54, 123, 124, 137, 140,
 145, 146, 155, 159, 190; black or kuro, 49; Chojiro, 49, 116;
 Chonyu, 51; Chou, 140; Choyu, 49; Chozayemon, 50, 51; Chusai
 Koho, 51; Donyu, 50; Ichinyu, 50, 51; incense burner or koro,
 49; ito giri, 70; Jokei, 33, 49, 50; Keinyu, 51; Kichibei, 50;
 Kichizayemon, 49, 50, 51; marks or seals, 50, 100, 137, 147;
 Masakichi, 49; Nonko, 50; nun's ware, 49; Raku line of potters,
 46, 49, 50, 51; red or aka, 48, 50; Ryonyu, 51; Sanyu, 51;
 Sasaki, 49; Sokei, 49; Sonku-Chusai Koho, 50; Sonyu, 51; Taki-
 nohoya Togobenzo, 50; Tanaka, 46, 49; Tanyu, 31; Tokunyu,
 51; white or shiro, 49
religious influence: Buddhist, 4, 26, 31, 33, 60, 96, 126; religious
 offerings, 52, 64; ritual, 3, 4, 15, 21, 64, 69, 70, 87, 116, 193;
 Shinto, 4, 9, 68
rensen kanu, 80
Ri dynasty, 77 (See Chapter on Korean Wares)
Ri Sampei, 104, 109, 114
Rice Porcelain, 162
richo tetsusa, 77 (See Chapter on Korean Wares)
Rikyu, 22, 31, 32, 35, 36, 49, 52, 140
Rokubei, 144, 147, 148; Guami, 148; Gusai, 147; Kiyomizu, 147;
 Seibei, 141, 144, 147; Seisai, 148; Shichibei, 148; Shimizu, 147;
 Shorin, 148; Shoun, 148
roof tiles, 49, 66
Ryokichi, 83
Ryosai: (See Sen no Ryosai)

S

Sakai, 52
Sakaida Kakiyemon: (See Kakiyemon)
Sakaida Kizayemon: (See Kakiyemon)

W

Y

Z

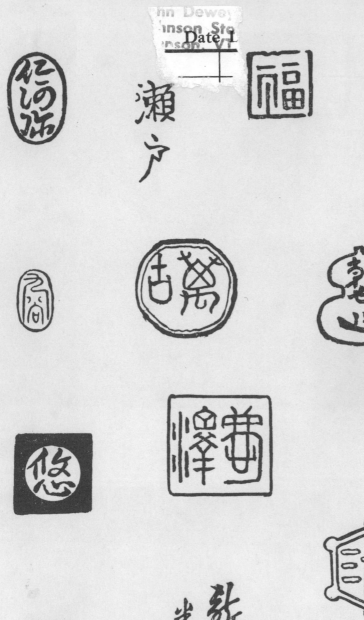

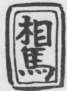